The Medium Format Advantage

The Medium Format Advantage

Ernst Wildi

Focal Press
Boston · Oxford · Melbourne · Singapore
Toronto · Munich · New Delhi · Tokyo

Focal Press is an imprint of Butterworth–Heinemann.

Copyright © 1995 by Butterworth–Heinemann

 A member of the Reed Elsevier group

Recognizing the importance of preserving what has been written, Butterworth–Heinemann prints its books on acid-free paper whenever possible.

Library of Congress Cataloging-in-Publication Data
Wildi, Ernst.
 The medium format advantage / Ernst Wildi.
 p. cm.
 Includes index.
 ISBN 0-240-80221-7
 1. Medium format cameras. 2. Photography—Handbooks, manuals,
etc. I. Title.
TR257.W5477 1995
771.3'2—dc20 94-44265
 CIP

British Library Cataloging-in-Publication Data
A catalogue record for this book is available from the British Library.

Butterworth–Heinemann
313 Washington Street
Newton, MA 02158-1626

10 9 8 7 6 5 4 3 2 1

Printed in the United States of America

Contents

Preface

The majority of photographers do not start in the medium format. Most often they move up from a smaller film size, such as 35 mm, hoping to produce better quality pictures or more saleable images or to simply become more successful photographers. All this is possible, but only by being aware of the possibilities and limitations of the format and equipment.

There are also professionals normally working with larger negative sizes who move down to the medium format because of its convenience, faster shooting capability, and portability.

This is happening more often today because of the superb definition of the modern color and black-and-white films. In the words of many photographers, large format image quality is now obtained on medium format rollfilm.

These trends of moving up as well as moving down have made the medium format truly the format in the middle. It combines many of the benefits of 35 mm photography with those of the large format, making a medium format system an excellent choice for almost all types of photography from candid action with a hand-held camera to critical studio work from a tripod. Special chapters are devoted to these different applications and the type of equipment that most likely meets your photography needs.

Since the camera may very well be used in so many different ways and applications, choosing the right system is of utmost importance. You need to choose a medium format camera with more care than you would a 35 mm camera because medium format camera systems produce images in different formats and vary greatly in size, weight, design, and operation—much more so than does 35 mm equipment.

You should put a lot of thought into your choice of a camera because a move into the medium format can be a fairly costly undertaking if you are looking at a complete system with lenses, finders, and film magazines

rather than just a basic camera. All components, especially the lenses, are larger and consequently more expensive than in 35 mm.

This book explains clearly the medium format's benefits, advantages, and disadvantages and provides a comparison of the medium format to other formats so you can decide whether it is right for you and your photography. It lays out the different camera and lens designs and gives a photographer's view of which features are important for specific applications and in different fields of photography.

For photographers already working in the medium format, the book is a guide for using the medium format camera and its features so that you can obtain the best possible image quality regardless of your purposes or field of photography.

The book is not a camera instruction manual. The instructions come with the camera and should be studied carefully before you start using the camera. Even expert 35 mm photographers should not assume that they know everything about the camera. Although some medium format cameras look and operate like 35s, some are quite different, especially if they feature interchangeable film magazines and lenses with leaf shutters. This book does not duplicate what the camera manufacturer can supply. It is a camera manual that takes over where the camera manufacturer's data stop.

There is one more objective I tried to accomplish: to inspire you to use your cameras, lenses, and accessories not just to record things as you see them, but to experiment and to use photography's unique capability to create a different world of images. Medium format cameras are well suited for creating images that are different from the way we see the world; they are, in my mind, the best photographic tools for this purpose.

The History of Medium Format

"Medium format" as it is defined today—to categorize the film formats between 35 mm and the larger view camera formats 4 × 5 in. and up—is frequently considered quite new.

But photography actually started with the medium format. The daguerreotype plates used in the 1840s were 6 1/2 × 8 1/2 in. large. But since silver and copper, the components of these plates, were very expensive, the image often did not cover the full size of the plate, so the plates were split into smaller sections (1/2 to 1/16) such as 2 3/4 × 3 1/4 in., 2 1/8 × 3 1/4 in., or 1 5/8 × 2 1/8 in. Judging from the large number of photographic images that have survived from this time, the 2 3/4 × 3 1/4 in. "medium format" was the most popular.

Roll film, which forms the basis for the design of the modern medium format camera, appeared in 1888 when George Eastman introduced the first camera with the Kodak name. The camera was factory loaded with roll film for one hundred exposures, and the entire camera had to be returned to Eastman for processing the finished roll of film and for reloading. The image size on the negative was a 2 1/2 in. circle.

The medium format took a giant step toward becoming the most popular film format for years to come when the Box Brownie appeared on the market in 1900. Eastman hoped that with the price tag of $1, the camera would fulfill his dream to bring photography to every schoolchild. The Brownie also ushered in today's most popular medium format, the 2 1/4 in. square, which was produced in the Box Brownie on a cartridge of 117 roll film with six exposures. The cost was 15 cents.

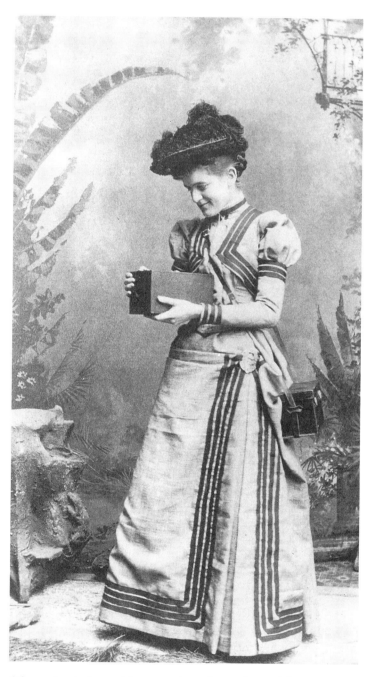

In one of the early photographic promotion pieces, the Kodak camera was shown handheld to emphasize its compact size. Photographers simply aimed these early "handheld" cameras at the subject, because the cameras didn't have a viewfinder. Courtesy International Museum of Photography at George Eastman House.

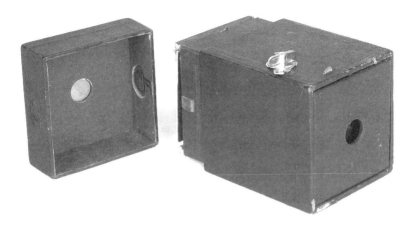

The original Box Brownie made in 1900 with a 105 mm *f*17 lens. The film support box at the rear was removable with a hinged panel in later models. Six 2 1/4 in. square images were produced on roll film. Cameras with the Brownie name were produced until 1965. Courtesy International Museum of Photography at George Eastman House.

The 120 roll film, which is the film mostly used in today's medium format photography, dates back to 1902, when it became a popular type for producing 2 1/4 × 3 1/4 in. images in Brownie and folding cameras. Other popular roll film sizes were (or still are) 127, introduced in 1912, and 620, which dates back to 1932. Brownie and folding cameras of many types and makes using the same type of film remained the amateur camera until the 1930s, to be replaced eventually by the twin lens types, and later by the single lens reflex (SLR).

There were twin lens reflex (TLR) cameras before 1900, but the TLR era was really born in 1929 with the appearance of the Rolleiflex. It was fast handling and compact, with a crank to advance the film. TLRs were immediately recognized as excellent tools, falling between the slow-handling larger format models and those using the small 35 mm film, which also established itself in the 1920s. The Rollei advantages were recognized by serious photographers, and the camera became one of the most successful types of all time.

The success also brought competition. Other companies, especially Zeiss and Voightländer, introduced TLR models. The success also brought about a Rolleiflex for the 40 × 40 mm format, today known as superslide.

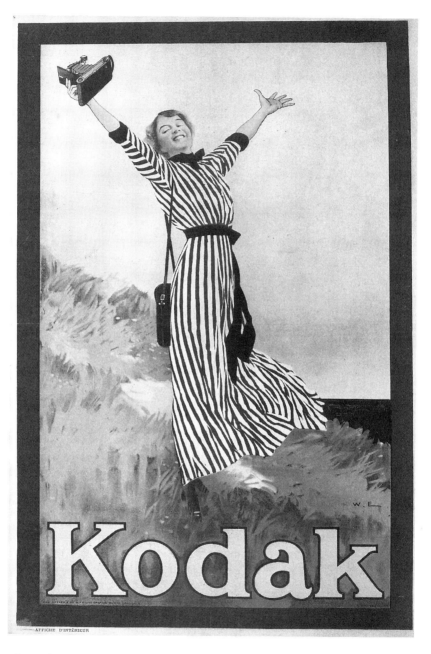

By the early 1900s Kodak promoted photography as a hobby for everybody everywhere. Female models were used, perhaps to emphasize that the camera had become so lightweight and so simple that it could be operated by everyone. The outdoor location emphasized that photography was no longer limited to the studio. Courtesy International Museum of Photography at George Eastman House.

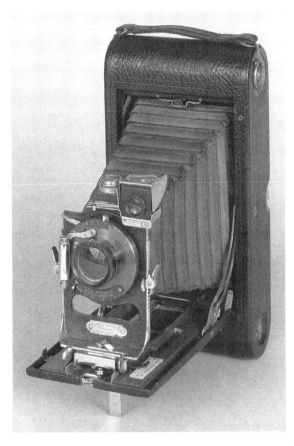

A 1903 Kodak Model 3A folding pocket camera with Bausch & Lomb 170 mm *f* 4 lens with iris diaphragm. The waist-level finder was reversible for horizontal and vertical framing. A plate back accessory for ground-glass focusing and dry plates were available for some models. Courtesy International Museum of Photography at George Eastman House.

SLR cameras for large film sizes date back to 1880. In the 1930s Graflex captured a large part of the market by introducing a small model with interchangeable lenses made for ten pictures on 120 roll film.

A milestone in medium format camera design came in 1948 when Victor Hasselblad showed his 1600F model. It not only had a new medium format shape but also was equipped with an interchangeable film magazine, which is the main attraction of the modern medium format SLR camera.

The panoramic image also started in the medium format. In 1899 Kodak introduced the Panoram-Kodak camera 4. It had a swinging lens producing a "large" 3 1/2 × 9 in. image on 103 roll film. The panoramic

camera design came down to a more normal medium format in 1900 with the Kodak 1 Panoram camera. It produced 2 1/4 × 7 in. images on 105 roll film.

In almost 150 years of photography, some film formats have disappeared completely or are no longer used in some fields of photography; others have appeared and gained in popularity. But the medium format has been in constant use in almost any type of camera and is still today the chosen film size for professional photographers working in almost every field, as well as for amateurs.

Today the medium format includes everything between the small format (35 mm and smaller) and the larger formats (4 × 5 in. and over) and is somewhat of a compromise between the two. It combines many of the conveniences of 35 mm with the benefits and advantages of larger studio cameras. That is the reason it is so popular and so valuable in almost all types of photography.

The Medium Format Advantages

IMAGE SHARPNESS

Thirty-five millimeter and medium format cameras use the same black-and-white and color films. Because the medium format negative or transparency is anywhere from two and a half to four times larger in area than the 24 × 36 mm frame, its sharpness is proportionately better. To look at it in another way, the medium format negative can be blown up proportionately larger (to 30 × 40 in. instead of 16 × 20 in.) while retaining equal quality, assuming everything else is equal.

Since the quality, especially the sharpness, of films has been improved drastically over the last few years, some people have commented that the 35 mm image quality is completely satisfactory for any application where the medium format was originally needed or suggested; that it is no longer necessary to move up to the medium format. True, 35 mm negatives can be enlarged to greater sizes without graininess or unsharpness becoming objectionable. But since the same emulsions are used for both the 35 mm and the medium format, the same differences still exist between 35 mm and 120 roll film. The medium format image is still better.

In my mind, it is exactly the fabulous sharpness of today's films that is the best reason for moving up to the medium format. Only the larger medium format images can truly convey the sharpness of these emulsions, so medium format photography should be more attractive to the serious photographer.

You will be greatly excited about the photographic image quality of the medium format when you examine the large 2 1/4 images under a 10× magnifying glass and compare them with 35 mm images. The 35 mm images might look great, but you probably would love to see the same image

The larger medium format image can truly convey the quality of today's high resolution films. Note the exceptional sharpness of the white frames in the windows.

It is the edge sharpness of such lines that conveys to our eyes the impression of sharpness.

two and a half times to four times larger so you can really see the details that only the medium format image can reveal to you.

Prints made from almost any size negative are salable, and 35 mm transparencies are also accepted for many purposes, but the medium format images are still preferred or requested in many fields for advertisements and editorial purposes. By presenting the larger medium format transparencies you will have a definite edge over your 35 mm competitors with many clients and art directors. You will convey a professional image and make a good impression on clients, who will be better able to see the results and determine how the image will fit into the advertising layout or design.

Although the 35 mm format cannot approach the sharpness of the medium format enlargement or the beauty and effectiveness of a medium format slide presentation, image sharpness and effectiveness are not necessarily the major reasons for stepping up to the medium format. Other features of medium format are even more helpful and valuable.

IMAGE EVALUATION

It is often said that once you work in the medium format, you'll never go back to 35 mm, probably because the medium format negative or transparency is easier to evaluate. For example, when a 35 mm and a medium format negative or transparency are placed side by side over a light box, the effectiveness, even the quality, of the medium format negative can be determined more easily, usually with the naked eye. There is no need to use a magnifying glass except to determine critical sharpness. Cropping possibilities also can be determined effectively and accurately.

Sorting slides is simplified with medium format transparencies. Medium format is also conducive to working with contact sheets, a favorite method of proof printing 35 mm and medium format negatives. Such proofsheets make it easy to compare images taken of the same subject or in the same location in order to select the best and decide on the final cropping. Differences in pose, lighting, expression, depth of field, composition, and even sharpness can be detected easily and usually without the use of a magnifying glass. The twelve 2 1/4 in. square or sixteen 4.5 × 6 cm images from a 120 roll film fit well on a single sheet of 8 × 10 in. paper, as do 35s. But the 35 mm contact proof images are frequently too small for this purpose. This is why many 35 mm photographers have the more expensive enlarged proofs made.

Proofsheets also provide a simple way for filing negatives. Negatives in their protective envelopes can easily be stored next to the proofsheet in a ring binder or filing cabinet.

The images on the 2 1/4 in. square (above) and 6 × 4.5 cm proofsheet are usually large enough to be evaluated carefully with the naked eye. Final cropping can also be determined easily. This is difficult or impossible with 35 mm contact proofsheets (right).

GROUND-GLASS SCREEN

The ground-glass screen size must be among the medium format considerations.

On any SLR or TLR camera, the ground-glass screen is the size of the negative; consequently, the medium format ground-glass screen is any-

where from two and a half to four and a half times larger than its 35 mm counterpart. The larger screen does not necessarily provide more accurate focusing, but with the larger screen you can view an image without needing to use a magnifying viewfinder.

Standard so-called waist-level finders, which allow two-eyed image evaluation, are available for most medium format cameras. Using a waist-level finder, you can do a complete and accurate evaluation of the image while viewing the screen with both eyes open—as you would evaluate the final print or projected transparency.

I still believe that viewing the ground-glass screen with both eyes open is the best way to evaluate the effectiveness of the image or decide what might be necessary to make it more effective. Viewing with both

The large ground-glass screen is an important feature of the medium format camera. It provides a view camera view on a compact camera.

eyes gives you an impression different from what you get by looking with one eye through a prism finder. Indeed, this might be the most important step in making you a better photographer.

One reason the square camera is such a popular medium format is because such cameras are always held the same way; they never need to be turned and thus can be equipped with any type of finder, eye level or waist level.

CROPPING

For maximum image quality from any negative, the photographer must frame the subject or scene so that the entire negative can be used for the enlargement. A cropped negative must be enlarged more, and enlarging means there will be a decrease in the quality of the image. Cropping, however, is an important step in putting an image in its final form. Here the medium format can show its advantage and increased possibilities. Even if the photographer uses only about 30 percent of the total medium format area, the negative can still be as large as the full 24 × 36 mm area of the 35 mm frame.

A square negative offers even wider possibilities. You can leave it as a square or frame it into a horizontal or vertical or into a long, narrow vertical or horizontal. You will undoubtedly start to see different compositions and different image shapes that you probably overlooked when evaluating the image on the camera's ground glass. The possibility of easily changing a

A 2 1/4 in. square negative can be cropped about 70 percent and still be the same size as the full 35 mm frame size.

square into other shapes to fit a layout is also a major reason why art directors in advertising agencies often prefer or insist on receiving square images.

FILM CHANGING

Various medium format cameras, especially SLR types, are designed with a completely removable film magazine. The film is not loaded into the camera, but into a magazine that can be attached to the camera or removed from it at any time without fogging the film. Several magazines can be preloaded, so changing from one roll to the next is almost instantaneous; therefore you are not likely to be loading film when the most important action is taking place. Using magazines is somewhat like carrying two or three loaded cameras, except you need only one camera and lens. You can also change from one type of film to another, from black and white to color, negative to positive, daylight to tungsten, high speed to low speed or instant, at any time. There is no need to finish the roll. Changing film can be done mid-roll without wasting a frame and without carrying more than one camera.

On various medium format cameras, the film is not in the camera body but in a separate film magazine, which can be removed at any time without exposing the film. Thus film can be changed mid-roll.

Changing film mid-roll can be one of the most important advantages and a major reason for selecting the medium format. It is, next to the larger film format, the major advantage of the medium format. It places the medium format one giant step beyond 35 mm for serious photography.

Most cameras are made for roll film for ten, twelve, sixteen, twenty-four, or thirty-two images per roll depending on the format or type of film. Roll film for medium format use does not provide the thirty-six exposures available in 35 mm film, but roll film is available with a sufficient number of exposures to limit film changing to a reasonable level of frequency. Roll film does not need to be rewound; thus film changing can be accomplished quickly. Several medium format cameras can also take 70 mm films with seventy exposures on a daylight loading cassette, and even more—over one hundred—from a darkroom spool load.

INSTANT PHOTOGRAPHY

Several medium format cameras also let you attach a Polaroid magazine. This is possible for some 35 mm cameras, but the magazine is not as practical and the Polaroid image size is too small to allow for careful evaluation. On a medium format camera, all you need to do is detach the regular magazine, even in the middle of a roll, and attach the Polaroid magazine. You can then shoot one or several Polaroid shots and see the image within a minute or less.

Polaroid film shows the image exactly as you see it through the lens and confirms that everything in the camera works properly (that the flash

is synchronized to the shutter, for instance). Nothing else can give you that peace of mind in important jobs. You can check exposure, lighting, and lighting contrast, which is especially valuable when you are working with multiple flash or when you are combining flash with daylight. The Polaroid image can also show things that you cannot see with your eyes or through a finder of any camera. For instance, you can see whether a certain shutter speed freezes or blurs moving subjects and how much blur is created. You can see what a zoom shot or a camera-produced double exposure looks like or what effect a moving camera produces on the film. If you do professional work or are interested in creating images and not just recording things as they exist, the Polaroid magazine is a great help. Other benefits of a Polaroid magazine are that you can show the client what the image will look like and get instant approval. You can also use the Polaroid shot as a teaching tool to show photography students the results of a shot instantly.

SHUTTERS

Medium format cameras are in the front seat in regards to shutters, giving the serious photographer more choice between focal plane shutters which are in the camera and move in front of film plane and leaf shutters which are in the lens. There are even focal plane shutter types that can also be used with shutter lenses, thus offering the advantage of both types of shutters.

Focal plane shutters offer high shutter speeds going as high as 1/2000 second in the medium format. Not having to worry about a leaf shutter in the lens, the lens designer also has more freedom to play with the lens design, the focal length, the maximum aperture, and the focusing range.

With focal plane shutters, flash is synchronized only up to a certain shutter speed, and in this respect medium format types take a back seat to 35 mm cameras, some of which are synchronized with flash up to 1/250 second. The maximum shutter speed in the medium format is 1/90 second because the shutter curtain is larger and must travel farther. Some cameras only go to 1/30 second or 1/60 second, so check camera specifications closely if flash is important to you.

All leaf shutters can be used with flash up to their top speed, which is usually 1/500 second. Therefore they are a better choice when flash synchronization at short shutter speeds is necessary or desirable, such as when photographing indoor sports or when combining flash with daylight.

Focal plane or leaf shutters can be completely mechanical or controlled electronically. Even if it functions electronically, the actual opening and closing of the shutter is still a mechanical function.

CAMERA SIZE AND OPERATION

The large medium format negative or slide can be obtained with cameras that have many of the 35 mm benefits. Medium format cameras are some-what larger and heavier, but most are still lightweight and suitable for handheld photography. With most you can also photograph as fast as with 35 mm cameras because shutter cocking and film advance is a single op-eration. Motor drives are available, although they do not operate as fast as 35s and do not allow you to shoot several frames per second.

The line of lenses available for medium format cameras is as exten-sive as for 35s. The lenses, however, tend to be somewhat slower than the 35 mm camera equivalent. Medium format cameras have become auto-mated in many ways, especially with built-in exposure devices, and oper-ating them is hardly more difficult than operating 35s.

Image Formats

SELECTING THE FORMAT

In the medium format, different cameras produce different image formats, so it is worthwhile to determine which image format serves which purpose best.

Professionals use the medium format camera daily or at least a few times each week. Your choice of image format is important because the medium format camera is likely to become the photographic tool you use the most. When you choose a camera, price should not take precedence over the camera's format and design characteristics.

The format decision for the camera should not even be based on the desired image shape of the final picture. For example, you should not choose a camera that shoots rectangular images simply because you or a client prefers such images over square ones. A rectangular camera is a fine choice if it has all the features that are important in your photography, or if shooting rectangular pictures does not carry with it some inconveniences. On the other hand, shooting with a square camera that is ideal for the job and then cropping the negatives later might be a more satisfactory solution. Since the medium format negative is so large and provides excellent cropping possibilities, the shape of the final image is a decision you can make in the darkroom. Rectangulars can be changed into squares, and, even more easily, squares can be converted into rectangles. Also you should not let the usual rectangular shape of enlarging papers restrict you. Instead, give serious consideration to the following points when choosing the format of a camera:

1. the convenience of viewing and focusing and holding the camera in handheld photography;
2. the size and weight of equipment, if you plan to use it on location;

3. the camera features—shutter, flash synchronization, available lenses and accessories;
4. the availability and degree of interchangeability of film magazines and the emulsions that can be used;
5. the possibility of attaching a Polaroid film magazine;
6. the convenience and speed with which you can operate the camera and lenses;
7. the availability of compatible projection equipment if slides are to be produced.

Various medium formats compared. The 2 1/4 in. square with 3020 mm^2 (p. 18, top); the 2 1/4 × 2 3/4 in., which is about 3850 mm^2 (p. 18, bottom); the 6 × 4.5 cm with an area of 2200 mm^2 (p. 19, top); the 6 × 9 cm with a 4760 mm^2 area (p. 19, middle); and 6 × 8 cm with an area of 4370 mm^2 (p. 19, bottom). All are considerably larger than the 35 mm frame (p. 20, top).

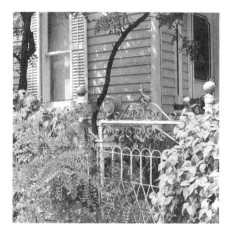

Special medium format camera models can produce panoramic images either in the 6 × 12 cm (below) or 6 × 17 cm format (bottom of page).

2 1/4 × 2 1/4 in. Square

Most photographers associate the medium format with the square, probably because the 2 1/4 in. square has been the most popular medium format in the last three decades. (It is also known under the metric measurement of 6 × 6 cm. indicating centimeters.) The actual negative size, however, is not 6 × 6 cm but slightly less, or about 55 × 55 mm. Twelve images fit on 120 roll film, twenty-four on 220, and seventy or more on 70 mm perforated film, which requires a special magazine.

The 2 1/4 in. square format can be found in SLR, TLR, and wide angle medium format cameras, and many cameras offer a second choice of a smaller rectangular format.

Square cameras are frequently a second choice or are not considered at all by photographers who know that their negatives end up as rectangular prints and who do not want to waste part of the negative. It is, of course, always desirable to fill the negative so the entire area is usable in the enlargement.

But you must also keep in mind that just because your image starts out being square doesn't mean that in creating your final print you end up enlarging it more than you would enlarge a rectangular negative. That is not the case when a rectangular print is made from a square negative because the degree of enlargement is determined only by the long side of the negative, not the negative area. The long side remains the same; thus the 2 1/4 in. square cropped to a rectangle has to be blown up exactly the same as the full 6 × 4.5 cm negative.

Photography with a Square Camera.

The square camera is designed for the greatest operating ease and convenience, so there is no need to decide whether to turn the camera sideways

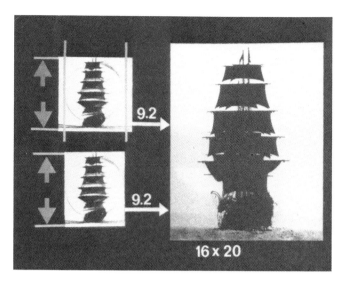

A 2 1/4 in. square negative cropped along two sides to make a rectangular print re-
quires.the same degree of enlargement as the full 6 × 4.5 cm negative; 9.2 times for
a 16 × 20 in. print. You are just changing the image shape.

Ground-glass screens or masks with vertical and horizontal cropping lines are
available for some square cameras. You can also make the lines on a standard
screen with a permanent-ink pen or by pasting thin strips of tape on the screen.
The vertical and horizontal formats become even more obvious if the four corners
are blacked out with ink or tape. Another method is to make the mask on a sepa-
rate sheet of acetate or high-contrast film, which is then placed over the ground-
glass screen.

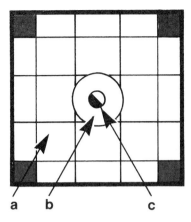

a b c

The guidelines on so called checked screens do also correspond to the paper proportions. The framing area becomes more obvious by darkening the four corners with translucent tape or colored foil so you can still see out into the corners for square framing. If such a screen also has a microprism and/or split image rangefinder, the image can be focused either on the ground glass (a), the microprism (b), or with the rangefinder (c).

to photograph verticals, an advantage when fast action requires fast shooting.

The real benefit of shooting square, however, is in viewing. A camera that needs to be turned for verticals must be equipped with a 90° prism finder, since using the prism finder is the only practical viewing method when the camera is turned. Thus for verticals your camera becomes an eye-level camera that must always be held in front of your eyes. The square format camera, on the other hand, can be equipped with eye-level finders—a 45° prism finder—or a waist-level type for viewing directly from the top. The square format camera gives you much more freedom, allowing you to photograph from practically any angle easily. All the benefits of not having to turn the camera can also be obtained with a 6 × 7 camera with a rotatable film magazine but only by compromising on size and weight.

Square Prints

Instead of changing square negatives into rectangular prints, why not crop the rectangular paper to make square prints? The final print format must be a personal decision, but square prints can be very effective for just about any purpose.

Square prints make for attractive wedding or display albums. Every print fits the square album page with an even border, looking like a framed picture.

Twelve square images can be contact proofed on one sheet of 8 × 10 in. paper. All images are right side up, so viewers need not turn the sheet.

Square images provide a lot of freedom in cropping. Subjects can be composed to make good squares (top), verticals (middle), or horizontals (bottom).

Square slides make an effective slide presentation, with each image taking up the same space and filling the full area of a square projection screen. Audiovisual professionals believe that using only square images is more effective than switching between verticals and horizontals. Slide mounts for 2 1/4 in. square images are readily available.

Since many images from professional photographers are used in a rectangular version, especially when they are used on covers of magazines, photographers often like to submit to the client or art directors images in the rectangular, usually vertical format. By submitting rectangular images photographers may prevent or reduce other cropping choices the art director may have in mind. The methods for producing rectangles in square format cameras are discussed under the heading "6 × 4.5 in the Square Format Camera."

6 × 4.5 cm

The true negative size of the 6 × 4.5 cm format is about 40 × 55 mm. Some medium format cameras are made specifically and only for this format. On others you can choose this format by attaching a separate magazine, thus you have the choice of shooting squares or rectangles. The 6 × 4.5 cm negative has an aspect ratio that is almost identical to 8 × 10 in. and 16 × 20 in. paper; thus the full negative can be printed. The degree of enlarging you need to do when making a rectangular print is the same for the 6 × 4.5 cm format as for a 2 1/4 in. square cropped along one or two sides.

The same original square image can frequently be changed into an effective horizontal or vertical image. Photography by Gene Martin.

There is no benefit to using the 6 × 4.5 format as far as image quality is concerned, but the large number of exposures per roll available for this format is a real benefit. Sixteen 6 × 4.5 cm. images fit on the same film length as twelve 2 1/4 in. squares if the images are equally and properly spaced. This is not the case on some 6 × 4.5 cm cameras. As a result only fifteen exposures are possible because manufacturers have cut production costs by eliminating the rather complicated mechanism that provides even frame spacing on the unperforated roll films. The three or four additional exposures per roll in the 6 × 4.5 format are a benefit. The film costs are 20 to 30 percent lower. All 6 × 4.5 cm format cameras must be turned for verticals, so viewing becomes limited to the 90° eye-level finder. This limitation must be considered carefully.

The 6 × 4.5 cm format is frequently referred to as the ideal format, but that does not necessarily mean that it is ideal for all photography. It simply means that the format has the same aspect ratio as the 8 × 10 in. enlarging paper. Whether the format or the 6 × 4.5 cm camera is ideal is up to each individual photographer.

6 × 4.5 cm in the Square Format Camera

Square format cameras with interchangeable film magazines usually can also be equipped with a film magazine for the 6 × 4.5 cm format. Depending on the manufacturer it produces fifteen or sixteen images on a roll of 120 film. Horizontals can be obtained in the normal camera position; for verticals the camera needs to be turned.

To make it still easier for the square shooting pro to produce rectangulars, some manufacturers now have available masks that can be inserted into the back of square cameras. They give the photographer the option of producing squares, horizontals, or verticals without turning the camera. You receive the same number of exposures in all formats: twelve on 120; twenty-four on 220 film. Using the mask also allows you to show the proper image format on the Polaroid test shot, which is frequently presented to the art director for final approval while shooting.

40 × 40 mm

The 40 × 40 mm format, known as superslide, used to be fairly popular because the images it produces could be projected in a standard 35 mm slide projector. Special superslide film magazines were available for some cameras. But this format has been discontinued because most modern 35 mm projectors no longer project these larger slides with proper corner to corner quality and illumination.

To produce superslides today, make the images in a 6 × 4.5 mm film magazine, then cut the long side to produce a square.

6 × 7 cm (2 1/4 × 2 3/4 format)

This largest of the more popular medium formats also has an aspect ratio that closely resembles that of the popular enlarging papers. The actual negative size, about 56 × 68 mm, makes the image visually very effective and large compared to the smaller formats. Ten negatives fit on one roll of 120 film—two fewer than 2 1/4 in. square, and five or six fewer than the 6 × 4.5 cm format. The film cost is thus 20 to 60 percent higher, and you will need to change film more often. More important are the size and weight of the camera. This larger negative can be obtained only on cameras specifically made for this format, which consequently have to be larger and heavier.

On some 6 × 7 cm cameras horizontal and vertical images are obtained by turning the camera; on others this is done with a rotatable film magazine that also changes the format aspect on the focusing screen.

The 6 × 7 cm format is not practical for contact proof printing because only nine of the ten images from a 120 roll film will fit on an 8 × 10 in. sheet of paper. This is a relatively unimportant consideration since most 6 × 7 cm photographers do not contact print their negatives but have individual proofs made instead.

The full 6 × 7 cm format shot can be projected only in a special slide projector. Other possibilities are to cut the rectangle down to a 2 1/4 in. square or a 6 × 4.5 cm rectangle for use in 2 1/4 in. slide projectors.

6 × 8 cm

A new medium format 6 × 8 cm appeared in 1986. It is presently available from only one camera company that promotes it as the format that provides the most effective vertical/horizontal ratio. The image size is 56 × 76 mm. Considering the 8 × 10 in. paper proportions as *standard*, the 6 × 8 cm format needs some cropping at the long side. You obtain nine exposures on 120, eighteen on 220 film. The nine exposures can be contact printed on an 8 × 10 in. proofsheet.

COMPARING FORMATS

All the formats discussed up to this point are good choices for any type of medium format photography in the studio and on location.

Image format therefore should not completely or mainly influence your choice of camera. You are more likely to make a wise choice by carefully considering the camera operation and handling, its features as they relate to your type of work, the reputation of the manufacturers, and especially camera size and weight.

If all your work is done on a tripod in the studio, size and weight need not be a factor. Yet few professional medium format photographers

do all their work in the studio, and amateurs do very little shooting indoors, using their cameras mainly during their travels.

Choosing a medium format camera system has everything to do with size. Not just the size of the image, but also the size and weight of the camera. To get an image that is only one centimeter larger (approximately 20 percent), you may have to carry a camera that weighs as much as 80 percent more.

Consider the matter of camera size and weight very carefully if you're looking for one medium format system that can do it all. A light, compact camera will handle your most critical studio work, yet handheld on location, it can be as much of a pleasure to use as a 35 mm camera.

One of the greatest benefits of the medium format is that it is a great format for any type of photography—that it allows you to use the same camera system for critical studio work as well as for handheld location photography. A good compact lightweight medium format camera system can serve both purposes and eliminate the need for owning and operating two systems.

Camera size and weight must be considered along with differences in negative size and the advantages and benefits of the larger format. When comparing different formats it is also essential that we differentiate between film area and image size. Film area is important in visual observation

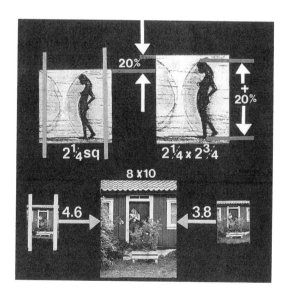

The film area of a 6 × 7 cm negative (right) is about 60 percent larger than the area of a 6 × 4.5 cm or a cropped-down 2 1/4 in. square (left), but the recorded image on the 6 × 7 cm negative or transparency is only about 20 percent larger than the other two. Image size is determined by the long side of the negative, which is 68 mm compared to 56 mm.

of a negative or transparency on a lightbox or in the size of a projected image. For these purposes, it is proper to call an image twice as large when the area is twice the size. Area, on the other hand, cannot be used to compare image size or necessary degree of enlargement. The length of the negative side must be used for this comparison. For example, the 6 × 7 cm film area is about 60 percent larger than 6 × 4.5 cm, but the difference in image size or degree of enlargement is only about 20 percent.

In a full-length portrait, for example, the model is only about 20 percent larger on 6 × 7 cm compared to either the 2 1/4 in. square or the 6 × 4.5 cm format. This difference will make retouching the original 6 × 7 cm negative or transparency somewhat easier. The same is true of the degree of enlargement. The 6 × 4.5 cm negative, or the 2 1/4 in. square cropped down to the 8 × 10 in. paper proportion, must be enlarged less than 25 percent more than the full 6 × 7 format image to obtain the same size enlargement.

IMAGE SHARPNESS

Assuming that everything else in the camera is equal—the performance of the lens, the film flatness, and that the mirror and screen are aligned accurately—the 6 × 7 cm negative should be about 20 percent sharper; or to say it in a different way, the larger negative should allow for a 20 percent higher blowup of the image while retaining equal image quality. Whether

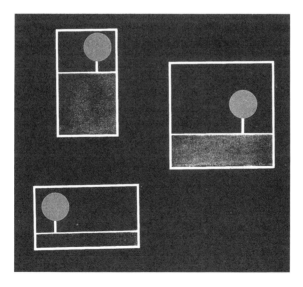

The same suggestions for good composition, such as placing main lines and main subjects approximately one third from left or right and one third from top or bottom, apply in squares as well as in rectangles.

Good composition usually requires a balance between left and right and between top and bottom.

the 6 × 7 cm image is better is another question, the answer to which is determined by doing an actual film test. Tests made by photographic magazines and photographers seem to indicate that the 6 × 7 cm format yields images that are not noticeably better or not at all sharper compared to a good 6 × 4.5 cm image cropped from a 2 1/4 in. square.

OTHER MEDIUM FORMATS

6 × 9 cm

One of the original popular medium formats has not disappeared: the 6 × 9 cm (2 1/4 × 3 1/4 in.) size producing eight images on a roll of 120 film. It is available in press cameras, rangefinder and wide angle types, aerial cameras, and special roll film magazines for view and press cameras.

Since standard roll film is used in most 6 × 9 format cameras, the same wide choice of film available for the more popular medium formats is also available for this format.

But the 6 × 9 cm format proportions do not match the 8 × 10 in. paper proportions. The long side is longer, just as on the 35 mm frame. The 6 × 9 cm proportions are identical to the 24 × 36 mm frame proportions in 35 mm.

Panoramic Formats

Although the usable width of roll film limits one side of the image to 56 mm, the other side of the image can be stretched along the film as far as the lens is capable of covering. That is what is done in panoramic cameras where the format ranges from 6 × 12 cm (six images on a roll of 120 film) to a format that is almost three times longer than it is wide: 6 × 17 cm (2 1/4 × 6 3/4 in.) with four images per roll of 120 and eight on 220. The film area of the latter is equivalent to three 2 1/4 × 2 1/4 in. images.

Although the panoramic formats may mainly serve to capture an area wider than is possible with a wide angle lens on an ordinary format, they are really meant for special uses of the final image. They offer a new way of creating visually dramatic images with excellent overall quality.

Panoramic images also have a lifelike appearance; they are closest to the way we see. Panoramic cameras can take into one picture the wide horizontal sweep that we can see with our eyes from the top of a mountain or building, a lake shore, beach, or city street. Since normal viewing is horizontal, these cameras are most often used for horizontals. The camera can be used for verticals and can be excellent for enhancing the height of a waterfall, tall trees, or buildings.

Although panoramic cameras need to be larger than most others, they still can be used in handheld camera work and are usually equipped with a spirit level to ensure straight horizontals or verticals. The film gate and pressure plate in such cameras must be well made and designed to keep the large negative area flat from one side to the other.

Negatives from panoramic cameras cannot be enlarged in an enlarger that is equipped for the typical medium formats. The 6 × 12 cm negative requires an enlarger made for 4 × 5 in., and a 5 × 7 in. type is needed for the even larger 6 × 17 cm negative.

Masks are available for some medium format cameras to produce panoramic images within the 2 1/4 × 2 1/4 in. image area.

35 MM IN THE MEDIUM FORMAT CAMERA

The combining of medium format photography and 35 mm film has been made possible by some manufacturers who supply a 35 mm film magazine for medium format cameras. This innovation was never meant to encourage the use of 35 mm film in a medium format camera. Most photographers are better off using a good 35 mm system when 35 mm is needed.

The idea for a 35 mm magazine goes back to the time when Kodachrome film was available only for 35 mm and some photographers or art directors insisted on this type of film. With the great choice of superb color transparency films available today, this application has lost its value at least for producing images in the standard 24 × 36 mm size.

Nevertheless, 35 mm film magazines are available for various cameras so you can produce a panoramic format 24 × 56 mm on a 2 1/4 in. square or 4.5 × 6 cm camera with twenty images on a thirty-six exposure role, or even wider, 24 × 69 mm on a 6 × 7 cm type. These wide screen options were easy to obtain because of the size of the medium format film magazine and because the camera lenses were designed for this field coverage. This double frame can be very helpful for multi-image shows and in printed form.

The 35 mm film magazines allow you to produce a panoramic format in a normal size medium format camera. One must, of course, mention that the same results can be obtained on 120 or 220 roll film in a standard 2 1/4 in. square, 6 × 4.5 or 6 × 7 cm film magazine by simply cutting the negative into the panoramic 24 × 56 or 24 × 68 mm shape.

Films and Film Loading

GENERAL COMMENTS

Most black-and-white, color negative, and color transparency films made for medium format cameras are identical to those made for 35 mm cameras. They are also processed in the same fashion. Thus for those photographers who have previously worked in the smaller format and are changing to medium format, selecting film is simple. In most cases, the film that you would use in the 35 mm camera is also the logical choice in medium format roll film.

Photographers who frequently work in low light situations with lens apertures of $f1.4$ or $f2$ on their 35 mm cameras may be better off switching to a faster medium format film if such exists. The reason is that medium format lenses are slower, and a faster film will make up for a slower lens. $F2$ lenses do exist for some medium format cameras, but for most the maximum aperture of the standard lens is only $f2.8$ and even slower on the wide angles and telephotos.

There is another reason for considering a faster medium format film: depth of field. To cover a certain size area in medium format requires using a lens with a longer focal length, an 80 mm lens on a 2 1/4 in. square compared to 50 mm on 35 mm. This 80 mm lens on a medium format camera requires $f16$ to produce an image with a depth of field about equal to that of a 50 mm lens on a 35 mm camera at $f8$.

By using 400 ASA film to capture the medium format image you can achieve the same depth of field as with 100 ASA film in 35 mm, using the same shutter speed in both. This approach can be especially valuable in close-up photography and is usually not a disadvantage especially when considering the difference in the negative size.

Slower medium format films tend to have a higher resolution and finer grain, thus producing a sharper image. They are the obvious choice when sharpness is your main goal or when the negative is to be enlarged tremendously or will need extensive cropping.

With the high quality of today's films, one should not hesitate to use the faster films. The fast films might allow handheld photography where otherwise a tripod would be necessary. More important, faster films allow you to use shorter shutter speeds and thus reduce the possibility of camera shake.

Wedding photographers have started to use 400 ASA color negative films instead of 100 ASA, because the faster film allows them to use a more compact, lighter flash unit.

Generally, however, for optimum sharpness it is still better to use the slowest film that can do the job and to select the faster ones only when necessary. Switching from slow to fast films and vice versa is greatly simplified in medium format cameras that offer interchangeable magazines. You can load two or three magazines with different films and then switch from one to the other in the middle of a roll. Thus you are always in the position to use the film that is best for each subject while carrying only one camera.

Those interested in experimenting in the darkroom should not overlook many of the films made for special purposes, such as high-contrast photography, copying, and photomicrography.

Amateur and Professional Film

Color negative and color transparency films made by some manufacturers come in an amateur brand and a professional brand with the same or a completely different name. The only difference between the brands is in the aging process of the film. The colors in an undeveloped film are not perfectly stable; they shift somewhat as the film is stored. Professional film is preaged at the factory so it produces the correct color when delivered to the store. To remain in the properly aged condition, however, the film must be refrigerated until about an hour before it is used. If it is not processed immediately after being exposed, it must be refrigerated. Professional films are made so that the professional can count on matched colors and exposure from roll to roll.

Amateur film is delivered to the store in a state such that it produces the correct color after it has been stored at normal room temperature for four to six months. Manufacturers have found that this is the average time that elapses from the moment the film is made until it is actually used. Amateur films need not be refrigerated, which can be an advantage when you are taking photos while traveling, but the colors in such films will vary somewhat based on the storage time and temperature.

The choice of amateur or professional film may also be determined by the laboratory. "Amateur labs" may not process professional films, or

any medium format films. Many professional laboratories do not process the amateur brands or do not guarantee professional results from the amateur brands.

Producing the Black-and-White Negative and Print

In addition to camera steadiness, accurate focusing, lens quality, and film flatness, the sharpness of the black-and-white negative is also affected by exposure and development. Overexposure and overdevelopment increase grain size and thus reduce apparent sharpness.

A thin negative that has just enough shadow detail makes the sharpest print.

Too little exposure causes loss of shadow detail. In a good print the lighter subject tones in the shadows must show detail for the picture to look natural.

Contrast is increased by developing longer and reduced by cutting the developing time. This is a helpful control that not only produces very printable negatives but also may make it unnecessary to have on hand a wide range of different contrast papers. Most or all negatives can have a contrast range that is printable on a standard grade paper regardless of the subject or lighting contrast.

This principle of contrast control is based on the zone system developed by Ansel Adams, which involves exposing for a specific subject area and then developing the film so that other areas have specific density values, and fall into specific zones. Serious fine art black-and-white photographers are advised to study one or some of the books describing black-and-white zone system photography. Using this contrast control requires that all negatives on a roll of film be taken of subjects with similar contrast. The shorter rolls with fewer images (usually twelve) of the medium format films have in this respect an advantage over the longer 35 mm rolls with twenty-four or thirty-six exposures. Choose a film development time such that normal subjects will match the contrast of medium or grade 2 papers when printed on your own enlarger.

Enlargers

Quality black-and-white prints can only be obtained with a clean enlarger lens that is in top condition.

Condenser enlargers yield somewhat higher contrast and slightly greater sharpness than the diffused light type. Condenser enlargers usually are brighter, so exposure times can be kept reasonably short. This type of enlarger is usually preferred for enlarging medium format negatives, but use the one that best suits the type of work you are doing. Whichever type you choose, make sure that the illumination is even over the entire field.

You can test this by making a print without a negative in the enlarger. Focus the lens on the edges of the negative carrier and stop down to your usual printing aperture. Expose the paper so that it develops out to a middle gray. If the test print varies considerably in density over the printed area, the illumination is uneven.

Photographic Print

To maintain the maximum sharpness in the print, consider the quality of the enlarging lens, film flatness in the negative carrier, accurate focusing of the enlarging lens, and steadiness of the enlarger during exposure. Pay special attention to the negative carrier. The base on most medium format films is thinner than on the 35s, and there is a greater tendency for the film to buckle when exposed to heat in the enlarger. The negative may pop, no longer lie flat, or actually buckle and move while the exposure is being made. Using a glass carrier will prevent this, but remember that all glass surfaces must be kept clean.

Print quality is best when:

- The printing paper is exposed so that the print density is just right when the paper has received the full development time. Considerable underdevelopment causes muddy and perhaps uneven image tones that may have an unpleasant, brownish image color. Overdevelopment results in a lack of highlight detail, fog, or stain, or all three.

- The specular highlights print as white (paper base white), with diffuse highlights printing as delicate grays.

- Dark subject tones in the shadows are reproduced as black (maximum density) in the print.

- Midtone to light subject tones in the shadows are reproduced as dark but lighter than black tones in the print.

- The midtone range of the print has good tonal separation.

COLOR NEGATIVE AND COLOR TRANSPARENCY FILM

Color negative films are made in the daylight version only because the majority of amateur and professional images are made in daylight or with electronic flash, both with the same color temperature. These films can be used under other light sources—tungsten or fluorescent lights, for instance—and without a filter on the lens. The necessary filtration can be employed when the print is being made, although I recommend using the necessary filter on the camera when the picture is taken. All images are then reproduced on the film as if you had taken them under the light for

which the film was made, and the filter you use is the same as required for daylight color transparency film; thus you eliminate many problems later in the darkroom.

Using a filter is especially suggested when no people are in the picture. Without flesh tones, the darkroom technician has no idea what the colors should be unless you include an 18 percent gray card or a color chart in at least one of the negatives. Even with people in the picture, correct colors cannot be assured because flesh tones vary from white to black. If nothing else, using a gray card eliminates future arguments with the laboratory.

Exposure and developing times cannot be varied when you use color negative film, because color negatives need the correct amount of exposure to produce sufficient shadow details.

Mounting Transparencies

Most professional laboratories do not mount 2 1/4 in. slides, but this is not really a disadvantage. Most professional slide work is presented to the client most effectively unmounted or mounted on a presentation board. If 2 1/4 in. slides are to be projected, glass mounting is highly recommended to eliminate popping in the projector. If the slides are to be glass mounted, the slides should be returned from the laboratory unmounted, because removing slides from cardboard mounts is a nuisance.

Projection Quality

The true quality of a slide, 35 mm or medium format, often cannot be enjoyed on the screen because of the somewhat questionable quality of most projectors' condenser systems and projection lenses.

If you are interested in 2 1/4 in. slide projection, it is worth investigating the quality of a projector before purchasing it, and be prepared to spend quite a bit more than for a 35 mm machine. Buying a projector is a worthwhile investment because 2 1/4 in. slide projection is very effective. Once you have seen your slides presented in a high-quality projector, it is difficult ever to be satisfied with 35 mm slides.

ROLL FILM

120 Roll Film

All medium format cameras—regardless of what image size they produce—can accommodate 120 roll film. Because of its popularity, 120 film is readily available in different types of stores—something travelers might want to keep in mind.

The 120 roll film comes in the widest variety of emulsions. You can find just about every emulsion necessary for general black-and-white and color photography.

The 120 roll film has a paper backing from beginning to end, and its main function is to ensure proper film transport. That is why the paper backing has frame numbers printed on it. In the past, the user advanced the film by looking into a window while turning the film advance knob until the next number appeared in the window. In most medium format cameras today, the film transport is automatic so the numbers are no longer necessary. As a matter of fact, the paper is no longer necessary, but it is still there.

220 Roll Film

Since modern medium format cameras no longer need the paper backing for spacing, film manufacturers started some years ago to spool 120 roll film with paper only at the beginning and end of the roll just to protect the film for loading and unloading in daylight. Leaving out the paper made it possible to put twice as much film on the same film spool, so a spool provides twenty-four instead of twelve 2 1/4 in. square images; twenty instead of ten in the 6 × 7 cm format; and thirty or thirty-two instead of fifteen or sixteen 6 × 4.5 cm images. This new film became known as 220. The 220 roll film is appreciated by photographers who want to cut down on film changing, as in wedding, sports, and stage photography.

220 roll film is used mainly by professional photographers. As a result only the most popular professional films are made in 220, and these films are available only in specialty camera stores that do professional business. If you like to work with different films, you might be better off staying with 120 film and buying one or two additional magazines or inserts so you can preload additional rolls.

Depending on the camera, the use of 220 film instead of 120 may require an adjustment on the film insert, a different film insert, an adjustment on the camera, or a different film magazine.

Manufacturers that supply a special 220 magazine feel it is important to adjust the springs and the pressure plate on the film insert to the particular thickness of each film to ensure film flatness.

Long Roll Film

Longer rolls of 70 mm film can also be used on some medium format cameras with interchangeable film magazines. The 70 mm film is manufactured without perforations and with different types of perforations known as type I and type II. Perforated 70 mm film looks like 35 mm film, with perforations on both sides. Each camera or film magazine is made for a specific type of 70 mm film. Few film types are readily available in 70 mm form, so find out which film types are manufactured in a compatible 70 mm form.

The 70 mm film used in most medium format cameras is the double-perforated motion picture type.

Most 70 mm film magazines are made for use with cassettes, which are built and look like the 35 mm cassettes, except that they are larger. A cassette holds about 15 ft. of standard base film, which provides room for about seventy 2 1/4 in. square images.

A few popular 70 mm films can be purchased in cassettes, ready to be loaded into the camera. Others are available only in longer lengths on spools for home loading into cassettes. The spooling must be done in complete darkness. It can be done by hand, but using a bulk film loader is more convenient.

The 70 mm cassettes can be loaded into the camera in daylight. Unlike 35 mm film, the 70 mm film moves from the full cassette into an empty cassette on the other side, so the film does not have to be rewound after it has been exposed.

Some cameras can also take magazines designed for 70 mm film on spools. The advantage is that the spools can hold more film and thus provide more exposures per roll. This advantage is not obtained without some drawbacks: the need for darkroom loading and unloading. Special emulsions for instrumentation, infrared, high-contrast work, copying, duplicating, and some microscope applications that are not available in 120 or 220 can be obtained in 70 mm, but a minimum order quantity is required.

Another consideration you should take into account before deciding on 70 mm film is that only a limited number of professional laboratories are equipped to process all or at least some of the 15 ft. or longer lengths of film without cutting them. But equipment is available for processing the film at home.

SHEETFILM

Various medium format cameras allow you to attach a magazine for sheet-film. This magazine is designed and operates like those made for view cameras. The film is inserted in complete darkness into the sheetfilm holder, which is protected by the dark slide. Sheetfilm does not come in ready-made medium format sizes, so you must cut your own from larger sizes. I suggest that sheetfilm be used only when you need an emulsion that is not made in any other form, perhaps orthochromatic black-and-white films or films for spectroscopy or photomicroscopy.

INSTANT FILM

Instant films can be used on a number of medium format cameras. Camera manufacturers have introduced this possibility not to provide the medium format photographer with an instant snapshot camera but so that serious amateur and professional photographers can see on a print the image actually recorded through the lens. Just as videotape allows an athlete to study his motions instantly or an audio tape allows a musician an instant test of sound quality and effectiveness, an instant print is the most reliable assurance you can have that the camera is functioning properly, that the lens and camera settings are correct, that the flash is synchronized with the shutter, and that you are using the correct accessories. Instant film allows you to experiment without guessing and to make changes before the shooting starts. It eliminates guesswork and saves on film and laboratory costs, and it also serves as an excellent teaching tool since it allows the student to see instantly the results of the teacher's approach. Professionals may want to use instant film to show an instant print to clients to determine whether the image is what was expected and to get instant approval.

Exposure Testing

Checking that exposure is correct is another, and often the most important, application for instant film. It is especially useful under unusual lighting situations or when you are combining different light sources. The exposure latitude of instant films is not as wide as that of regular negative or slide films, and lens settings must be correct to within half an *f* stop. A good exposure on instant film should, therefore, be a *perfect* exposure on other film materials.

When you use Polaroid film for checking exposure, keep in mind the type of film you will be shooting. Transparency films must be exposed for the lighted areas, negative films for the shade. The lens settings are thus correct for slide film when the Polaroid test shot is properly exposed in

the lighted areas. They are correct for negative film when the test shot has shadow detail.

Checking Light Ratios

In multiple flash setups, you can use instant film to check the effectiveness of the lighting, how and where shadows fall on the subject and the background, and to detect possible disturbing highlights on eyeglasses or other shiny surfaces. When you are combining light from different light sources— flash fill-in, for instance—Polaroid shots become still more valuable.

An instant picture is a must for determining exposure as well as the effectiveness and evenness of the lighting when you are painting with light.

Effects of Shutter Speeds

There is no way you can see with your eyes or in the viewfinder how the shutter speed will affect or change the image of a moving subject. If you

Instant film allows you to evaluate effects which cannot be seen on the focusing screen, such as the amount of blur produced by moving the camera in combination with a slow shutter speed.

want to stop action, you can follow written guidelines, but there are no strict instructions for those instances when you want to record the moving subject with a blur to enhance the feeling of motion.

Make a test on instant picture film at one shutter speed. If the results are not satisfactory, shorten or lengthen the shutter speed to get more or less blur, and repeat the process until the instant picture shows exactly the desired results.

It is a good idea to make a test using instant film when you plan to move the camera to produce the blur; when you want to change the focal length of a zoom lens while the shutter is open to produce a zoom effect; when you are going to move the focusing ring on the lens, use vignettes, or other accessories in front of the lens; or when you are combining electronic flash with slow shutter speeds.

As a Teaching Tool

Instant film material helps give others immediate visual proof of what you are shooting. This can be for the purpose of showing photography students immediately the result of a photographic approach under discussion, or for showing a model's performance in front of the camera.

Instant film material allows you to show to an entire group things that normally can be seen by only one person, such as the view through a microscope. Other valuable applications are for showing a client or an art director a layout using actual images instead of sketches.

Adjusting for Film Sensitivities

In the majority of cases, the negative or transparency film used for your final image will have a different exposure index than the instant film material used for the test. Thus, for correct exposure, something must be adjusted. The following adjustments are possible:

1. *Change the shutter speed.* Do this only when the shutter speed is not a deciding factor in creating the image. For blurred motion effects, the same shutter speed that produced the proper results on the test shot must be used.
2. *Change the aperture.* I recommend this course of action when the shutter speed cannot be changed and/or when depth of field is not the deciding factor.
3. *Use neutral density filters.* Either when making the test shots or when making the final shots, depending on which film has the higher sensitivity, using such filters allows you to make identical lens settings with any combination of films.

The amount of correction necessary is shown on the chart below, which is based on an instant film sensitivity of 70–80 ASA, 19 DIN, the most common film used for test shots.

EXPOSURE CORRECTIONS OF 70–80 ASA POLAROID FILM FOR FINAL FILM

Final Film		Change in Aperture	Multiply Shutter Speed	Use Neutral Density Filters
ASA	*DIN*			
25	15	Opens 1 1/2 stops	3×	0.50 with instant film
40	17	Open 1 stop	2×	0.30 with instant film
50	18	Open 1/2 stop	1.5×	0.10 with instant film
64	19	None	1×	None
100	21	Close 1/2 stop	2/3×	0.10 with final film
125	22	Close 1 stop	1/2×	0.30 with final film
160	23	Close 1 stop	1/2×	0.30 with final film
200	24	Close 2 stops	1/3×	0.60 with final film
400	27	Close 2 1/2 stops	1/5×	0.60 with final film
800	30	Close 3 1/2 stops	1/10×	0.90 with final film

Shutter speeds are multiplied as follows:
Original shutter speed 1/125 second
2× : 1/125 × 2 = 2/125 = 1/60 second
1/2× : 1/125 × 1/2 = 1/250 second

Polaroid Film Magazine

The instant film image is obtained by attaching a special magazine to the camera; regular Polaroid film packs are used. It should be possible to switch magazines at any time, even in the middle of a roll of film. The sheet of instant film is larger than the image produced by the medium format camera so you waste some film, but the image and image size are the same as recorded on the roll film, and that is more important. Follow the instructions on the instant film pack regarding the use, storage, and developing of the film.

FILM LOADING

Roll Film Loading

The 120 and 220 roll films are sold on spools. On the majority of medium format cameras, the film is loaded on a separate insert, which is inserted into the camera or a film magazine. The spool with the unexposed film goes on the feed reel, and the beginning of the film is attached to an empty take-up spool. Roll film need not be rewound on the original spool as in 35 mm, so changing film is quite fast.

The film insert with the loaded film may go into a removable film magazine or directly into the camera body. The latter allows you to pre-load several inserts before going on a job; then changing film involves only switching inserts. Inserts are less expensive than film magazines but do not give you the opportunity to change film midroll or to attach a Polaroid magazine. The danger of fogging film is also greatly increased. If you want to take full advantage, you must consider loading the film into a completely interchangeable film magazine and forget about interchangeable film inserts.

On some cameras, the film moves from reel to reel in its natural curl, as rolled on the spool; on others, it moves in an inverse curl. It has been mentioned occasionally that inverse film movement reduces film flatness. Films have been running through motion picture cameras in the inverse curl since motion picture cameras were invented. Film flatness is a matter of a properly designed pressure plate and magazine. I have never seen proof that the natural curl results in better film flatness and thus better sharpness, so I must assume that testimonials about natural curl are nothing more than an advertising strategy.

Roll film must be advanced to a certain point to ensure proper spacing. With 120 and 220 films, the thick arrow on the paper is set opposite an index engraved on the film insert before the insert goes into the camera or magazine. Some 220 films have a dotted line on the paper backing before the black arrow. Do not put the dotted line opposite the index. You will lose the first two frames. Move the film further to the black arrow.

On modern film magazines and cameras, the arrow on the roll film must be set opposite an index. Do not set the dotted line on some 220 films opposite the index.

Before a picture can be made, the paper leader must be moved through the camera. On older cameras and magazines, there was no automatic stop at frame 1. The film had to be wound to 1 by watching the paper through a window and turning the crank until 1 appeared in the window.

The beginning of the actual film is now behind the aperture, and spacing between the images should be fairly even from here on. *Spacing* refers to the blank space between the frames. On some cameras designed for the 6 × 4.5 cm format, however, the space between frames changes, which is the reason you can obtain only fifteen images instead of sixteen on a roll of 120 film. On a well-designed camera or magazine, the space may vary somewhat, but it should never vary so much that the last image falls into the paper trailer, and there should always be sufficient space between images to cut the film.

While loading is simple, a few suggestions need to be made. Always completely remove the paper that holds the film tight on the spool; otherwise it may become loose and wedged in the film aperture and act like a mask in front of the film. Although roll film is designed to be loaded in daylight, do not load it in bright sunlight. Keep the film in the shade and the film tight on the spool during the entire process; otherwise light can fog the edges. Practice so you can load quickly without exposing the film to daylight longer than is necessary. After the last picture on a roll is taken, you must wind up the paper trailer before removing the film. The now empty feed spool becomes the take-up spool for the next roll of film.

Film Magazines

Cameras with interchangeable magazines are likely more expensive because they require a greater precision so every magazine fits on every camera and couples to the camera mechanism as if it were part of the camera itself. But the versatility of such cameras—allowing you to do things with one camera that otherwise require two or three cameras—may well be worth the additional cost.

Before removing a loaded film magazine from the camera, you must insert a dark slide so the film is not exposed to light. The purpose of a dark slide is the same as the dark slide in a sheetfilm holder of a view camera: to protect the film when the magazine is off the camera. It serves no purpose as long as the magazine is attached to the camera. Well, not quite. On some cameras you cannot depress the release until the dark slide is removed, at least partially. Thus the dark slide can be used to prevent accidental releasing.

Rotatable Film Magazines

Most medium format cameras made for rectangular pictures must be turned for verticals just like 35s. Another solution in the medium format

is a rotatable film magazine; the film magazine, not the camera, is rotated for verticals. Such a design is a convenience, especially when you are working on a tripod, but to accommodate this magazine the camera body needs to be considerably larger—at least as wide as the long side of the negative in either direction—so what you gain in versatility you may lose in convenience.

OPERATING SIGNALS

Medium format cameras, especially those offering interchangeable film magazines, should have operating signals and controls to prevent mistakes and to make it unnecessary for the photographer to do a lot of worrying while shooting. A frame counter that shows the number of exposed pictures is taken for granted. Most frame counters are coupled to the gears and work whether there is film in a camera or not. The camera or the film magazine should have a signal that shows whether there is film in the camera or magazine. The signal must work whether the magazine is on or off the camera, and to be reliable it must be controlled by the film itself, not the mechanism in the magazine.

The camera or magazine should have a place where you can make a notation of the type of film you are using and its ASA rating. Furthermore there should be a signal that indicates whether the film is advanced, and this signal must work with the magazine on or off the camera.

Unless you use the same film all the time, always indicate what film is in the camera or magazine.

The camera should have some arrangement whereby the release cannot be depressed after you have exposed the last frame. This warning should preferably come right after you have shot the last frame, rather than when you try to depress the release again.

Camera Types

Medium format cameras come in a wide variety of styles. Most are satisfactory for many different jobs, but some are better suited for certain applications than others. Your selection of a camera therefore must be based first on the subject matter or the photographs you plan to take. Then you can make a final choice of camera by investigating and determining how important the following features are for your application:

- shape of the camera;
- size, weight, and portability;
- type of viewing;
- degree of electronics and automation;
- component interchangeability;
- shutter;
- special camera features;
- availability of compatible lenses and accessories;
- quality and workmanship.

SINGLE LENS REFLEX

The single lens reflex (SLR) camera has become the most popular type in the medium format, replacing the twin lens reflex (TLR) that was the standard in the 1930s and 1940s. Now only a few TLR systems are still being made; whereas the number of SLR systems is constantly increasing.

Shutters and Mirrors

Medium format SLRs are available with a focal plane shutter or a lens shutter. Those without focal plane shutters use interchangeable lenses

with built-in leaf shutters. Furthermore, some focal plane shutter cameras can be fitted with leaf shutter lenses—either just one or two special lenses or a complete range of lenses.

Some focal plane shutter models allow you to use shutter lenses. You can then decide which shutter to use for each shot and switch from one to the other. The focal plane shutter is likely to produce higher shutter speeds, while the lens shutter provides flash synchronizations at higher speeds.

In both cases, the reflex mirror swings out of the way so light can expose the film. Therefore the viewfinder image is blocked out until the mirror drops back in place after exposure. On some makes, the mirror returns instantly and automatically after the exposure has been made; on others, the mirror returns when you crank the shutter and advance the film.

Those who are used to the instant return mirror operation of the 35 mm may find the blackout of the viewfinder objectionable, at least at the beginning. Once you are used to it, you will see that it has no disadvantages. It is often said that the instant return mirror lets you see whether you have captured the expression; whereas the noninstant return type does not. This is not true. With both mirror systems you cannot see the subject on the ground glass the moment the exposure is made because the mirror is lifted up at that moment. On all SLRs, you can see the subject

When the camera release (1) is depressed, the mirror (2) swings up, blacking out the view on the ground-glass screen. This happens on all SLR cameras. An instant return mirror swings back to the viewing position immediately after the exposure is made. A noninstant return mirror comes back when the film is advanced.

right before shooting; with the instant return mirror, you can also see the subject right afterwards. To see the subject the moment the exposure is made, you need a finder that does not view through the taking lens, as on a TLR or rangefinder camera. This can be accomplished on the SLR by attaching a sports or frame finder, part of many 2 1/4 in. SLR systems. Because the mirror on all SLRs (35 mm and medium format) must move out of the way before the film can be exposed, there is a slight delay between the time the release is depressed and the time the exposure is made. The delay is short on most systems and nothing to worry about in most applications. But in action photography, the delay could result in your capturing on film a slightly different image of the action than what you see in the finder. The delay can be eliminated on most SLRs by locking up the mirror, thereby prereleasing the camera.

Viewing

In medium format SLRs the picture is viewed, focused, and taken through one lens, and framing and focusing are accurate, so there is no parallax error. With a prism finder, the image is right side up and unreversed. With a waist-level finder, you view from the top, and the image on the focusing screen is right side up but laterally reversed.

When you change lenses on an SLR, the viewfinder automatically shows the area covered by that lens. I believe that the most valuable aspect of SLR viewing is that you can see how the image changes as the diaphragm is opened or closed. SLR viewing also simplifies close-up

photography. You just focus until the image on the screen is sharp, regardless of what close-up lens or accessory you are using. Many SLR cameras offer another benefit: the possibility of measuring light through the lens, combined with more or less exposure automation.

Size and Shape

The shape of the camera is an important consideration, especially for handheld location work. A medium format SLR can look like an oversized 35 mm camera, but most SLRs are more of the boxy type, with the largest dimension of the camera being the distance from the lens to the rear of the camera. The dimensions of the camera are dictated by the room the mirror needs to move freely up and down and by the design of the film magazine. Width and height are generally kept rather small—usually just a little more than the negative size. On the other hand, a camera with a rotatable film magazine needs to be considerably larger, because it allows you to photograph verticals or horizontals without turning the camera. The convenience of the rotatable magazine is an advantage, but the camera's bulkiness can be a drawback.

It takes a little time to get used to the boxiness of the medium format camera. It is held differently from the 35; the release is likely in a different position; and the viewing method may be different. But you can get used to these differences quickly and soon be holding a compact medium format camera as steady as a 35 mm and shooting as fast as with a 35 mm SLR. Those who find holding a camera inconvenient should keep in mind that camera manufacturers make grips for their cameras. These typically mount to the tripod-mounting screw on the camera's base and have a handle at one side of the camera or a grip at the bottom. The most convenient grips have a shutter button on the handle.

Convenience Features

Convenience features are important. If you do not have to worry too much about technicalities and camera operations while shooting, you are more likely to produce exciting images. You can concentrate on the subject, lighting, and other creative aspects of photography.

Among available convenience features are the signals that show whether film is in the camera and is advanced; the interlocks between components that let the release be depressed only when everything is done properly; and the positioning of the various knobs and scales. You should be able to read all important scales, preferably with the camera in the normal shooting position, without having to turn and twist it in all directions.

Lenses

Medium format SLRs also vary in the camera body–lens connection. Usually the lens is attached directly to the camera body, which results in a rugged camera that can take abuse yet is small and mobile. The optical relationship between lens and film plane, so important for image sharpness, is likely to be accurate in this type of setup. Some cameras have a bellows between camera body and lens mounting plate; this allows continuous focusing from infinity down to close distances, somewhat like with a view camera. These cameras allow you to shoot close-ups without buying additional accessories. The lens board might even tilt to increase field depth. This design also eliminates the need for focusing mounts in lenses, reducing the lens cost, but ruggedness and precision in the body/lens alignment suffers.

An SLR camera with a lens shutter requires a somewhat elaborate interlocked mechanism. The lens operation must be coordinated with the mirror and rear curtain. When the release is depressed, the lens shutter closes down, and the normally wide-open aperture closes down to the preset aperture (1). At the same time, the mirror lifts up (2). When the lens shutter is fully closed, a rear curtain must open (3). Then the lens shutter opens and closes for the set time to make the exposure (4). The purpose of the rear curtain is to protect the film from light before and after the exposure is made. In a focal plane shutter camera, the shutter serves this purpose.

Camera Design

SLR cameras in any format are complex. They contain a mirror that must move in a precise path up and down and must do so quickly and without causing too much camera movement. The mirror must maintain accurate focusing by moving down so it rests every time in exactly the same position. Its movement must be synchronized to the shutter in the lens and camera. If lenses are interchangeable, the diaphragm and shutter of every lens must synchronize with the rest of the operation. If the film magazines are also removable, precision is necessary so that each magazine fits on every camera as if it were part of the camera.

In any SLR camera the mirror must be aligned so that the distances from lens to film and lens to focusing screen are identical. It is suggested that you have the mirror alignment checked occasionally.

The SLR is the most expensive type of medium format camera, but it is also the most versatile. But versatility is probably what you want and expect from a medium format camera system—a system that provides the desired results in the most convenient fashion regardless of what you may have to or want to photograph.

TWIN LENS REFLEX

Twin lens reflex refers to the camera's optical system. In a TLR, two lenses of identical focal length are mounted one above the other, with centers 40

to 50 mm apart. The top lens is for viewing, and the bottom lens is for taking the picture; the lenses are called, respectively, the viewing lens and the taking lens.

In contrast to the SLR design, the TLR is simple. The mirror is installed permanently and never moves. There is no rear curtain, so the lens shutter need not be synchronized to any other operations. The simplicity means the camera has few problems; little can go wrong during normal operation. And it has another benefit: very quiet operation. The only audible noise when the release is pressed is the opening and closing of the lens shutter blades. On an SLR camera with a lens shutter, the sound can be brought down to the TLR level by prereleasing the camera, which lifts up the mirror and opens the rear curtain, the two operations responsible for the sound. When the release is depressed later, only the lens shutter opens and closes, just as on the TLR. TLRs also have little or no vibration when used on a tripod or camera stand.

A TLR camera is actually a combination of two separate camera boxes. The viewing box on top contains a fixed mirror (1) and ground glass (2) and is for viewing and focusing only. The picture is made on the film plane (6) in the box below. The two lenses of equal focal length are mounted on a common plate (3) that moves forward and backward when you focus. The viewing lens (4) in a TLR camera sees a different area than does the taking lens (5). At long distances, the two coincide, but you must compensate for this parallax in close-ups. Interchangeable lens models are also available with the removable lenses mounted on a common plate.

Although TLRs are simple in design and operation, they are not snapshooter's cameras. For many years they were the most professional medium format camera available and are still used today in professional work, and experienced photographers have learned to live with the limitations and make the best of what the camera offers. The limitations do not mean inferior image quality. TLR cameras have always been equipped with top-quality lenses.

Viewing on TLRs

On a TLR, only the taking lens needs to be of high quality. The viewing lens needs to be just good enough to provide a good image for viewing and focusing.

The image formed by the viewing lens is reflected by a reflex mirror and intercepted by the focusing screen. When the focusing knob is turned, both lenses move together. The typical viewing lens cannot be adjusted to visually check the image at the shooting aperture. The image on the screen is always as seen by the lens wide open, perhaps even wider than the taking lens, because some viewing lenses have larger apertures to produce a brighter image. Therefore you cannot see how the image changes by opening or closing the aperture, and this is the camera's greatest weakness for serious photographers.

There is a benefit to the fixed mirror, on the other hand. When you trip the leaf shutter, the viewing image is not blacked out. The leaf shutter operates only in the taking lens. So you can see the subject at the moment of exposure, not just before and just after.

On some TLRs focusing screens and viewfinders are interchangeable, and the choice of finder may include a type with a built-in metering system.

Parallax

The image you see through a TLR is not exactly the same image captured on the film, because the centers of the two lenses are separated vertically, giving them slightly different fields of view. The effect is called parallax error. It is not a serious problem except with close-up pictures.

The TLR's weakness is in versatility. It is a great tool for ordinary photography at longer distances. The range of accessories is limited to those designed for photographing long distance shots.

Camera Shape

The shape of all TLR cameras is identical. With viewing and taking chambers arranged vertically, the longest camera dimension is from bottom to

top. This camera is made for the square format, mainly because it would be impractical to turn the camera sideways for verticals. It is not made for interchangeable film magazines but usually offers the possibility of using 120 and 220 roll film. Although the operating cycle is much simpler than the SLR's, shooting speed is about the same. Both require turning a knob or crank to advance the film, which usually also recocks the shutter.

RANGEFINDER CAMERAS

Rangefinder cameras have an optical viewfinder that is as bright and clear as the view with the naked eye as there is no focusing screen between the subject and the viewer. Since the camera does not need a mirror, the camera can be made to fold up, with the lens collapsing into the camera body. The result is an extremely compact camera, the smallest and lightest medium format type. If made for the smaller 4.5 cm × 6 cm format, it can be truly pocket size. Some cameras have built-in meters. In shape, all look like oversized 35s, with the viewfinder or viewfinder-rangefinder combination on top. Some manufacturers offer two models with the same or similar features but with lenses of different focal lengths. All rangefinder models have shutters in the lens, usually up to 1/500 second, synchronized for flash at all speeds. The choice of format ranges from 6 × 4.5 cm to 6 × 6 cm, 6 × 7 cm, and even 6 × 9 cm. Rangefinder cameras do not have film magazine interchangeability. But most cameras provide the choice of 120 or 220 roll film.

The major variation in design among basic models is in the lens-camera connection. On some the lens is fixed to the camera body; in the folding type the lens collapses into the camera. The latter are not only more compact but provide complete lens protection while you are carrying the camera around. Although rangefinder cameras do not have the range of features and possibilities one might associate with medium format photography, they are beautiful and modern looking. Some even include built-in light measuring through a separate window rather than through the lens.

Rangefinder cameras are not intended for sophisticated work but have all the features that the press photographer and average amateur needs for family and travel shooting. Focusing with a full field rangefinder is easy and most accurate, assuming that everything is aligned properly. A rangefinder is a fairly delicate instrument, so its accuracy should be checked once in a while by focusing on a subject at a known distance, infinity or perhaps 10 ft., and checking that the distance on the focused lens corresponds with your actual distance from the subject.

Since you don't view the image through the lens, the finder can be made to show a field larger than that covered by the lens. The area covered on the film is then indicated by lines within the finder. This wider field

can help you decide on the composition. You can see subjects that might be coming into the field of view before they actually do. A rangefinder camera also lets you see the subject the moment the exposure is made.

WIDE ANGLE CAMERAS

Some of the viewfinder or viewfinder-rangefinder cameras are equipped with a wide angle lens ranging in focal length from 38 to 65 mm. These cameras are made so the medium format photographer can take advantage of and benefit from lenses typically found only on view cameras. Their wide angle lenses are not the retrofocus types found on SLR cameras. They are optically true wide angles, the best quality available. Architecture and aerial photography are among the more serious applications for such a camera. The 47 mm lens has a diagonal angle of view of 93° on the 6 × 9 cm format. The 38 mm lens has a diagonal angle of view of 90° on the 2 1/4 in. square format. Since these short focal length lenses have great depth of field, focusing by estimating the distance is usually satisfactory. A spirit level, built in or as an accessory, however, can be a great help, because it is the only way to be certain that the camera is level to record verticals, straight and parallel.

The Hasselblad SWC/M must be mentioned separately. It offers magazine interchangeability—the possibility of using 120 and 220 roll film, 70 mm sheetfilm, and Polaroid film and the ability to focus on your subject with the aid of a ground-glass back accessory.

PANORAMIC CAMERAS

The range of medium format cameras is increased by cameras designed for a very long format negative—12 to 17 cm—but that still use the standard roll film.

The long format is appropriate for wraparound book covers, calendars, and annual reports, or just for presenting something different. The panorama can also be used for multi-image slide presentations. The lenses on panoramic cameras are actually view camera lenses; they are by far the most expensive part of such cameras. To cover that long format with superb corner-to-corner quality, the lens must be made to cover either the 4 × 5 in. or 5 × 7 in. view camera format. The full negative requires an enlarger capable of printing from 5 or 7 in. negatives.

The features and operation of panoramic cameras are very much like those of the viewfinder-rangefinder cameras. Panoramic cameras can be handheld or set on a tripod. A built-in spirit level is helpful because a level camera is important for effective panoramas.

Although they are specifically made for the panoramic image format, the negatives or transparencies of these long images could be cropped to a normal format; this, however, is an expensive way to produce normal shots.

PRESS CAMERAS

Press-type cameras—the folding type with bellows or the models with the lens mounted on the camera body—are another version of medium format viewfinder-rangefinder types. They have a large viewfinder, a permanently attached camera grip, and leaf shutters in the lenses, which can be replaced by lenses with focal lengths from wide angle to telephoto. Shutter cocking is a separate operation, not coupled to film advance. I consider these cameras outdated, especially for news work.

VIEW CAMERAS

Medium format photography can be done on view cameras by attaching either a roll film magazine in place of sheetfilm holders or attaching a medium format camera body with film magazine to the rear of the view camera. Special accessories for this purpose are available from some view camera manufacturers. Combining the two allows you to use roll film instead of sheetfilm in the view camera and makes it possible for you to use swings and tilts when photographing in the medium format.

STUDIO CAMERAS

School photographers use motor-driven long roll cameras made specifically for this staged, large production photography. The cameras use either 70 mm or 46 mm film and the cameras are designed to print information on the negative for identification purposes.

MOTOR DRIVES

Medium format cameras are available with motor-driven film transport. This feature can be built into the camera, or you might be able to attach an accessory motor winder to the camera in place of the manual winding crank. If this motor drive accessory is also designed as a carrying handle, it is usually referred to as a power grip.

The main function of a motor is to advance the film automatically after each picture. A motor that does nothing more than that is an autowinder. In a more sophisticated version, the autowinder might also wind the roll film to frame 1 and wind up the paper trailer after the last frame has been shot or provide automatic exposure bracketing. A true motor drive, on the other hand, can provide additional helpful possibilities, such as remote and multiple camera operation.

Motor-driven film advance is a convenience: it can increase the speed of shooting. Motor drives are usually very reliable; the danger of something going wrong with the motor is not any greater than with any other part of the camera mechanism. The motor drives perform the cam-

era operations in the proper sequence at the proper time. Motor drives do have negative aspects as well: they add weight and bulk to your camera, and the motor operation is dependent on batteries. You need to be sure that your batteries are in good condition, and carrying spare batteries is highly recommended. If the motor drive on your camera is an accessory, you can avoid both problems by removing the motor and operating the camera manually. Some cameras with built-in motors also allow you to operate the camera manually in an emergency, perhaps in a limited mode.

One specification you must check when investigating motor-driven cameras is the number of images you can obtain per battery charge. This depends partially on the type of batteries. Most cameras use either rechargeable nickel cadmium types or standard AA or rechargeable AA cells.

Nicads work well and can be recharged hundreds of times, but they must be treated properly. They should never be overcharged, and they must be discharged completely once in a while. If you use them only partially and bring them up to par with a partial charge, you create a memory of the battery capacity that is no longer the full capacity. Discharging the batteries completely also gives you the advantage of knowing how long to charge. But there is no practical way of determining how much charge is left in a partially used Nicad.

Standard AA cells seem to be preferred by pros. They are inexpensive, can be purchased anywhere in the world, and the battery capacity can be determined with a battery checker that may even be built into the camera's motor drive.

Sequence Operation

Shooting sequences of images at a fast rate can be valuable in action, sports, and scientific studies. If this is your main reason for considering a motor drive, however, first determine what rate of speed you'll need to be photographing at in your application and then read camera specification sheets. Most medium format cameras do not provide the speed of several frames per second that is offered by 35s. Most medium format cameras operate more in the neighborhood of one frame per second, which is often satisfactory—practically perfect for photographing models in action in fashion photography.

Shooting Readiness

The motorized camera is always ready for shooting. You can take a second picture a second after a picture is made. You can shoot that second or third image without even having to remove your eye from the finder, whether you

work handheld or from a tripod. When photographing people, especially children, the best expression often appears just after the picture was snapped, perhaps as a sign of relief. This expression lasts for a moment— never long enough for you to capture it with manual film advance but long enough for you to give a second push on the release of the motor-driven camera.

Simplicity of Operation

Camera operation, which is reduced to pressing the release on a motor-driven camera, can be done with one hand. This ease of use comes in handy when your other hand is holding onto something, holding a flash or other accessory, directing people, or shading the lens or your eyes.

Automatic electric film advance is smooth, and there is little danger that a mounted camera will move out of position between shots—an advantage especially in close-up photography, and copying documents.

Remote Operation

Remote camera operation is useful or necessary when it is dangerous or impossible to be near the camera. That is the way that most striking images of space liftoffs at Cape Canaveral are done. Remote operation is frequently used in aerial applications, with the camera built into the aircraft. Remote operation, however, is not limited to such special applications; it can also be helpful in portrait, fashion, pet, and child photography.

To be successful photographing people, you need to be able to direct them, whether they are professional models or nonprofessionals. Although this can be done from behind the camera, it is often easier when you are close to the subject. With a motor drive, you can be close to the people, watch their expressions, direct, play with a child, and snap the shutter when everything is right. You need return to the camera only to change film and lens settings.

A motor-driven camera can be set up to photograph a wedding ceremony from a location where a photographer is not allowed or from where the camera can provide a different view from the one the photographer has standing in the aisle. One photographer can actually operate two cameras: one handheld and the other set on a tripod somewhere else.

Remote operation can be done in many ways. Cables provide the simplest and least expensive method. Wireless operation may also be possible.

The triggering source can be a radio signal, a sound signal, a light signal, or infrared. A signal is produced by a transmitter and picked up by a receiver on or close to the camera and connected to the remote release socket.

MULTIPLE CAMERA OPERATION

Multiple camera operation (taking simultaneous pictures at exactly the same moment with more than one camera) has interesting possibilities and important applications in many fields of photography. It usually involves recording unique events or happenings where the photographer has only one opportunity to capture a particular image on film and no time to change film, lenses, or camera angles. It could be the finish of a horse race, the takeoff on a ski jump, or almost any other sports action. You can record the event as a color transparency and a black-and-white print by loading one camera with color slide film and the other with black and white. For an overall view and a close-up of the same action at the same moment, equip one camera with a normal or wide angle lens and another with a telephoto lens, or record the action from two or more angles. Recording simultaneous images on different film emulsions is also known as multispectral photography. This technique is used mainly for investigating water pollution problems or diseases in fields and forests. The images captured on different films, including infrared, and taken through different color filters can show the scientist the source of the problem, which may not be apparent in one image.

In all these cases, two or more motor-driven cameras are connected to one release, and the cameras are released electrically, not mechanically.

CAMERA MODELS AND MANUFACTURERS

The camera models available in 1994 are shown and the major features listed in chapter 20. Contact the manufacturers for more detailed information.

Shutters

FOCAL PLANE SHUTTERS

The focal plane shutter consists of two curtains moving vertically or horizontally in front of the film plane.

With a focal plane shutter, the film is exposed progressively as the shutter curtain moves across the film area. When the release is depressed, the first curtain starts to move. The second curtain is delayed. The shutter speed determines the delay. At high shutter speeds, the full film area is never exposed at the same time; thus flash synchronization is impossible.

In medium format cameras with interchangeable magazines, the focal plane curtain is at the rear of the camera body and is fully exposed when the film magazine is removed from the camera. To avoid curtain damage, the camera should be stored with the magazine on the camera, and the magazine should be changed with care. Most curtains are damaged when a corner of the magazine accidentally hits the curtain.

Shutter Design

A modern focal plane shutter consists of two curtains. Between pictures, the curtains cover the film completely so that the lens can be changed at any time without fogging the film. At high shutter speeds both curtains start moving the moment the release is depressed. When the shutter speed is set slower, only the first curtain moves when the release is depressed; the second curtain follows later. The delay time is determined by the shutter speed.

On modern cameras, the shutter speed is controlled electronically. The actual movement of the curtain is mechanical, but compared to a leaf shutter in lenses, fewer mechanical components are involved, especially parts that require lubrication.

The focal plane shutters are usually timed electronically, up to 10 or more seconds. Longer exposure times can be obtained by manually keeping the shutter open for the desired number of seconds.

Flash Synchronization

Since a focal plane shutter scans the film area, different areas of the film are exposed to light at different times. This means that when flash is used, the flash must go off when the shutter is open over the entire film area; otherwise only part of the film area will be exposed when the flash goes off. At high shutter speeds, the second curtain starts to move and cover up part of the film area before the first curtain has disappeared completely. Consequently you should make flash pictures only at slower shutter speeds. Over the years the flash synchronization range has been increased dramatically for 35 mm focal plane shutter cameras, so that they can be synchronized with flash up to 1/250 second. On medium format cameras, such a wide flash synchronization range is not possible because the curtains have to travel across an area that is about twice as wide as that on 35 mm cameras. Some medium format cameras allow a top speed of only 1/30 second, a serious limitation in such applications as sports and flash

1. 2. 3. 4. 5.

The flash must fire when the first curtain has fully exposed the film area but before the second curtain starts to move (3), which occurs only up to a certain shutter speed. At higher speeds, the second curtain starts to move before the first curtain has fully exposed the film area. Part of the picture is blank, as in (2) and (4).

fill-in. But the highest flash synchronization on focal plane shutter medium format cameras at present is 1/90 second, quite an improvement over 1/30 second.

If you accidentally set your camera's shutter speed too high, you usually won't discover the mistake until the film is processed. To avoid this, some manufacturers have built a flash-firing control so that the flash will not fire when the shutter speed is set higher than the synchronization range, or the shutter speed will set itself automatically at a synchronized speed, eliminating or reducing the danger of a costly mistake.

Distortion

Focal plane shutters, especially those that move horizontally, produce another undesirable effect when you photograph moving subjects. By the time the shutter curtain has moved across the film area, a moving subject has also moved. As a result, the image you record of the moving subject may appear physically longer than it really is when the image crosses the film in the same direction as the curtain, or physically shorter when it moves in the opposite direction. In either case, this irregularity is referred to and recognized on the film as a form of distortion. A moving round wheel is recorded as an ellipse. There are few cases, however, in which this distortion is objectionable.

Focal plane shutters can distort images of moving subjects because the recording of the image is progressive rather than instantaneous. Thus an object moving in the same direction as the shutters will appear elongated; one moving in the opposite direction will appear shortened.

Shutter Speed

Because the focal plane shutter is completely separated from the lens aperture, the effective shutter speed is the same with all lenses, at all aperture settings. Focal plane shutters tend to be noisier because the curtains move at a rapid speed over a large area, and the shutters are more likely to create camera vibration. Lens shutters are quieter and operate more smoothly.

Lens shutters are efficient up to speeds of 1/500 second, sufficiently fast for most forms of photography. In contrast, focal plane shutters can be

made to produce accurate exposure times at higher speeds—you can find speeds of up to 1/2000 second on medium format cameras. Cameras in the future may go even higher.

Lens Variety and Design

The focal plane shutter camera can be used with just about any type of lens, including special types—photomicrographic, for example—without losing shutter control. They can also be used in applications where lenses are not needed at all—for instance, photographing through a microscope or telescope. Focal plane shutters eliminate the need for each lens to have its own shutter, thus perhaps reducing the cost of the lens. More important, putting the shutter in the camera instead of in the lens increases the possibilities in lens design; whereas a shutter in a lens limits lens design by making it more difficult to increase the maximum aperture and the minimum focusing distance.

LENS SHUTTERS

In a leaf shutter in lenses, shutter blades open and close at the set speed, exposing the entire film area at the same time and for the same length of time. With lens shutters, distortion of moving subjects does not occur.

A lens shutter adds to the cost of the lens. On the other hand, if you have a problem with a shutter in one lens, you can continue to photograph by switching to another lens.

A lens shutter also complicates the design of an SLR camera because a curtain of some kind must be built into an SLR lens shutter camera to prevent light coming through the lens or finder from reaching the film.

The lens shutter and rear curtain operations must then be synchronized so that the lens shutter is fully closed before the rear curtain starts to open, and the rear curtain must be fully open before the lens shutter opens again to make the exposure. These operations are done fully automatically and with a very short delay of perhaps 1/25 second in a modern camera.

Prereleasing Cameras

Lens shutters function smoothly and quietly. In an SLR camera, however, most of the sound and vibration do not come from the shutter but from the mirror lifting up and the moving protective rear curtain. To assure that your lens shutter operates smoothly and quietly, which is especially important in suppressing camera noise when photographing in churches, synagogues, and museums, prerelease the camera before shooting. This means the mirror is lifted up and the rear curtain is opened before the exposure is made. Prereleasing is recommended when you are using any

SLR camera on a tripod or stand, especially at slower shutter speeds and with longer focal length lenses.

Flash Synchronization

When the lens shutter is used, the entire film area is exposed immediately. During the cycle, the image becomes bright and then darkens again. There is no distortion because the entire film area is exposed simultaneously.

Focal plane shutters go to higher speeds, as high as 1/2000 second in medium format cameras, allowing you to freeze even faster moving subjects.

Lens shutters synchronize with electronic flash up to 1/500 second, which is helpful in flash fill work outdoors.

Lens shutters can be used with flash at every shutter speed up to 1/500 second. This must be one of your main considerations when choosing a camera type for flash work. To overcome this limitation on focal plane shutter types, some medium format camera manufacturers offer one or two special shutter lenses for use with these cameras. Some medium format focal plane shutter cameras with focal plane shutter can be used with an entire line of shutter lenses, from fish-eye to long telephotos. That means users have a camera with two shutters—and therefore the benefits of both.

Electronic and Mechanical Shutters

Lens shutters can be controlled mechanically or electronically. Electronic control is likely more accurate, especially at cold temperatures, but you have to rely on battery operation. Since the movement of shutter curtains or blades is mechanical in all shutters, shutter speeds in lens shutters without electronic timing can be just as accurate as those controlled electronically.

Mechanical lens shutters, however, must be cleaned and lubricated frequently to remain accurate and reliable in cold weather. This is necessary mainly because lenses cannot be sealed completely, so as a result, dust will make its way onto the lense. Lubricants also work differently at different temperatures. Lens shutter operation is therefore affected more by temperature, especially cold temperatures, than focal plane types.

OPERATING CONSIDERATIONS

Lens shutter operation on most cameras is as automatic as the focal plane type. After the exposure is made, moving a lever or turning a crank recocks the shutter and advances the film. On some older cameras, however, shutter cocking and film advance are two separate operations—a rather old-fashioned approach that limits the speed of shooting.

It is worthwhile to check out the position of the shutter speed and aperture indication on the camera-lens combination. When both indicators are next to each other, making the settings and checking the settings is more convenient and your speed of shooting increases.

Focal plane and lens shutters may be connected to a self-timer. Self-timers trip the shutter automatically after a delay of a few seconds, allowing the photographer to be in the picture.

Image Quality

Image quality depends on many factors—precision in the camera design, especially the lens-body and lens-film magazine connection, mirror and focusing screen alignment, film flatness, and the quality of the lenses. Image quality is also determined by the camera/lens operation, accuracy in focusing, exposure, and camera steadiness.

The superb sharpness and definition of today's film requires that we be more critical about everything that affects sharpness if we want to be assured of capturing images of the utmost quality on these films. We must be more precise in focusing and exposure; we must be more restrictive in the use of depth of field; more selective in the choice of camera, lens, and film magazine; more careful about camera steadiness. Sharpness can be ensured only if the camera is absolutely motionless from the moment the shutter opens until it closes.

HANDHELD OR TRIPOD

A fairly common opinion is that medium format cameras are made for tripod use. Some are so heavy that they cannot be carried too far or for too long without becoming a burden. But most medium format cameras are still light enough to be carried suspended around your neck, on your shoulder, or held in your hand without becoming uncomfortable, and are ideally suited for handheld operation. Properly held and operated, they can be as steady as handheld 35s.

Handheld camera operation is particularly suggested when you are photographing from different heights and angles. A tripod does not preclude this but does restrict you. It is time-consuming to set up a tripod and change tripod height, even more time-consuming to move the tripod around while you are investigating different camera angles. Also a tripod

often makes it impossible to go down to low angles. As a result, tripod pho-
tographers tend to shoot everything from the same, most convenient cam-
era height. They never investigate different possibilities. If you want or
have to use a tripod, I suggest, first, that you investigate all the possible an-
gles and lenses before placing the camera on the tripod. Move around the
subject with a handheld camera; view the scene from every angle, from dif-
ferent distances, and through different lenses; go down on the ground and
view it from below; go as high as possible and look down. Don't set up the
tripod until you have thoroughly exhausted all possibilities and found the
most effective camera position.

Handheld Photography

Most medium format cameras can be operated handheld. A grip or handle
does not necessarily improve camera steadiness; it may make camera hold-
ing more convenient and certainly allows more convenient camera carry-
ing. Grips and handles are available for many cameras. It is worthwhile
investigating and actually trying out these accessories under specific shoot-
ing conditions. Many photographers would never use a medium format
camera without a grip, and others feel more comfortable with their hands
on the camera body. Whether or not to use a grip is a personal decision.

Manufacturers usually suggest a specific way of holding the camera
that works fine in most cases and with normal lenses. When using tele-
photo lenses you may find using a different grip helpful: place one hand
around the lens barrel rather than both hands on the body.

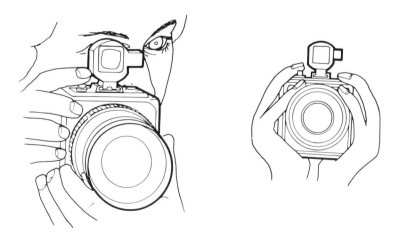

Cameras can be held in many ways. The manufacturer's suggested method works
well in most cases, at least with normal lenses. With some cameras, both hands
surrounding the camera body works well. With long lenses, it is frequently better
to use one hand to steady the lens.

Try different methods of holding the camera until you find the way that suits you. However you hold the camera, you need a firm foundation. Start by standing with your feet apart. Press your elbows into your body for additional bracing. To hold something steady, you need two forces opposing each other: one pushing one way and the other the opposite way. The direction of the action depends on the type of viewfinder. With a waist-level finder, pull the camera up and push it down with your face. With a 90° or 45° viewfinder, pull the camera diagonally up while pushing down with your face.

Best camera steadiness is obtained when two forces work against each other, such as the eye pressing the camera down or forward and the hand pressing it in the opposite direction. With the waist-level finder, the hands press the camera up and the eye pushes it down. With prism finders, the hands push the camera back toward the face, and the eye pushes it forward. Always look for natural supports for your camera or your body.

When shutter speeds become too long for steady handheld photography, some kind of support is necessary. Before rushing for a mechanical camera support, investigate other methods of steadying the camera, such as by leaning your body, head, or camera against a wall, post, or tree or resting the camera or your elbows on a suitable surface. Rather than placing the camera directly on the surface, try using a beanbag, which shapes itself to the contours of the surface and the camera and minimizes camera movement. For low camera angles, lie on the ground and use your elbows as a support.

Tripods

Holding the camera in the hand complicates communication with your subject. A tripod-mounted camera leaves you free to direct the people you are photographing because your eye need not be glued to the viewfinder.

Steadiness is the main but not the only reason for using a tripod. A mounted camera also leaves you free to move around communicate more directly with your subjects. This is especially true with a motor-driven camera. Once you have lined up a shot, you no longer need to look on the ground glass; you can look directly at the people and communicate with them. With a handheld camera in front of your face, you lose contact with your subject; you talk into the camera, not to your subject.

CAMERA STEADINESS

Tripods and cable releases are excellent accessories for improving camera steadiness, but using either or even both is no assurance of picture sharpness.

When exposure times exceed 1 second, your body and hands should not be in contact with the camera; use a cable release. For shorter times, steady the camera by pressing it firmly toward the ground with your hands and face.

Two types of camera motion cause unsharpness: motion or vibrations produced by the camera mechanism and motion produced by the photographer. Motion produced by the photographer may be caused by not holding the camera steady in handheld photography or by jarring the release, which can happen with handheld or tripod-mounted cameras. To minimize this happening, depress the release slowly and gently so you hardly know when the shutter clicks. With a tripod-mounted camera, a cable release serves as a flexible link between you and the camera, absorbing whatever shake your finger might produce.

Depressing the release on any SLR camera brings various camera functions into motion, which can blur an image. All camera manufacturers try to dampen the motion as much as possible, but the camera mechanisms can still produce vibrations. These vibrations do not seem to affect picture sharpness in handheld photography; the body seems to absorb the effect. But the vibrations can affect sharpness when the camera is mounted on a tripod or stand.

A camera on top of a heavy studio tripod is probably steady. On a more lightweight tripod, the kind most often used on location, camera-produced vibration is not eliminated, especially when the center elevator of the tripod is extended more than a few inches. The camera ends up actually sitting on a single post rather than on a three-legged extension. In

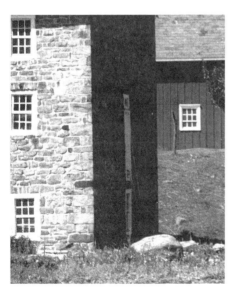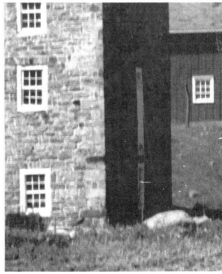

A 10× magnified image shows the difference in sharpness from a tripod-mounted camera when the mirror is locked up (left) and when the mirror lockup is not used (right). Exposure at 1/8 second with a 150 mm lens. A cable release was used for both.

this position the camera is prone to vibrate, as you can easily see when you tap the camera. A cable release does not in any way reduce these vibrations; in fact, camera motion is more likely eliminated by not using the cable. To minimize camera shake, hold the camera as firmly as you do in handheld work. Lay your own weight on top of the camera, pressing the tripod and camera to the ground. Using this approach, which may be opposite from what you have been told, allows you to use lightweight tripods without suffering image blurriness. This approach, however, works only with exposure times up to 1/2 or 1 second. It does not work for time exposures, because you will not be able to keep your body steady long enough.

MIRROR LOCKUP

Most motion in an SLR camera is produced by the mirror, and some by the lens aperture and shutter. Therefore it is logical to perform as many of these motion-producing functions as possible before the exposure is made. The camera feature that will let you do this is the prerelease or mirror lockup.

When the prerelease is depressed, the mirror lifts up, and the camera performs all the other functions it needs to do before the shutter can make the exposure. Now you can wait a second or two to let the camera settle down before you push the release.

The prerelease or mirror lockup is one of the most important features of an SLR camera. Use it whenever you work from a tripod or camera stand. Use it also when making long time exposures with a cable release and on a motor-driven camera.

The prerelease or mirror lockup can also serve another purpose: eliminating the time delay between when the mirror is being lifted out of the way and the film can be exposed. This delay is short but nevertheless exists on SLR cameras. With the camera prereleased, the exposure is made the instant you depress the release.

TRIPOD USE

Selecting a Tripod

Maximum camera steadiness would call for the largest, heaviest studio tripod, but tripods are used out in the field, so you need to make a compromise between steadiness and portability.

A medium format camera does not necessarily require heavier gear than a 35 mm camera. You can achieve excellent steadiness with a relatively lightweight model if tripod and camera are used, as discussed before. But with long lenses, tripod size must be more seriously considered.

A tripod must be designed for fast, convenient operation so that it is a pleasure to work with rather than a nuisance. The attributes I recommend

you look for in a tripod are, in order of importance: steadiness; convenience of viewing and operating the camera; tripod head locks strong enough to hold any combination of equipment in all positions; ease of setting up; quick camera mounting and release; convenient adjustment of camera height and angle; portability; and the possibility of changing lenses and film magazine without having to remove the camera from the tripod.

All tripods are made for what could be called normal shooting heights (5–6 ft.). For photography from lower levels, some tripods are made so the legs can be spread beyond their normal position. Other tripods allow you to attach the camera to the bottom of the center post, or the centerpost can be inserted upside down so the camera sits between the legs.

Center Post

The most solid, vibration-free camera support is obtained when your camera sits directly on top of three legs, not on top of a single post. If you raise the center post of your tripod extensively, camera steadiness is jeopardized, and the advantage of a heavy tripod with good leg construction may be nullified completely. On the other hand, an elevating extension is convenient for lowering or raising the camera, so try to compromise. Never consider the center post as part of the tripod height. Raise the tripod as high as you have to with the three legs, and use the center post only for minor adjustments in camera height.

The steadiest position for a camera and tripod combination is when the camera rests directly on the three legs of the tripod and the center post is not extended. The center post should be used only for minor height adjustments. When the center post is extended too far, the tripod is susceptible to vibration.

Tripod Head

The tripod head used with a still camera should tilt forward as well as sideways. The two movements can be separate—controlled by separate locking levers (left) or a ball head that moves in all directions (right). Courtesy Bogen Photo Corp.

The tripod head must hold the camera without putting excessive pressure on the locking levers, not only when the camera is in a horizontal position but also when it is tilted up or down with any of the lenses and accessories you normally use. The platform of the head should be large enough to hold the camera so it does not easily move when the camera controls are operated or when the film is advanced. Neither the platform nor any other part of the tripod should interfere with camera operation.

Coupling

Most tripods hold the camera on the platform by means of a screw from underneath the platform that fits into the camera. Attaching and removing the camera can be inconvenient and time-consuming because the locking screw is not easy to reach and practically impossible to adjust with gloves. Locking screws can also be dangerous because they can be forced into the camera body, causing damage to the inside of the camera. These problems are eliminated with a tripod coupling, which allows instant attachment and removal of the camera. The coupling is attached to the tripod and left there, becoming part of the tripod. The camera slides into the

A tripod quick coupling permanently attached to the tripod head can save you time when you set up a tripod shot. Slide the camera onto the accessory and lock it in place by turning the lever.

adapter plate, where it may be locked in some way. To remove the camera, you simply slide it right out.

Tripod Screws

Cameras are locked to tripods with either of two tripod screws which are part of the tripod: the small so-called American type and the larger European type. Practically all 35 mm and medium format cameras are made to accept the American type. Better professional tripods come with both types and some medium format cameras have sockets for both.

MONOPODS

Excellent camera steadiness can be obtained with a *monopod*, which is easier to carry and quicker to set up than a tripod. A monopod may not guarantee sharp images at 1 second, but it is possible to obtain sharp results down to 1/4 of a second. Considering that it is convenient to carry, and can serve as a walking stick during a hike, and the short time required to set it up, it is well worth considering. Most photographers keep the monopod straight up, although that is not the best solution for camera steadiness. In that position the monopod is free to move in all directions.

The steadiest position for a monopod is when it forms the third leg in combination with the photographer's two legs and the camera is pushed firmly against the face. In this position, the two forces oppose each other. When the monopod is vertical, keeping it steady is difficult.

It is better to move its foot 2 or 3 feet forward and tilt the shaft toward you; that way, the monopod forms the third leg of a tripod, with your own legs as the other two. You can obtain a steady grip with your eye pressed against the viewfinder, elbows pressed against your body, and either both hands on the camera or one hand on the camera and the other on top of the monopod. Pull the camera and monopod toward your face and press the outfit forward into the ground with your viewing eye. Depressing the release is preferable to using a cable release.

Lens Design and Performance

The medium format camera best suited for your photography may be, and often is, determined by the lens or lenses. If you are in the market for a camera, consider the following features:

- type and make of lenses,
- range of lenses available,
- simplicity of changing lenses,
- convenience of reading the scales and operating the lens controls,
- extent and desirability of automation,
- lens quality.

LENS COST

Lenses are an expensive part of a good camera system; a single lens can cost more than the camera body. Medium format lenses may cost more than equivalent 35 mm lenses because everything—the lens elements, lens mount, and diaphragm—is larger, and increasing the size of a lens element increases the cost drastically. The medium format lens requires a larger piece of glass, and more time is needed to grind and polish the larger surfaces to perfection.

Selecting a high-quality lens is a wise decision, especially in the medium format. Most people probably select the larger format to get better image quality, so it makes no sense to sacrifice some of the benefits of the larger negative by using an inferior lens. Besides, the larger medium format negative or transparency will show up lens deficiencies more than

the 35 mm frame. The films available today are capable of resolving more detail than most of the lenses, so lenses, not film types, are the limiting factor in image sharpness. It simply does not pay today to sacrifice quality; the second best will never produce incredibly sharp images for you.

The natural conclusion: with the films of yesterday, differences in the quality of lenses were not so obvious or even visible. This is not so today. To be happy with your medium format camera system and to achieve competitive results, evaluate the quality of the lenses and the entire camera system very carefully. Since you undoubtedly moved up or will move up to the medium format for the improved image sharpness, the quality of the lenses and the proven precision in the camera and film magazines must be a major consideration in your selection of a camera system. As films likely will be further improved, purchasing a good quality lens and camera is the best investment for the future.

FOCAL LENGTH

Focal length is an optical characteristic built into the lens. Focal length is the same regardless of whether the lens is used on camera, enlarger, or projector. You do not change focal length by adding extension tubes or bellows (they simply move the lens physically farther away from the film

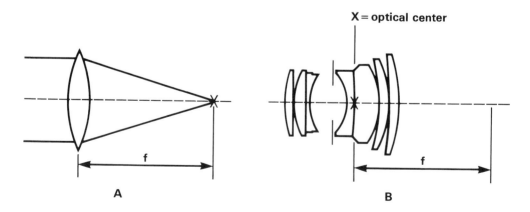

On a single lens, the focal length is the distance from the lens to the point where the lens forms an image of a subject at infinity (A). On a compound lens, the focal length is measured from the rear nodal point or optical center, which is known to the lens designer only (B).

plane) or by switching a lens from one camera to another or by using a lens for different film formats. For example, a 150 mm lens remains a 150 mm lens whether used on a 4 × 5 in., a 2 1/4 in. square, or 35 mm camera.

Focal lengths can be changed only by adding or removing optical components, such as a teleconverter. A Proxar or close-up lens is also an optical component. It changes the focal length, but to such a small degree as to be negligible. The purpose of adding close-up lenses is to allow photography at closer distances, as discussed in the chapter on close-up photography.

On zoom lenses, focal length can be changed within a certain range by moving some of the components inside the lens.

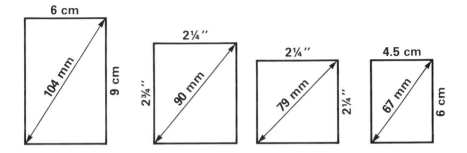

A standard lens has a focal length approximately equal to the length of the format diagonal. This is about 79 mm for a 2 1/4 in. square. The length of the diagonal, and thus the standard lens for the various medium formats, is shown here.

To classify lenses into standard, wide angle, and telephoto, consider the focal length in relation to the format. A lens is considered standard when the focal length is about equal to the diagonal of the picture format for which it is used; for example, an 80 mm lens is normal on a 2 1/4 in. square camera because the diagonal of the 2 1/4 in. square is 78 mm. Lenses with focal lengths shorter than the diagonal of the picture format are classified as wide angles, and those of longer focal lengths as telephotos.

ANGLE OF VIEW

The *angle of view*, as the name indicates, is the angle the lens "sees" when it is used on a specific camera. The angle of view can be related to the picture format in three ways: in relation to the diagonal, the vertical, or the horizontal side of the negative. On the 2 1/4 in. square format, the vertical and horizontal lengths are equal. For example, the 80 mm lens used with the 2 1/4 in. square has a horizontal angle of 38° and 52° diagonally. Used on the 4.5 × 6 cm format, the view is still 38° horizontally but only 46° diagonally and 28° vertically. Any lens that has a diagonal angle of approximately

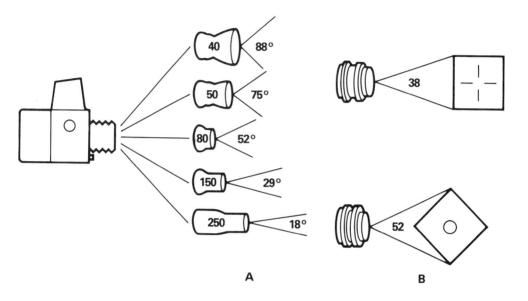

A B

The focal length of a lens in relation to the picture format determines its angle of view. The longer the lens is, the narrower is the angle of view for the same format (A). The angle of view an be expressed in relation to the picture diagonal or to the horizontal or vertical. The two are different (B).

50° is considered standard; when the diagonal angle is larger than 50°, the lens is considered wide angle, and when it is smaller, telephoto.

Lens makers commonly give diagonal angles of view. This makes sense for the lens designer because the lens produces a circular image that must cover the square or rectangular format. For practical picture taking, however, this figure is useless. As a photographer, you must think of horizontal or vertical coverage. What you normally want to know is what focal length is necessary to cover the same width on a smaller or larger negative. The angle of view can be calculated, but it is simpler to use the following chart.

The chart shows equivalent focal lengths for 35 mm; 2 1/4 in. square and 6 × 4.5 cm; 6 × 7 cm; and 4 × 5 in. The figures are based on the horizontal coverage (that is, the long side of the negative). As an example, to cover the same width of an area as an 80 mm lens on 2 1/4 in. square or 6 × 4.5 cm (angle of view 38°), you need a 52 mm lens on 35 mm, 100 mm on 6 × 7 cm, and 175 mm on 4 × 5 in.

EQUIVALENT FOCAL LENGTHS FOR DIFFERENT FILM FORMATS

	Focal Length of Lenses (mm)			
Horizontal Angle of View (degrees)	*4.5 × 6 cm and 2 1/4 in. square*	*35 mm (24 × 36 mm)*	*6 × 7 cm*	*4 × 5 in. (98 × 120 mm)*
84	31	20	38	67
72	28	25	48	83
69	40	26	50	87
65	43	28	54	93
62	46	30	58	101
58	50	33	63	109
54	54	35	68	117
49	60	39	75	130
40	76	50	96	167
38	80	52	100	175
36	84	55	105	183
32	100	65	125	218
30	105	69	131	229
26	120	78	150	261
24	130	85	163	283
23	135	88	169	295
21	150	100	190	330
15	206	135	259	450
13	250	163	314	545
10	306	200	383	667
9	350	229	439	763
7	458	300	575	1000
6½	500	327	627	1090

AREA COVERAGE

The angle of view determines area coverage. The area coverage for any lens is directly proportional to the subject distance. At twice the distance, a lens covers an area twice as wide; at half the distance, half as wide. A larger area coverage means that the subjects are recorded smaller.

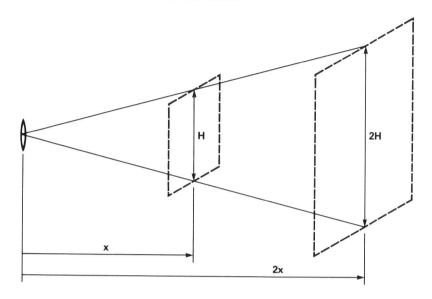

Area coverage at different distances can easily be calculated when it is known for one distance. At twice the distance, the lens covers an area twice as wide and four times as large in area.

COVERING POWER

Covering power is not the same as area coverage. Lenses are designed in the factory to cover a certain negative size. Since all lenses produce a circular image, this so-called covering power of a lens can be indicated by the diameter of the circle in which definition and illumination are satisfactory.

Covering power of a lens is the diameter of the circle within which satisfactory image quality and illumination are obtained.

The diameter of this circle must be at least as large as the diagonal of the image format for which the lens is designed, for example, 79 mm for the 2 1/4 in. square. Such lenses for the 2 1/4 in. (55 × 55 mm) square are designed to produce the promised image quality and corner illumination on the 2 1/4 in. (55 × 55 mm) square and not necessarily beyond. They are not likely to perform properly for the larger 6 × 7 cm format. The *covering power* is a function of the format for which the lens is designed, not the focal length. For instance, 50 mm lenses can be designed to cover nothing larger than 35 mm, or the larger 2 1/4 in. square, or 4 × 5 in., and perhaps even larger format cameras. If lenses designed for a small format camera are used on a larger format, the corners are beyond the covering power of the lens, so they may be completely cut off, or the illumination and image quality in the corners may be unsatisfactory. Lenses designed for a large format camera, however, can be used for a small format camera; for example, lenses designed for 4 × 5 in. could be used for the 2 1/4 in. format, and medium format lenses can and are being used on 35 mm cameras with adapters.

LONG TELEPHOTOS AT CLOSE RANGE

As the focal length increases, so usually does the minimum distance at which the lens can be focused. The relatively long focusing distances of telephoto lenses give some photographers the impression that these long lenses are meant for long distance photography only. This is not so. The focusing distances are limited for mechanical design reasons, but telephoto lenses can be used at all distances and at closer range in combination with close-up accessories, Proxars, or extension tubes.

MAXIMUM APERTURE

The *lens aperture* determines how much light reaches the film at a given moment. The f stop number is the focal length of the lens divided by the working diameter of the lens. It used to be said that the working diameter was the diameter of the front element. This is the case on some lens designs but not on others. The working diameter is the diameter of the entrance pupil, a measurement known only to the lens designer.

TRUE TELEPHOTO

It is common in photography to classify all lenses with a focal length longer than normal as tele or telephoto lenses. In the optical field, such lenses are separated into long focal length types and optically true telephotos.

An optically true telephoto lens (A) is physically shorter than its focal length. The point from which the focal length is measured is in front of the lens. Practically all long focal length camera lenses are of the optically true design. In a retrofocus design (B), the rear nodal point from which the focal length is measured is not inside the physical dimension of the lens but behind it. The retrofocus wide angle design (C) is necessary on an SLR camera. The rear element of the lens is far enough from the film plane to clear the mirror. An optically true wide angle (D) does not provide this space.

An optically true telephoto is a specific design of a lens with a positive front and a negative rear section. The principal plane, from which the focal length is measured, is not within the physical dimension of the lens but somewhere in front of the lens. The advantage of the true telephoto is that the physical length of the lens can be much shorter than its focal length, so these lenses are shorter, lighter, and easier to carry and use. Because of these advantages, practically all long focal length lenses used in photography are optically true telephotos.

RETROFOCUS LENSES

From an optical design point of view, there are also two types of wide angle lenses: retrofocus and optically true wide angle. In an optically true wide angle lens, the rear nodal point from which the focal length is measured is

within the physical dimension of the lens. This is the original wide angle design that is still used today on view camera lenses.

For the very best in corner-to-corner sharpness, for architectural, product, or scientific photography with a super wide angle, or for photogrammetric applications that require view camera quality without distortion, true wide angles should be considered. They produce superb image quality that is maintained at close distances. They are therefore also good lenses for photographing large documents. Such wide angle lenses are, however, found only on special wide angle cameras; they are not available for mounting on SLR cameras.

On SLR cameras, the mirror needs space to swing up and down between the lens and film. Lenses cannot be too close to the film, For this reason SLRs cannot accommodate true wide angle lenses. Lens designers have found a solution by designing retrofocus lenses in which the rear nodal point is behind the lens. Practically all wide angles, and definitely those of shorter focal length, on all 35 mm and medium format SLR cameras are retrofocus types.

Because wide angles are mostly used for long shots, retrofocus lenses are designed to produce the best image quality at long distances. There is a visible loss of sharpness, especially at the edges, when the lenses are used at close distances, so these lenses are not recommended for that purpose, at least not at large apertures. Closing down the diaphragm will restore some of the loss of sharpness.

In a floating lens design, you move some lens elements separately (B) to improve image quality in close-ups. When you focus, the entire lens moves (A).

FLOATING LENS ELEMENT

In recent years lens manufacturers have been trying to improve the close-up quality of retrofocus-type wide angle lenses and have succeeded by incorporating what has become known as a *floating lens element*. When an ordinary lens is focused, all elements move together at the same rate. In the floating element design, you move one or several elements of the lens separately. It is somewhat like a zoom lens where you move some elements when changing the focal length.

On some retrofocus wide angles, the floating elements move automatically when the focusing ring is turned, requiring a rather complicated lens mount design. Other retrofocus lenses have a second focusing ring that operates the floating part. This is a less costly design and has no disadvantages except that you need to adjust both focusing rings before shooting. You adjust the floating element ring first for either long or medium distances or close-ups; then you do fine focusing with the regular focusing ring.

LENS NAMES

The names of most lenses today simply refer to the manufacturer rather than the lens design, as in the past. Years ago when most lenses were designed and made in Germany, the lens design determined the lens name, which often was the name of the designer (Gauss). When the designer came up with a new development, he gave the lens a new name. As a result, lenses made by the same manufacturer for the same camera may have different names, such as Planer, Sonnar, and Tele-Tessar. Also, different makes of cameras might have been supplied with lenses of the same name. European lens manufacturers still use this system today. There is no specific advantage to the photographer except perhaps that the lens design is specified. For example, if the lens has a Distagon name, it is a retrofocus type. If it is engraved *Biogon*, it is an optically true wide angle.

TELECONVERTERS (TELE-EXTENDERS)

Teleconverters are negative optical components consisting of at least four lens elements. They are mounted between the lens and camera like an extension tube and thus move the camera lens farther from the film plane.

The negative lens components in the tele-extender move the image back to the film plane. Teleconverters can be used with various focal length lenses. They increase the focal length of the lens used in front of them. Any 2× extender doubles the focal length, so, for example, a 150 mm lens becomes a 300 mm. Any 1.4× extender increases the focal length 1.4 times. Instead of purchasing a lens with a longer focal length, you can

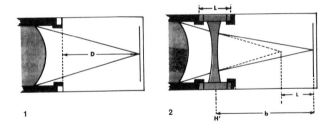

The lens without tele-extender forms an image on the film plane, distance D from the lens mount (1). A tele-extender moves the lens forward by the distance L, the length of the extender. The image formed by the lens also moves forward for the equivalent distance. The negative lens components in the tele-extender disperse the light rays so the image again falls on the film plane (2).

purchase at less cost a tele-extender, which you can then use to increase the focal length of all lenses.

You cannot make such an addition without losing something, and the main sacrifice is the loss of two f stops for a 2× converter. For example an $f4$ 150 mm lens becomes a 300 mm $f8$. You lose one f stop with a 1.4× converter.

When lens components are added to a lens, image quality changes. How much depends on the quality of the teleconverter and the quality of the lens with which it is combined. A prerequisite for achieving good image quality with any teleconverter is using a high quality camera lens in front of the converter. A lens of questionable quality is likely to produce unsatisfactory results when used with any converter.

A teleconverter's performance is also determined greatly by the design of the lens with which it is used. Design varies from one lens to another, so it is impossible to make a general comment. It can be said, however, that if a converter is available from the same company that makes the lenses you use, it is likely to perform better since it is designed with these lenses in mind. Such a converter can produce an image quality that is equal, or almost equal, to that of a prime lens, especially the longer focal length lenses with which it is usually combined. Such a tele-extender may have as many as or more lens elements than a prime lens.

If there is an image quality falloff, it is mainly at the edges and may not be objectionable (in portrait photography, for instance). You can improve the quality by stopping down the lens.

ZOOM LENSES

Zoom lenses, very popular in 35 mm for both amateur and professional work, are also available for medium format cameras. They are, however,

not used extensively, never as all-purpose all-around lenses as is fairly standard in 35 mm amateur photography. The reasons: to produce good quality on the larger format, the lens design requires a large number of lens elements, and the elements have to have large diameters. The lenses are, therefore, costly to produce for the medium format. The elements have to be mounted into a large, long, and heavy lens barrel. The weight and size of such lenses reduces the mobility of the medium format camera and may make handheld operation practically impossible.

The focal length of a zoom lens is changed by moving some of the lens components (A and B) while turning the zoom ring. Effective aperture does not change, and in the case of an optically true zoom, the image remains in focus.

Likely to be of a larger diameter than their 35 mm counterparts, medium format zoom lenses also require large filters, shades, and other accessories. In addition, the zoom range is limited, frequently not exceeding 2:1, and the maximum aperture is likely less than the aperture of fixed focal length lenses of equivalent focal length.

Optically True Zooms

Better zoom lenses are of the optically *true zoom* type. That means they remain in focus while zooming. On less expensive zooms, especially those used on projectors, the image moves out of focus when the focal length is changed. So each time you change image size, you have to refocus. I consider this extra step unacceptable. Although an optically true zoom stays in focus, always focus the image on the ground glass with the lens at the longest focal length, regardless of what focal length you actually will use.

At the longest focal length, the image is at its greatest magnification, the depth of field is at the minimum, and focusing is, therefore, most accurate.

You can find zoom lenses today that closely match the sharpness of a high-quality fixed focal length lens. The quality, sharpness, distortion, and illumination naturally vary from one focal length to another. If you want to evaluate a zoom lens, you must test it at different focal lengths.

Close-ups

Some zoom lenses have macrofocusing, but at macro, zooming is no longer possible because the zoom ring is locked at one focal length, usually the wide angle.

If you want to maintain zooming in the close-up range, however, you must invest in a Proxar or close-up lens. They are the only close-up accessories usable with most zooms, and are described in Chapter 13. Extension tubes do not work with most zoom lenses because they change the back focus (the lens seat to film plane distance) so that the subject does not stay in focus when the focal length is changed.

FISH-EYE LENSES

Fish-eye lenses are constructed to produce curved images of all straight lines that do not pass through the center of the image. The effect is exaggerated barrel distortion, resulting in curved images that can be strangely beautiful. To most photographers the typical fish-eye image is a round circle covering only the central area of the frame. That is one type of fish-eye image produced by one type of fish-eye lens. The effect can be striking, but it is largely the circular image that attracts attention. The subject, usually reproduced on a tiny scale, is often secondary. But the fish-eye effect wears off quickly, and the pictures start to look alike. The possibilities for cropping are slight, and therefore, such lenses have very limited applications.

On a full-frame fish-eye lens, the 180° diagonal angle of view is completely out of proportion to the 112° horizontal or vertical angle. This is what makes the lens different from a regular wide angle and gives the images the curved lines. Diagonally, the 180° coverage is twice as much as the 88° or 90° of a wide wide angle.

There is another type of fish-eye lens which covers the entire format with no visible light falloff in the corners. The focal length is still long enough to produce a relatively large image in the center, yet the lens also embraces surrounding subjects from corner to corner, usually within a 180° field. Since the entire image format is used, part of the image can be used and enlarged. The distortion of the fish-eye lens is completely unrelated to sharpness. Good sharpness is obtained from corner to corner even with the lens wide open.

Fish-eye lenses with a 180° diagonal angle of view do not allow you to use a shade. A shade (C) may be part of the lens. The lenses also do not allow you to attach filters to the front. The lens may be designed to take filters (B) inside the lens after you detach the front section (A).

The 180° diagonal angle of view of most fish-eyes does not allow you to place any accessories, filters, or shades in front of the lens because they would cut into the field of view. If you need to use filters, you need to have a fish-eye lens that allows you to attach filters inside the lens. The front section on such a lens is completely removable, and small filters can then be attached to the front or rear section. In such a design, the filter is actually part of the lens. This means that the lens must always be used with a filter or a clear glass of the same thickness; otherwise image sharpness suffers.

LENS QUALITY

The quality of any complete lens is not determined by the number of elements it comprises but by the skill of the designer in combining the minimum number of elements to produce the best quality lens, using the latest design techniques and types of glass. The quality of the final lens is determined even more by the accuracy with which each lens element and each mechanical component of the lens mount is made and assembled and how carefully and thoroughly the finished lens is tested.

The overall sharpness or quality of a lens used to be, and still is in many cases, expressed by *resolution*: the number of lines per millimeter a lens is capable of reproducing as separate lines. Lens and photo technicians have found, however, that image quality in a photograph is not so

much determined by the resolution of fine detail as by the manner in which the more easily perceptible, larger structural elements in the picture are reproduced. This is more a question of contrast rendition. Edge sharpness (called *acutance*), not resolution detail, is what gives a photograph the appearance of sharpness.

The quality of a photographic image is not so much determined by the number of lines that are resolved, but by the edge sharpness, which is called acutance. High acutance means a sharp line between white and black or two different colors. With a low acutance lens, there is a gradual transition between the two.

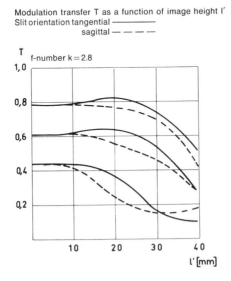

An MTF diagram shows contrast transfer curves for three spatial frequencies: 10 (top), 20 (middle), and 40 line pairs per mm (bottom). The solid line shows the contrast transfer of sagittal surface, the dotted line the tangential image surface.

Modulation transfer T as a function of image height l'
Slit orientation tangential — — — —
 sagittal ─────

White light
Spatial frequencies R = 10, 20 and 40 periods/mm

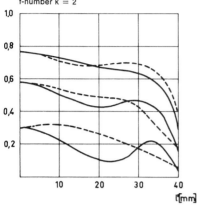

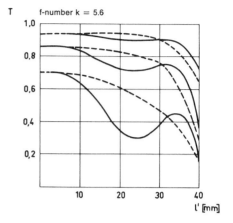

Modulation transfer T as a function of image height l'
Slit orientation tangential ─────
 sagittal — — — —

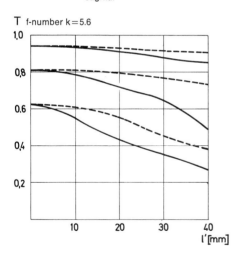

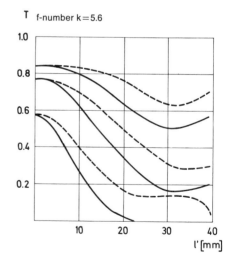

The acutance of lenses is published in MTF diagrams. The center of the image is
at the left and the corner at the right. These diagrams allow a quality comparison
among different lenses (bottom) or at different apertures (top).

The image-forming qualities are expressed through the rendition of
contrast with modulation transfer function (MTF) diagrams. Unfortunately,
MTF diagrams are not readily available from most lens manufacturers.

IMAGE QUALITY

Image sharpness improves as the lens is stopped down; however, beyond certain limits, the nature of surrounding light affects the sharpness of the image. Light pouring through a small opening such as the minimum aperture of a lens spreads slightly at the edges, an effect known as *diffraction*. On high-quality lenses, however, the minimum aperture is usually limited to a point where the degradation of the image is not noticeable. You need not be concerned about closing the aperture too far and losing quality, so do not hesitate to stop the lens down completely if you need a small aperture for the required depth of field. The lack of sharpness caused by limiting the depth of field would be more noticeable than the loss of overall definition caused by diffraction.

As a general rule, the best image quality appears two to three f stops below the maximum ($f5.6$–$f8$ for an $f2.8$ lens). If a lens aperture must be closed more than two f stops to obtain corner to corner quality, I consider it a poor lens. There are also lenses that have superb corner sharpness already wide open. A film test is the only practical way to determine the quality of a lens.

Making your own film test is not a nuisance; it is the most reliable quality measurement. Such a test takes into account not only the performance of the lens itself but other sharpness-determining elements as well, especially the film flatness in the camera.

Load the camera with the highest resolution film that you can find. This is probably a low-speed, or special type, black-and-white or color transparency film. I have found that sharpness differences can be seen easier on black and white than on color. Photograph a subject with fine detail. Brick walls always come to mind first, but they actually are poor subjects. The brick itself has little fine detail, and the contrast range is very narrow. You need high contrasts for easy evaluation, such as white window frames against darker walls, a black railing in front of a light building in the distance, newspaper pages, or good lens test charts at close distances.

While you make the test, test the lens at different apertures and in the center and at the edges.

To conduct a reliable test, you must keep a few other points in mind:

1. When comparing lenses of different focal length, move the camera to different distances so each lens covers the same image area.
2. Make certain that each negative or transparency has exactly the same exposure and development.
3. Make certain that the test target is lighted evenly and identically for each lens you test.
4. The test target must be flat or the subject far enough away so you need not worry about depth of field. The film plane must be parallel to the test target.
5. Eliminate any possibility of camera motion.

Always evaluate the actual negative or transparency with an 8× or 10× magnifying glass. Never evaluate prints made from a negative or slides projected on a screen because too many other factors can enter in and distort the results. Evaluate the center and corners.

COLOR CORRECTION

Most photographic lenses are *achromatic*, which means that they are corrected for two colors. This is good enough for most photography.

Apochromatic lenses are corrected for three colors and show an improvement in reproduction of fine detail. For this reason, they are often used for high-quality copy reproduction and for color separation work. In most other work, you would have to be extremely critical to appreciate the quality improvement. Apochromatic lenses may also be corrected so infrared radiation (from 700 to 1000 μ) falls on the same film plane as visible light, which is not the case with "ordinary lenses." Such infrared corrected lenses do not require the focusing adjustment necessary with ordinary lenses and thus simplify infrared black-and-white photography.

Apochromatic lenses usually have one or more lens elements made from fluoride to make the improved color correction possible. Fluoride is affected by temperatures and actually changes with temperature more than regular glass does. The change affects the distance setting, which is why on such lenses, the focusing does not stop at infinity; it goes beyond. Always focus the image visually on the ground glass, even if the subject is at infinity.

MULTICOATING

For over forty years, good photographic lenses have been coated, meaning that glass-air surfaces are covered with a thin layer of a fluoride, which reduces the amount of light reflected from a lens.

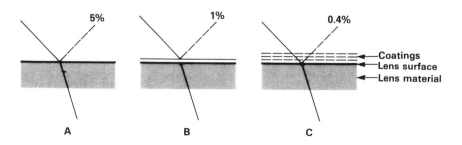

An uncoated glass surface reflects about 5 percent of the light (A). Coating (B) and multicoating (C) reduce the amount of reflected light, resulting in a reduction of flare. Actual benefits depend on lens design.

When light hits an uncoated glass surface, about 5 percent is reflected. What happens to the reflected light? It probably reaches another lens surface and is reflected back to another lens or part of the lens mount. The reflected light causes *flare*, a haze over the image that reduces contrast. In a multicoated lens, each element has several coatings, each of a different thickness, so that each coating eliminates the reflection caused by a different wavelength of light. With multicoating, light transmission is increased, and the reduction in flare can be significant.

Reduction of flare, however, depends greatly on the design and focal length of the lens. The improvement provided by multicoating is more noticeable on wide angle lenses and least noticeable on lenses of longer focal lengths. Multicoating is most helpful when you are photographing against white backgrounds or directly into a light source when a lens shade cannot protect the lens. In all other cases, a good lens shade is more important and can do more than multicoating to prevent flare.

LENS SHADES

Multicoating has not reduced or eliminated the need for lens shades. They are still important for achieving maximum contrast, especially when you are photographing toward light sources or against white backgrounds or bright areas in general (including overcast white skies, water, sand, and snow). Regardless of what camera, type, and focal length lens you are working with, equip it with the best possible shade, even if this means purchasing a separate shade for each lens. Sunshades can also protect a lens from possible physical damage and from rain or snow.

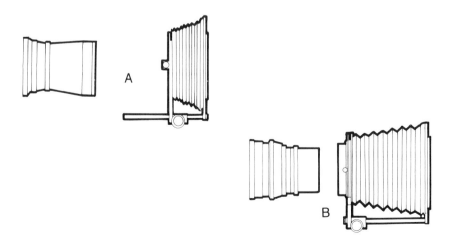

A bellows shade can be extended more or less to provide maximum shading for different focal length lenses, from wide angle (a) to telephoto (b). The bellows shade may have a slot for inserting gelatin or square resin filters.

The shape of the shade should also be considered. Square or rectangular shades are more effective because they correspond to the image format. Round shades are less effective.

Regular metal or plastic shades are the most compact types. For most medium format cameras, you can also buy shades with a flexible bellows; these are usually referred to as professional lens shades. They provide better shading of the front element. The bellows can be extended to suit the focal length of the lens. Therefore one shade can be used for a wide range of lenses of different focal lengths. The permissible maximum extension may be engraved on the rail of the shade.

Although you should use the longest possible shade for each lens, also make certain that it does not vignette the corners of the image. Usually a check on the ground glass is sufficient; a film test, photographing evenly lit surfaces, is better. In either case, make the test with the lens completely closed down because vignetting in the corners becomes more visible at small apertures.

A bellows shade can also make a good holder for masks, vignettes, and other special effect devices that must be placed a few inches in front of the lens. A bellows shade, furthermore, may have an arrangement for fitting gelatin or other square filters. The higher cost of the bellows shade is therefore justified.

RELATIVE ILLUMINANCE

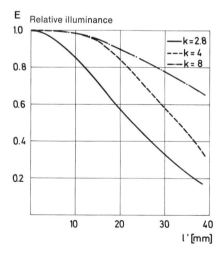

The relative illuminance of lenses can be illustrated. This graph shows that the center of the image has a greater relative illumination (left) than the corners of the image (right). The three lines represent different apertures.

Every lens has a lower illuminance at the edges. Wide angles have a higher falloff than normal lenses and telephotos. The difference between center and corner can amount to one or two f stops. This is unacceptable in serious photography because the difference is visible and objectionable. A difference up to one half of an f stop is not objectionable. Unfortunately, illumination curves for lens types, like MTF diagrams, are published by only a few lens manufacturers. So illuminance falloff is something you must determine by doing a film test. Unlike sharpness, light falloff is more easily recognized on color films. Illumination changes with the aperture and must therefore be evaluated with the lens wide open and closed down.

COLOR RENDITION

Many types of glass used in modern lenses are not absolutely clear but have a color tint and, therefore, act as a color filter. Although the eye adjusts easily to different colors when viewing individual images, when you photograph the same subject with different lenses it is important that color rendition matches in the lenses. When colors do not match from one lens to the next, you cannot combine the images or project one after another because the slight color variations become objectionable. If you use lenses of the same make, it is more likely that the colors will match.

DISTORTION

Distortion is the lens's inability to record straight lines as straight lines over the entire film area. If the lens has distortion, straight lines near the edges appear curved either inward (*pincushion distortion*) or outward (*barrel distortion*). In some photographic fields, such as portraiture, the degree of correction is less critical than in architectural, product, and scientific photography. Even slightly curved lines on a skyscraper are noticeable and distracting and certainly unacceptable in professional architectural work. If you are doing this type of photography, you need to determine distortion by conducting a film test, because distortion curves are difficult to obtain from lens manufacturers. For the test, photograph a subject with straight lines so that the straight lines are very close to the vertical or horizontal edges of the frame. This test can be done at any aperture because distortion does not change when you close or open the diaphragm.

Retrofocus-type wide angle lenses have more distortion than the optically true wide angles, which architectural photographers use on view cameras. If you want to use a medium format camera to do architectural work or any other photography where distortion is unacceptable, you may want to use one of the special cameras equipped with an optically true wide angle lens.

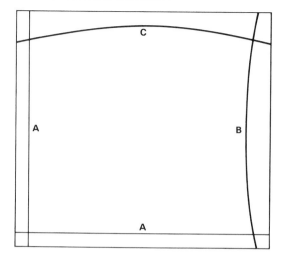

A lens corrected for distortion records straight lines straight over the entire image area (A). Insufficient distortion correction shows up as curved lines near the edges. An inward curvature is referred to as *pincushion distortion* (B) and an outward curvature is known as *barrel distortion* (C).

Photographers call various other effects in a photographic image distortion and usually blame the lens. When subjects that were closer to the camera, like the nose in a portrait, appear too large in proportion to the rest of the image (the eyes and ears, in this case), the short focal length of

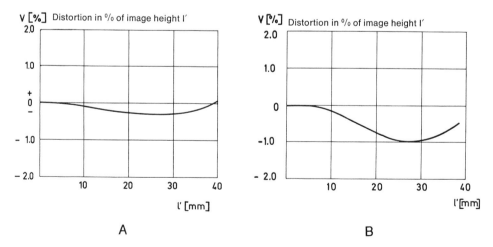

In a lens designer's diagram, distortion is shown as a percentage of image height. The two diagrams show the difference in distortion between an optically true wide angle lens (a) and a retrofocus lens (b).

the lens is usually blamed—and incorrectly. This so-called foreshortening is caused by shooting from too close. The problem is caused by the distance, not by the lens.

Slanting Lines

Slanting vertical lines—on a building, for instance—are caused by tilting the camera. This is not a fault in the lens or camera; it is a normal way of seeing. When you look up at a skyscraper, you will see that the lines converge as they recede into the distance. A wide angle lens can enhance the slanting.

Perspective Control Lenses

Recording straight and parallel verticals is simplified or made possible with the use of perspective control (PC) lenses or PC teleconverters that are used in combination with regular wide angle lenses. Such lenses or converters allow shifting the optical part of the lens up or down in relation to the optical axis.

To straighten verticals, shift the lens up or down until the entire subject is recorded on the film (until the top of the building is in the film area) without tilting the camera. It is possible to use the same control sideways if the PC lens has both controls or by turning the camera sideways.

The range of movement of the lens or teleconverter is limited by the covering power of the lens and also because of mechanical reasons, so perspective control probably will not cure all situations, especially in architectural applications. A PC lens or converter, however, can solve many shooting problems that otherwise would require a view camera.

Wide Angle Distortion

Another type of distortion occurs when three-dimensional subjects are photographed with wide angle lenses. The objects near the edge of the picture appear wider than those in the center. For example, when you shoot a group of people, the distortion is created partially because the lens views the people in the center of the group from the front, and those at the outside from the side. A second reason for wide angle distortion is that the film plane is flat rather than curved. A perfectly round bowl thus appears stretched out when geometrically projected on a flat plane. This so-called perspective distortion happens with all lenses and is not the fault of the lens. The distortion becomes obvious only with wide angles; the distortion with a 50° angle of view lens is only 10 percent but increases to about 40 percent with an 85°–90° wide angle.

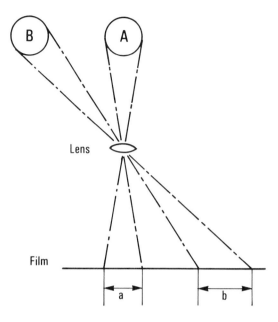

Wide angle distortion is caused by the film being flat. A round subject at the edges (B) becomes elongated when traced onto the film plane. Distance (b) is greater than distance (a) for the same round circle in the center.

When you are photographing groups of people or products, wide angle distortion is further emphasized because the lens photographs the side of the head of people standing on the sides (B), while it photographs the front of the face of those standing in the center (A). You can greatly reduce the distortion by turning the people or the products to the side so that the lens also sees the front of the face or object (C).

Even a 10 percent distortion can be objectionable in some types of photography—for example, in commercial photography when known symmetrical objects are shown at the edges or in photographs of an architectural interior. The solution is to frame the area so that such objects are away from the edges of the photograph. In group pictures, the people at the edge should be turned toward the center or they should be arranged in a curve so all are photographed from the front.

CHAPTER **9**

Lenses and Lens Controls for Creating Images

Focal length determines area coverage. The shorter the focal length is, the wider the coverage. Wide angle lenses thus can be used to cover a larger area without your having to move the camera; telephotos allow you to photograph and thus enlarge a distant detail.

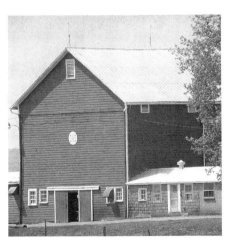

The area coverage of a 1000 mm focal length (500 mm + 2× teleconverter) compared to a standard 80 mm focal length.

Changing lenses is frequently more convenient than moving the camera, especially if it is on a tripod. Often it is the only possibility; for example, the size of a room may prevent you from moving farther away. Lenses can do much more than just cover larger or smaller areas. They are major tools for creating effective, beautiful, unusual, and interesting images.

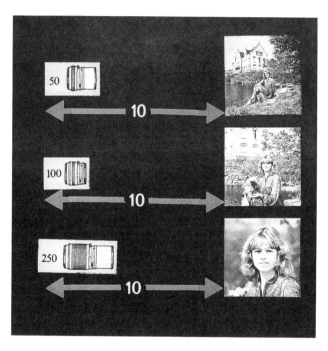

Because different focal length lenses cover different sized areas, you can take a long shot, a medium shot, and a close-up without moving the camera by changing from wide angle to standard to telephoto.

PERSPECTIVE

Perspective refers to the size relationship between subjects close and far away. With our eyes, area coverage and perspective do not change. The normal focal length lens records images in a perspective quite close to what we see with our eyes. That is the main reason for calling it *normal*. If you want to create images as we see the world, photograph the scene with a standard lens. In legal photography, for instance, it is important that the scene be presented in court in the normal perspective. A distorted perspective might present objects to the court in a completely different light.

In photography we can change the size relationship between foreground and background by changing the camera distance, then switching

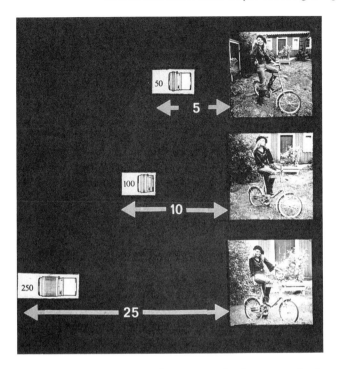

Different focal length lenses (wide angle top, standard center, telephoto bottom) can be used from different distances so the foreground subject is recorded the same size. The background subject is larger and appears closer in the standard and telephoto pictures.

the camera lens to maintain the size of the foreground subject. The background then becomes larger, appears closer with a longer lens, or smaller and further away with a wide angle.

Rooms photographed with a wide angle lens appear longer because the furnishings in the back appear smaller. With telelenses, background subjects are recorded larger; they appear closer, and perspective is compressed. A car photographed in this way, for instance, appears shorter than as we see it with our eyes. Long telephotos are perhaps the greatest tool to give outdoor scenes a special look.

With wide angles used from a close distance, the subjects in the foreground are oversized in relation to the rest of the image. Including foregrounds—especially small subjects such as flowers and leaves—at very close distances, must be an important consideration when composing wide angle shots. These foreground elements can make wide angle pictures very exciting and different. They add the feeling of depth.

Perspective is determined by the viewpoint (the camera position)—not by the focal length of the lens. But different focal lengths are needed to cover a certain foreground subject size from either close or far away.

Distance determines the size relationship between foreground and background (perspective). When a wide angle lens is used from a close distance, the foreground subject appears much larger in relation to the background (above), and the background subject appears to be farther away than it does when it is photographed with a telephoto (right). A standard lens records the scene as we see it with our eyes.

To make the discussion complete, I must mention that the perspective in a print or a projected transparency also depends on the viewing distance.

Every photographic image is seen in the correct perspective when the viewing angle corresponds to the angle at which the image was photographed. This would mean that you need to view wide angle pictures from a closer distance than those taken with telephotos. Since we normally view all projected slides or all prints of a certain size from the same distance, that is, under the same viewing angle, the different perspective in wide angle and telephoto pictures is maintained when viewing prints or projected transparencies.

FORESHORTENING

The exaggerated size of foreground subjects, also referred to as *foreshortening*, is frequently referred to as distortion. Often the lens is blamed for

this effect, but foreshortening is caused by photographing a subject from too close a distance; thus the photographer, not the wide angle lens, should be blamed for this effect. Although this type of perspective can be very striking, it can also be distracting or even unacceptable, especially with portraits. Photographing a person from less than 3 ft. makes his or her nose, the feature of the face closest to the camera, appear too large in relation to the eyes and ears. To avoid this problem, select a short telephoto so you can take the portraits from a longer distance.

SELECTIVE BACKGROUNDS

Backgrounds are a very important part of most images, and the effectiveness of many photographs and slides is determined mainly or completely by the background. Different focal length lenses can be used to change the background area without changing the size of the foreground subject. Unfortunately this technique is often neglected by photographers.

Instead of photographing a subject with a standard lens from, say, 10 ft., you can photograph it with a 150 mm telephoto from about 18 ft. The size of the subject remains the same, but the background area becomes smaller.

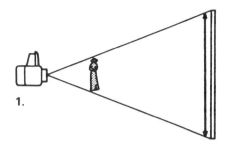

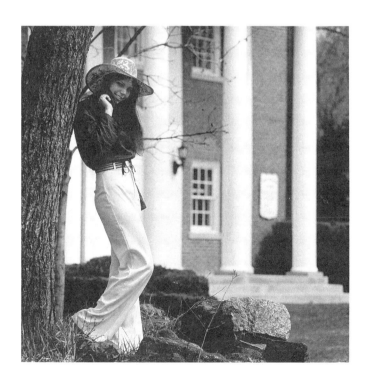

Left, top: By using different lenses, you can cover smaller or larger background areas without changing the size of the main subject. A short lens from a short distance (1) covers a large background area. A longer lens from the necessarily longer distance (2) covers a smaller background area. The size of the main subject is the same with both lenses.

Long lenses permit us to cut down background areas and eliminate distracting background elements, such as billboards, cars, people, or direct light sources. Longer lenses are valuable in the studio because they allow you to use smaller backdrops. In a formal outdoor wedding picture or portrait, the longer lenses may be preferable because they produce a small, blurred, undisturbing background. In a candid shot, however, creating a large background may be desirable as a means of identifying the location. By photographing the wedding couple with a wide angle, you might be able to have the entire church in the background, not only the entrance steps. Do not hesitate to use a wide angle in such an application if it yields the desired background coverage.

The 150 mm telephoto includes only a small part of the church in the background (left, bottom). With the 50 mm wide angle, you can see almost the entire church while the model in the foreground is the same size and is standing in the same place (below).

VERTICALS

Vertical lines—the lines of a building, for instance—appear in the finished picture vertical and parallel to each other only if the camera was level when you pressed the release. As soon as you tilt the camera up or down, the verticals begin to slant toward each other. Such an effect can be disturbing, or interesting visually, depending on how much you tilt the camera. Tilting the camera slightly up for no reason other than to get the whole building in the picture is a poor use of the camera. The result looks like a mistake. Either hold the camera level or tilt it excessively so your audience gets the feeling it was done purposely. Slanted, diagonal lines can produce exciting and moving images.

Slanted verticals happen with all lenses. The shorter focal length lenses simply add to the effect. This means that with short focal length lenses, leveling is more critical and must be done more accurately. Vertical and horizontal guidelines on the ground-glass screen can help, but because the image on the screen is enlarged only about three times, even this help may not be sufficient for critical work. A spirit level is the

Including an effective foreground can make the wide angle shot more attractive and eliminate the need for cropping the bottom.

tool that can help you be more accurate in leveling your camera. If one is available as an accessory for your medium format camera or even built into the camera, use it.

There are various other ways of obtaining straight verticals. Use a wider angle lens that will cover the top of the subject so that you do not have to tilt the camera. As long as the film plane is parallel to the subject you are photographing, the lines of your photograph will be straight and parallel. A wider angle lens, however, also covers more on the bottom—perhaps too much to make a pleasing picture. You can later crop out the bottom, perhaps making a horizontal out of the square image. If possible, try to have an interesting foreground—a flower bed perhaps—at the bottom of the picture, so that cropping will not be necessary.

Another way to fill the foreground is to have a major subject, such as the lamppost, extending from the bottom of the picture to give the feeling that the image "had" to be composed in this fashion.

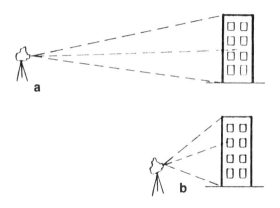

The longer focal length lens used from a longer distance requires less tilting of the camera to cover the same area as a shorter focal length lens does from a shorter distance.

A more effective solution, when it is possible, is to use a longer lens from a longer distance. This allows you to cover the same area without needing to tilt the camera as much or even at all. If you cannot move farther away from your subject, try to raise the camera. Carry a small stepladder so you can shoot from higher than eye level. Raising the camera just 2 or 3 ft. can make a great difference with extreme wide angle lenses. Professional architectural photographers use this technique for shooting architectural subjects, especially interiors, with a medium format camera.

Another possibility is to attach the medium format camera body and magazine to a view camera body using special adapters that are available for some view cameras. This technique allows you to use swings and tilts while

recording the image on roll film, and you still have the benefit of the SLR's ground-glass viewing and focusing. To get the full benefits from medium format view camera photography, study a good book on large format photography so you understand how these cameras are used and operated.

With negative films, verticals can be straightened when prints are made by tilting the easel, perhaps combined with tilting the negative carrier in the enlarger.

PC LENS CONTROL

Another and professionally the best and most versatile method for straightening verticals is with PC lenses or PC teleconverters. In either case, the lens is shifted up, down, or sideways, parallel to the film plane, so that it covers more of the subject on the top, bottom, or side without the need for tilting the camera. Since the film plane remains parallel to the subject, the lines recorded on film are straight and parallel.

PC teleconverters have the advantage of being usable with the camera's existing lenses and usable with lenses of different focal lengths. The focal length of the lens, however, is made longer (probably 1.4×) by the teleconverter. An extreme wide angle lens becomes just an "ordinary" wide angle; a 40 mm focal length is changed into 56 mm.

With a PC lens, on the other hand, all your pictures must be made at the focal length of that particular lens.

CREATING IMAGES WITH ZOOM LENSES

A zoom lens gives an unlimited range of focal lengths between the minimum and the maximum focal length.

In sports, action, and news photography, the use of a zoom lens reduces or eliminates the time-consuming chore of changing lenses. There is also the problem of what to do with the lens that is removed and where to put it. While a lens is being changed, your camera is unusable, and meanwhile the most startling action may be taking place. With a zoom lens, you can change the focal length without disturbing the lens setting, so you are always ready to shoot.

Zoom lenses not only duplicate the uses of fixed focal length lenses; they also have the unique capability of creating images that are completely different from the way we see the world. These images are created by zooming while the shutter is open. The change of image size is recorded on the film in the form of streaks, which can go from the center to the outside, or vice versa. The streaks extend toward the outside when you zoom from the short to the long focal length because image size increases. Going from long to short, the image becomes smaller, so the streaks radiate toward the center. The image recorded on the film also depends on other factors. If you alter the focal length for the entire exposure

time, the image consists of streaks only; the subject itself is hardly visible. Most zoom shots are more effective when the subject can be recognized and is simply surrounded by streaks. To produce this effect, keep the focal length at a fixed setting (usually at either the shortest or longest setting) for about half of the exposure time, and change focal length only during the second half. If the total exposure time is 1 second, wait about 1/2 second before moving the zoom control.

Effective zoom shots require subjects with bright areas because these are the areas that produce the streaks. The streaks produced by the highlights are most visible if they cross darker image areas. You can vary the length of the streaks by zooming over the entire focal length range (for long streaks) or over only a part of the range (for short streaks). Fast zooming produces faint streaks, and slow zooming more pronounced ones. Exposure time must be long enough so that you are able to rotate or move the zoom ring during the time the shutter is open. It is possible that 1/8 second may be sufficient, but the results may be questionable; 1 second gives you greater control. Obviously, you need a tripod for these long exposure times.

FISH-EYE LENS PHOTOGRAPHY

While circular fish-eyes have limited use as creative tools, the full-frame fish-eye lenses do. The beautiful curved lines they produce are an attention-getting device, making every fish-eye image different from the way we see the world. The curved lines also make an image that is more moving and dynamic than straight horizontals or verticals. When using a fish-eye, try to compose the curved lines to enhance the visual effect and excitement of your subject.

With a full-frame fish-eye design, lines need not necessarily be curved; images need not have the "distorted" fish-eye look. All straight lines that intersect the center of the field are recorded as straight lines.

In scenic pictures the fish-eye look can be avoided, or at least reduced, if you aim the camera so that the horizon crosses the center of the field. An image of trees in a forest can look like a wide angle shot if you point the fish-eye lens toward the sky and you compose the shot so that the tree trunks go from the corners toward the center. Circular subjects centered on the focusing screen remain as perfect circles. A doughnut, a balloon, the face of a clock, or a round plate is recorded as it appears to the eye.

While such images do not have the typical fish-eye look, they are effective because they cover a 180° angle diagonally and therefore include a background area much larger than is possible with any other lens. The most interesting fish-eye images are often those in which the viewer is not aware that they were made with a fish-eye lens. The uses for these lenses are practically unlimited, whether or not the images you capture have the fish-eye look.

This scene (right) was photographed with two different distance settings on the lens. In one picture, the lens was focused on the wall of the stone building on the left. In the second, the actual distance for the building was set at the end of the depth of field range, but within the engraved depth of field scale. The difference in sharpness between the image focused on the wall (p. 117, left) and the one at the end of the depth of field range (p. 117, right) is very obvious in the enlargements.

Fish-eye images are characterized by curved lines, which give them an attention-getting quality.

DEPTH OF FIELD

Turning the aperture ring on a lens controls not only exposure but also depth of field, which is equally important.

When you focus the lens at a certain distance, say 10 ft. the only subjects that are sharp are subjects exactly 10 ft. from the film plane. Anything closer or farther away is not as sharp, but the falloff in sharpness is gradual.

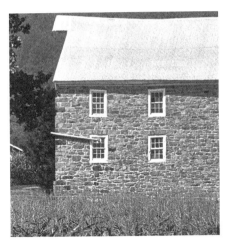

Because the falloff in sharpness is very gradual, there is a certain range in front of and beyond the set distance where the degree of unsharpness is not noticeable, or at least not objectionable to our eyes when the final print or projected slide is viewed. This range is know as *depth of field*.

Depth of field is a calculated figure not based on the design or workmanship of a lens but simply based on the fact that some degree of unsharpness based on optical principles will not be recognized as unsharp when viewing the final print or projected transparency enlarged to a certain size. This acceptable sharpness or depth of field is based on an enlargement made from the negative or slide. What may appear sharp on the small screen or print may appear unsharp when the negative is enlarged ten or twenty times.

Depth of field scales are based on this assumption. There can be differences in depth of field scales between different makes of lenses. This does not mean that one company makes better lenses than the other, but just that a less critical manufacturer may base the depth of field tables on a larger degree of acceptable sharpness. What you must know as a photographer is that at normal distances, the lack of sharpness increases more rapidly in front of the subject and more gradually behind it. As a result, about one third of the total depth of field is in front and two thirds behind. This can be seen clearly on the engraved depth of field scales.

How critical you should be about depth of field depends on your own standards and how much you plan to enlarge a negative or transparency. For very critical work or when negatives will be enlarged beyond normal sizes, you may want to consider a somewhat smaller depth of field range. This is definitely suggested with today's high resolution films. Subjects that are close to the limits of the depth of field but still within it look outright unsharp when you view the negatives or transparencies under a 10× magnifying glass.

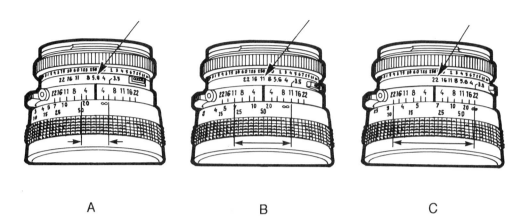

A B C

At f5.6, depth of field is from 50 ft. to infinity (a). Depth of field increases as the lens aperture is closed down. At f11, it goes from about 20 ft. to infinity (b) and at f22 from about 11 ft. to infinity (c). Depth of field should always be determined from the depth of field scales on the lens, not the ground glass image.

Focal Length and Depth of Field

It is generally accepted that wide angle lenses have more depth of field and telephotos less, but this statement needs some investigation.

When you photograph a subject with different lenses from the same camera position, a short focal length lens gives you more depth of field than a longer telephoto, but each lens covers a different area. If the standard lens produces a three-quarter length portrait, the telelens gives only a head and shoulder portrait, and the wide angle a full-length shot. So the three lenses produce three completely different images.

Usually you work the other way around: you know the size of the subject you want to photograph, so the area coverage is predetermined. Then you decide whether to cover that area with a standard lens, or to go closer and use a wide angle, or to go farther away and switch to a telelens. If you work this way, lenses of different focal length no longer provide different depth of field ranges. When you are covering an area of the same size, every focal length lens gives the same depth of field.

The focal length of the lens, then, really does not affect depth of field. Depth of field is determined by two factors only: the lens aperture and the area coverage, which we call *magnification* in close-up photography. Depth of field thus can be changed only by opening or closing the lens aperture or by changing the area coverage. Open the aperture for less depth; close it to obtain more depth. If you run into a situation where even the smallest aperture does not provide enough depth of field, which often

happens in close-up photography, the only solution is to photograph a larger area and crop later. This works only with negatives.

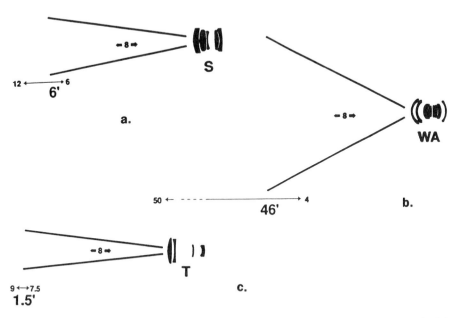

If different focal length lenses are used from the same distance, the wide angle (b) has more depth of field than the standard (a) or telephoto lens (c).

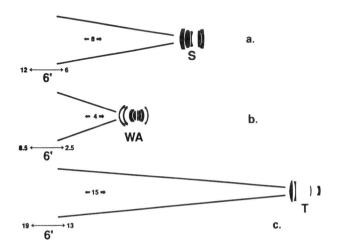

To cover the same size area, the wide angle lens (b) must be used from a closer distance than the standard lens (a). The telephoto lens (c) must be moved further away. From these different distances, all three have the same depth of field.

Knowledge of depth of field is most helpful in close-up photography. The area coverage is almost always predetermined because you want to fill the frame with a subject of a specific size—a piece of glassware, a tool, a flower. Regardless of what lens you use, the depth of field remains the same; and regardless of what close-up accessory you use to cover that area, depth of field remains the same. Close-up accessories, do not determine the range of sharpness, as is often thought.

Medium Format Depth of Field

If you switch from 35 mm to medium format you must be prepared for one fact: the medium format provides less depth of field. The decreased depth of field can best be explained by the difference in magnification between medium format and 35 mm.

At life-sized magnification with any camera or focal length lens, for instance, the depth of field is about 2 mm at $f11$. Life-sized magnification with a 35 mm camera means covering an area 24×36 mm—the size of the 35 mm frame. To fill the larger medium format frame with the same area— 24×36 mm—the magnification is about 1-1/2×, which reduces the depth of field down to half, or 1 mm at $f11$. Your focusing must be more accurate; thus checking depth of field scales is more important.

Setting Depth of Field

When depth of field is unimportant, simply focus on the main subject— the eyes in a portrait, for example. But when you need a particular range of sharpness, you have to manipulate the focus and aperture settings. Focus the closest subject and the farthest subject that need to be sharp, read the distances on the focusing scale, and then set aperture and focusing ring so the closest and farthest objects fall within the depth of field scale engraved on the lens.

If the range of distances is beyond the depth of field range even at the smallest aperture or at a usable aperture-shutter speed combination (for instance, at a shutter speed short enough for handheld work), you have to compromise. Decide whether it is more important to have the background or the foreground sharp or whether it is better for both to be beyond the depth of field range.

Camera Controls for Increased Depth of Field

Depth of field can be increased in some instances by using the tilt control built into a few medium format models. The camera must have a lens or a film plane that actually tilts in relation to the optical axis and can there-

fore produce more depth of field along one plane. This technique is based on the Scheimpflug theory and can be applied whenever a subject is photographed from an oblique angle.

HYPERFOCAL DISTANCE

If you want distant hills or mountains in sharp focus and, at the same time, you want to have the maximum depth of field, set the distance ring so that the infinity mark is opposite the depth of field indicator on the right. The focusing ring is then set to what is known as the *hyperfocal distance*. The depth of field extends from infinity to half the hyperfocal distance. For example, if the 80 mm lens at $f22$ is set that way, the lens is actually focused at 16 ft., and the nearest point of sharp focus is then 8 ft. The hyperfocal distance is 16 ft.

CREATIVE USE OF LENS APERTURE

Now comes your most important decision: how much depth do you want or need in a picture? That is where technical thinking ends and creative ideas must enter the photographic process. Before you snap the shutter, you must decide whether everything from foreground to background should be sharp or whether one or both should be blurred.

Many subjects look best or most satisfactory only when they are sharp from front to back. Keep in mind, however, that such images are the most ordinary ones because they represent the world as we see it. The lens aperture provides one of the most powerful means to make images look unique by allowing you to concentrate sharpness on one narrow plane while making the rest of the image blurred. So think before you lose the effect by stopping the lens down to make everything sharp.

Background Sharpness

The lens aperture also determines the degree of unsharpness of subjects in front of and beyond the depth of field. It dictates how sharp or how blurred the background appears in the photograph. Since backgrounds form a large portion of many images, your treatment of background is an important consideration. Therefore do not set apertures just for depth of field. Evaluate the image on the ground glass at different apertures, and check the degree of sharpness in the background. Perhaps also try different lenses.

As longer lenses magnify backgrounds, they can also magnify the blur. If you use a short focal length lens, your background may be just slightly out of focus. At the same diaphragm opening but with a longer

focal length lens, you can create a completely blurred background that forms a subdued, undisturbing backdrop behind the main subject.

Foreground Sharpness

The focal length of the lens determines whether foregrounds are sharp or become a patch of diffused colors. The blurred foreground approach usually works on color film but not in black and white. The blurred patches can add a touch of color or can be used to frame the main subject. Suitable objects for blurred foregrounds can be found almost everywhere outdoors, but they can also be artificially composed; a tree branch or flowers can be held in front of the lens, for example.

Out-of-focus foregrounds are generally best when blurred completely so that they are not even recognizable. If blurred just a little, the blurry foreground might look like a mistake. If the standard lens does not provide enough blur, go to a longer focal length lens.

MANUAL DIAPHRAGM STOP-DOWN

On SLR cameras, the diaphragm is normally wide open to provide the brightest viewing image. The image you see through the finder is the image that will appear on the film when made at the maximum lens aperture. Too often photographers focus and view the image only with the lens wide open and don't give a thought to what the image might look like with the aperture set at a smaller opening. The manual stop-down control allows you to see the image at different lens apertures. The manual stop-down lever is one control most photographers should use more often. When you operate the stop-down mechanism, the lens closes down to the aperture set on the lens. The ground-glass image becomes darker, but you can see the image as it will be recorded on the film.

ACTION AND SHUTTER SPEED

The shutter speed may be predetermined by exposure or by your need for handheld camera operation. The speeds that can be chosen with reasonable assurance of sharpness in handheld photography depend on the focal length of the lens and one's ability to hold the camera steady. A fairly safe rule is to use a shutter speed fraction not longer than the focal length of the lens. A 60 mm lens is satisfactory at 1/60 second or shorter; a 250 mm lens is preferably used only at speeds of 1/250 second or shorter. You may be able to go to shutter speeds twice as long, but I suggest being careful before doing so with today's sharp films. Rather I would suggest that you go the other way and consider as a slowest speed one that is double the inverse of the focal length; for example, 1/125 second for a 60 or 80 mm lens.

When you are photographing moving subjects, the shutter speed should also be chosen from the image-creating point of view. You must decide whether the motion is to be frozen, recorded with a little blur, or completely blurred.

Freezing Action

A moving subject recorded with a high shutter speed appears to be standing still. The shutter speed necessary to stop action depends on the speed of the moving subject but also on the magnification of the subject as recorded on the film. If a particular subject fills the entire frame, its image moves farther across the film in a given time than it would if it were to fill only half the frame.

The amount of movement also depends on the angle at which the subject is photographed. The image moves the greatest distance when you

High shutter speeds record moving subjects in the ordinary way, as shown above. Slow shutter speeds—1 second, as shown on p. 124—produce an image different from the way we see moving subjects.

record the subject from the side as it moves across the picture. However, the image moves relatively little when you record it from the front as it moves toward or away from the camera. Between these limits, the movement varies. A change in camera angle to 45° or to straight on can, therefore, stop action in a way that would not be possible from the side.

Another way to stop motion is to photograph the subject at the peak of the action. This works well with all sports or actions that are not continuous but have a beginning and end or are repeated. In golf or tennis, shoot at the end of the stroke; with a person on a swing, shoot at the maximum height as he or she changes direction. There is a peak of action on many rides in amusement parks, in jumping on a trampoline, in ballet dancing, and in other stage and circus performances. If such actions are caught at their peak, a shutter speed of 1/500 second is more than sufficient for stopping action with most lenses. To stop continuous motions, such as those of skiers, motorcycles, cars, horse races, divers, and roller coasters, 1/2000 second may be necessary, especially when you are using a long focal length lens.

One method to reduce blur when photographing moving subjects is to release the shutter when the subject is momentarily still—for example, at the end of a swing or at the top of the bounce from a trampoline. Another method is to follow the movement of the subject in the viewfinder. When the exposure is made, the subject appears sharp against a blurred background.

Blurred Motion Effects

Shutter speed is one of the greatest creative tools available in photography. It is a tool that allows you to record on film any moving element in an unusual way. The eye cannot stop fast-moving action, nor can it blur movement, which is why blurred-motion effects are fascinating and attract attention.

The feeling of motion can be visually conveyed in a still photograph by recording any moving subject partially or completely blurred. Such subjects can include reflections, clouds, smoke, wind-blown trees, flowers, grass, and rain, as well as more common subjects, such as rides in amusement parks, racing cars, and football games.

It is not easy to know how blurred an image will come out. Evaluating the image on the ground glass can help, but you won't get a definitive conception of the effectiveness of the image. Try to photograph the subject not only at the speed you calculate will work, but also at two slower and two faster shutter speeds. Keep a record of the shutter speeds for future reference. Even better, make a test on instant film. Within a minute you can see what the image looks like and make the necessary adjustments in shutter speed while the camera is still set up.

The amount of blur recorded when a moving subject is photographed depends on the position from which the photograph is taken and the size and distance of the subject. Using the same shutter speed, blur is greatest when the subject is moving at a right angle to the camera view (1). A subject moving at the same speed straight toward the camera (2) or at an angle (3) is less blurred. Viewed from a greater distance (that is, when the image area of the subject on the film is smaller), there will be less blur, even at the same shutter speed.

Following Moving Subjects

You can also follow a moving subject with the camera and trip the shutter while the camera is moving. This approach is good not only because it stops motion but also because it produces a different image. If you move the camera at the same speed as the subject, only the background is blurred.

The amount of blur depends on the shutter speed and focal length of the lens. You can also move the camera slower or faster than the subject,

creating a blur in the background and in the subject. With many subjects, some elements are moving in all different directions and at different speeds—for instance, the spokes of a wheel, the legs of a bicycle rider or horse, the wings of a bird, the arms of a ballet dancer or ice skater. So even if you move the camera at the same speed as the subject, some elements may still be blurred, in addition to the background, which adds to the impression of motion. If several subjects move at different speeds, there is still more choice for being creative in capturing the image.

Because the desired effect on film is frequently a personal choice, it is difficult to give recommended shutter speeds for photographing moving subjects or with a moving camera. But for a basic idea, start with around 1/8 second for a bicycle rider or runner. Try using Polaroid film to make a test shot.

Choice of background is important. With a completely plain background, such as blue sky, an empty wall, or a dark theater set, camera movement is not noticeable. To bring out the feeling of motion, the streaking effect must be obvious. So choose highlights and bright areas for streaking and select a contrasting background, such as trees against the sky, sunlight on water, or crowds of spectators.

Cameras can be moved handheld or on a tripod. Many photographers find it easier to follow their subject with a handheld camera, especially when the subject changes speed or directions, as birds or ice hockey players do. If the subject, on the other hand, moves along in a straight line—for example, a racing car, an athlete in a 100 meter sprint, a bicycle rider on a straight road, or an object falling to the ground—a tripod-mounted camera is more likely to produce a successful result.

Looking straight down on the ground glass with the regular finder or magnifying hood cannot be recommended for motion photography, mainly because left and right are reversed. All prism viewfinders reverse the image. Many photographers find sports and frame viewfinders the best choice for motion photography. The simple mechanical frame or mask of these finders makes following the subject easy, because you see everything as bright as it actually is. And because you can also see the surrounding area you can see where the subject might be going and where the camera is moving.

Creating the Image in the Viewfinder

The medium format image is only as good as the view through the finder. The type of finder and your method of viewing, framing, and focusing are important elements for creating the image.

On most nonreflex cameras—the rangefinder, press, folding, and special wide angle types—the finder is a permanent part of the camera body and you have no choice of finder. This is not necessarily a disadvantage. These finders are usually well designed and serve their purpose of framing the view. A split image rangefinder is part of the finder if it is designed for focusing as well as viewing.

These optical finders have their own advantage. The image appears very bright, as bright as what you see with your eyes, because there is no lens, mirror, and ground glass to cut down the light. On the other hand, these finders show only the area coverage, so you have no idea of how the image will be recorded on film.

PARALLAX

Optical viewfinders are adjusted at the factory so that their fields of view are the same as that covered by the lens at long distances, where most cameras are used. But because the finder is located above or to the side of the camera lens, it sees the subject from a slightly different point of view than does the lens. This creates a problem known as parallax. But parallax is a concern only when you are photographing a subject at a close distance. It must also be considered with TLR cameras (see chapter 5).

RANGEFINDER FOCUSING

In rangefinder focusing you view the subject through two windows, on the left and right of the camera body. Each window views a somewhat different area, so you can see a double image over the entire field, or, in the case of a split image rangefinder, the two images are separated along a split. A horizontal or vertical line appears split. The image is brought together by turning the focusing ring. When the line appears unsplit, the lens is focused on that subject.

A B

Accurate focusing with a split image rangefinder is obtained when a straight line in the subject crossing the split is continuous (a), not broken (b). The split line can be horizontal, vertical, or diagonal. The rangefinder area can cover the entire viewing area or only a portion of it.

Split image rangefinder focusing is accurate because you can easily see whether a line is split or continuous. It is also rather reliable because even a user with impaired eyesight can usually see the line. This is one of the reasons why many SLR users like screens with split image focusing.

GROUND-GLASS SCREENS

SLR and TLR cameras are equipped with focusing screens. Most modern medium format SLR and TLR cameras allow you to select a type of ground-glass screen and change from one screen to another at any time. Ground-glass screens can be made from glass or plastic. Plastic screens are not necessarily of cheaper quality; they have the advantage of being unbreakable.

The choice of screen must be a personal one. Do not purchase one specific screen simply because someone else uses or recommends it. If at all possible, check the different screens to determine which is best for your eyesight and for the lighting conditions, the lenses, and the accessories you use most.

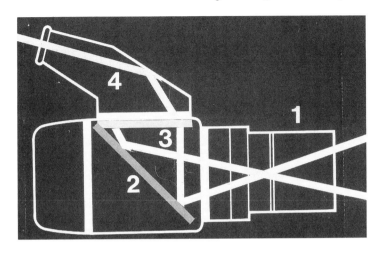

On an SLR camera the image recorded by the lens (1) is reflected by the mirror (2) to the viewing screen (3). The purpose of the viewfinder (4) is to magnify the ground-glass image for accurate focusing.

Most focusing screens are combined with a Fresnel brightener, which consists of closely spaced, very finely beveled concentric circles. The rings bend the light, striking the corners back toward the center to be seen through the eyepiece. The Fresnel lens thus brightens the corners of the viewing area.

A brighter screen is great for seeing and composing the image but does not necessarily provide faster or more accurate focusing. For this you need a ground-glass screen that provides an image in which fine details and fine lines are seen with the utmost sharpness and contrast. This is an important consideration because accurate focusing, not viewing, is still the main reason for using a ground-glass screen.

The overall matte surface of a standard screen dims image brightness. New technology using lasers and fiber optics has resulted in focusing screens that are noticeably brighter than their predecessors. This great improvement in brightness justifies the higher cost, especially for those who work extensively in low light levels or for those who work with slow lenses. When investigating the new screens, however, compare not only the brightness but the focusing accuracy as well.

Plain Ground-Glass Screens

The plain ground-glass screen is considered the most satisfactory by many photographers. It provides an image that, with the exception of perhaps some fine black marks for centering, is uninterrupted by circles and clear areas, making it the best choice for evaluating image effectiveness.

On the other hand, seeing whether the image formed by the lens falls accurately in the plane of the screen is not as easy with a plain screen as it is with other types. For this reason, screens with microprisms and split image rangefinders have become very popular.

Focusing Screens with Split Image

You might also have a choice of a ground-glass screen combined with a split image rangefinder. The split can be horizontal, vertical, or diagonal. The image can then be focused either in the clear split image center circle or on the surrounding ground-glass area. For split image focusing, the camera must be aimed at the main subject, perhaps an inconvenience in action photography or in motion photography in general. Focusing with the split image also requires that the image contains a straight line that crosses the split area, because focusing relies on your eye's ability to detect breaks in otherwise continuous lines. When the points come together and the lines are continuous, the focus is correct.

The main limitation of the split image screen involves lenses. When the aperture of the lens is smaller than about $f4$, one of the two halves of the split image field blacks out. Thus you cannot focus except through the ground-glass area. So the split image screen should not be considered if you use $f5.6$ or $f8$ lenses extensively.

With $f4$ or faster lenses, both fields of the split image field are clear only when your eye is in the optical axis. If one of the fields is blacked out, move your eye slightly up, down, or sideways.

Ground-Glass Screens with a Microprism

This popular screen has a large bright microprism focusing area in the center of the screen.

As the name indicates, the center area consists of many tiny prisms that shatter the image when it is out of focus, making it appear blurred. It blurs much more quickly than the image on the overall matte field. Microprisms thus appear to provide easier focusing because the image seems to jump more readily and rapidly into place than it would on the standard screen.

Screens with microprism centers can be used with lenses of all focal lengths and apertures, and consequently focusing can also be done with the lens stopped down. New screen technologies can provide the same benefits.

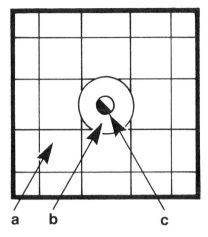

A popular screen combines a split screen center (c) with a surrounding micro-prism (b) and ground glass (a). Screens with grid lines help you align vertical and horizontal lines but are not as accurate for leveling a camera as a spirit level, especially when you use wide angle lenses.

Clear Glass Screens

A clear glass screen can be recommended only for special applications—when photographing through a telescope, for instance, but especially for photomicrography, where accurate focusing of fine detail in a specimen is almost or completely impossible with a ground glass.

Screens with Grid Patterns

These screens, also called *checked screens*, have vertical and horizontal guiding lines, which are helpful when the subject lines have to be parallel to the edges of the image, as in architectural photography or in aligning flat art for copying.

Other screens or screen masks for square format cameras may provide guiding lines to show the vertical and horizontal 8 × 10 in. paper proportions. Such screens should be used by every photographer who plans to crop square negatives into vertical or horizontal prints.

To make the 8 × 10 proportions more pronounced while viewing, you can darken the four corners with black lacquer or cement a gray filter foil over it.

Cleaning Focusing Screens

Lens cleaning fluids must never be used on plastic screens or glass screens combined with a Fresnel lens. Since screens rarely get finger or grease marks, you usually need do nothing more than brush or blow dust away. Wipe a screen only if absolutely necessary, and if you do, do so very gently with a soft cloth, perhaps slightly moistened with water or a mild soap and water.

VIEWFINDERS

The viewfinder serves two purposes: to magnify the image on the screen for accurate focusing and to shield the screen from extraneous light.

The choice of finder for most SLR cameras includes the standard foldable waist-level type (1); a magnifying finder, which may include a metering system (2); a 45° prism finder (3); and a 90° prism finder (4). The last two may also include a metering system.

In handheld photography, the proper viewfinder can be a great help in improving camera steadiness.

Viewfinders to Improve Camera Steadiness

For handheld photography, select a finder that allows for steady and convenient holding of the camera. A finder equipped with a large comfortable

rubber eyepiece that can be pressed firmly against the eye is recommended.

The firm contact between eye and finder is lost when you wear eyeglasses, because they prevent your pressing the camera against your eye. They also prevent your placing your eye right behind the eyepiece. Thus you may not see the entire ground-glass screen area. Light may also enter between the eyepiece and your eyeglasses, flaring the screen and reducing the apparent brightness of the screen. Try to find a way to view and focus without eyeglasses. Perhaps you may have to take off and put on your glasses constantly, but avoiding wearing glasses is the most satisfactory solution, at least in handheld photography.

Film Format and Viewfinder

A medium format camera designed for the square format or a 6 × 7 cm camera with a rotatable magazine offers a wide choice of finders. Since the camera never needs to be turned, the ground-glass image can be viewed straight down with a waist-level finder, a sportsfinder, or from 45° or 90° with a prism finder. This is obviously an advantage for anyone interested in photographing subjects from different camera angles.

A camera made for the rectangular 6 × 4.5 cm or 6 × 7 cm format without a rotating film back needs to be turned for shooting verticals. If the camera needs to be turned, only the 90° prism finder is practical. The choice of finder is thus practically eliminated. That is also the reason these cameras come equipped with prism finders for eye-level photography. Square format cameras, on the other hand, usually come with a foldable waist-level finder.

Prism versus Waist-Level Finders

The folding-hood viewfinder is the simplest, lightest, and least expensive interchangeable viewfinder. When folded down, the camera is compact, and the focusing screen is protected from dirt and scratches.

A folding-type finder, often called a waist-level finder, need not and should not be used from the waist level. It is best pressed against the eye like a prism finder, especially for handheld shooting. The lens is then only about 2 inches lower than it would be with a prism finder, and convenient, handheld photography from eye level is then possible. With a folding hood viewfinder you can also view the image on the screen directly without an eyepiece, and you can view it with both eyes open. This gives greater flexibility in viewing from many different angles. The camera need not be in front of your eye.

With this folding-type finder, right is left, left is right. This consideration is unimportant in general photography. You get used to it quickly

and are hardly aware of the reversed image. But it becomes objectionable when you are photographing moving subjects. You'll probably turn the camera the wrong way and miss the shot. Following action through the waist-level finder is also impractical. With a prism finder, the image is not only right side up but also laterally correct, so what is left is left and what is right is right.

A prism viewfinder that provides 45° or 90° viewing can add quite a bit of bulk and weight to the camera and costs more than the folding type, especially if it is made of prisms, not mirrors. But a true prism finder is rugged and likely to give good image quality. Also, a prism viewfinder may be made with a built-in light meter, which by itself can be a good reason for selecting this type of finder.

For tripod work, a prism finder is a definite advantage because it allows you to put the tripod on a higher level.

Somewhat of a compromise between prism and folding-hood finders is a magnifying hood. With this type of viewfinder you view the image through a built-in magnifying lens. The finder does not fold, so the camera is bulkier, but not having a prism, it is lighter and much less costly.

Advantages of Viewing from the Top

Focusing and framing are done easily with the folding hood viewfinder, even if the camera is on the floor or on the ground and without

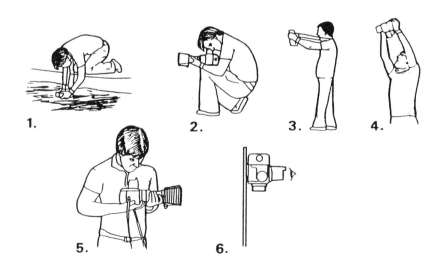

Viewing from the top has great advantages when you are taking photographs—for example, from low angles (1), from the knee (2), straight down (3), from over the head (4), sideways (5), or from a vertically mounted camera (6).

your having to lie on the floor. In a nightclub or restaurant, for instance, you can place the camera on the table and view the image on the ground glass without anyone else being aware of your actions. When kneeling down, you can photograph with the camera on your knee for steadiness. You can look right at the ground glass from the normal working position when the camera is mounted on a copy stand or microscope.

Taking candid shots of people—without their being aware of the photographer—is frequently more successful with the camera pointing to the left or right instead of straight ahead. Just turn the camera sideways at waist level and view through the standard finder.

Viewfinders for Accurate Focusing

Besides convenient corner-to-corner evaluation of the image, viewfinders must show exactly and quickly when the lens is set at the correct distance. For that, you must be able to see the screen sharply. As we get older, our eyes do not adjust at all distances, and they may no longer be able to adjust to the finder's viewing distance. If you are never certain whether the image is in sharp focus, if it takes a long time focusing a lens, if you do not see the image jumping in and out of focus when turning the focusing ring, or when the focused distance is different every time you focus on the same subject, you have a problem. See if you can match your eye to your finder.

Matching Viewfinder to Eyes

A built-in diopter correction eyepiece is adjusted to the photographer's eyesight by turning the eyepiece (14) until the ground glass looks sharp. The diopter correction can be read on the scale opposite the index. A rubber eyecup (16) shields extraneous light.

Fortunately most camera viewfinders provide a method whereby you can adjust the finder's eyepiece to your eyesight. This may be by means of an adjustable diopter correction eyepiece with a dial that you simply adjust until the image of the focusing screen appears sharp.

When you adjust the eyepiece, keep in mind that you want a sharp image of the screen—not the subject in front of the lens. The adjustment is, therefore, best made without a lens on the camera. Point the camera without the lens at a bright area and turn the diopter ring until the grain on the ground-glass or the engraved lines appear absolutely sharp. After adjusting, take your eye away from the finder, view a subject at infinity, and recheck the adjustment once more to see if it is still sharp. Adjusting at infinity will ensure that the eyepiece is adjusted for a relaxed eye. You need do this diopter adjustment only once, and, if possible, you should then lock the ring. You should not change the setting when switching lenses or taking pictures at different distances. On other viewfinders, the "matching" is made by changing the eyepiece or adding diopter correction lenses.

Diopter correction lenses or eyepieces are not corrected for astigmatism. In most cases, such correction is not necessary. Only in severe cases may it be necessary, and if so you need a special lens ground to the proper diameter by an optician.

In all cases you must decide beforehand whether you want to view with or without your eyeglasses and then select the correction for whichever method you decide. Viewing without glasses, if practical, is recommended. Camera steadiness will be improved and you will always see the entire field of view. What should you do with the glasses? Hang them on a chain around your neck.

Cleaning Viewfinders

The magnifying lenses or eyepieces of your viewfinder are in an exposed position, and grains of sand and dust can accumulate in the hood crevices. Blow and brush away all dust particles before wiping with lens tissue and, if necessary, applying lens cleaner.

The same approach can be used on the exposed bottom prism surface unless the manufacturer advises against it. Clean, and especially wipe, lens or prism surfaces only when absolutely necessary. Off the camera, the prism viewfinders should always be protected with the cover that slides over the bottom plate and usually comes with the prism finder.

THE IMAGE

Seeing the Image as It Appears on the Film

SLR cameras offer the great advantage of allowing you to see the image as it will be recorded on the film, but only if you do not forget one of the impor-

tant controls on the camera: the manual stop-down or preview lever found on most medium format SLR cameras (unfortunately omitted on some).

On SLR cameras, the lens aperture is always wide open to provide the brightest ground-glass image for framing and focusing. The image you normally see is thus the image as it would be recorded on the film if you were to take the picture with the lens wide open. If you take the picture at any smaller aperture, depth of field and foreground and background sharpness are different. The aperture, more than any other control on the camera, determines what the image on the film will look like. The aperture is the greatest and most important control factor in creating images and making them different. To use your camera in a creative fashion, you must use the manual stop-down control so you can see how the image and the foreground and background sharpness change by closing and opening the aperture, and to be able to determine visually which aperture creates the most effective image.

Evaluating the image with the lens closed down is essential when you use special effect devices in front of the lens: with vignettes, the sharpness of the outline and the size of the cutout in the vignette change with the aperture; with partial filters, the dividing line between the filtered and non-filtered area shifts; with multiprisms, the images overlap more at large apertures and become more separated at smaller ones; on some diffusion devices different degrees of softness are produced at different apertures.

Depth of Field Evaluation

The focusing screen of any SLR camera gives some indication of depth of field, but, contrary to general belief, it cannot show depth of field accurately and should never be used for that purpose.

Focusing screens, even in medium format cameras, are relatively small, making it impossible to determine what may look acceptably sharp on a large print or projected transparency. Seeing depth of field on any focusing screen is made still more difficult because the ground glass darkens as you close the aperture, to a point where even focusing may become difficult.

In summary, SLR viewfinders are great for accurate framing and focusing. They are also excellent for evaluating the effectiveness of an image and to see what lens aperture produces the desired results. But do not waste your time trying to determine depth of field through the SLR finder. Consult your camera's depth of field scales for this purpose. That is why they are still engraved on the lenses.

Frame and Sports Viewfinders

Many medium format cameras also provide the option of viewing through sports or frame viewfinders. They may be separate accessories, which are

attached to the camera body, the lens, or the lens shade, or they may be built into the folding hood viewfinder.

A frame viewfinder with diagonals crossing the center is excellent for following moving subjects.

Frame and sports finders have advantages. The type with cross-hairs makes it easy to follow a moving subject. Sports and frame finders also make viewing with both eyes open easy. More valuable, you see the area in the finder and also the area around it. You can see what exists and what is happening outside the area. When panning with the camera, you can see where the camera is moving to, how far to move it, and when to press the release. In low light levels, a sports- or frame finder shows the view as brightly as you see it with the naked eye.

When the prerelease is depressed and the mirror locked up, sports and frame finders are the only types of finders that provide the ability to view and frame your shot.

LEVELING THE CAMERA

While the grid patterns on a checked screen can help in leveling the camera, they do not guarantee a level shot. The ground-glass image is not sufficiently large to see whether verticals or horizontals are perfectly aligned. A spirit level is a better solution. If the camera does not have a built-in spirit level, one might be available as an accessory.

COMPOSING THE IMAGE

Medium Format Image

The effectiveness of an image is greatly determined by *composition*: the arrangement of lines, shapes, and colors within the image area. Regardless of what camera and viewing system you use in medium format photography, you must try to arrange the subject elements within the outlines of the finder so they form a well-composed image.

Complete books have been written on this subject, and whatever information is provided is undoubtedly helpful to all photographers. I consider the principles of composition to be guidelines that usually contribute to making a well-balanced image. They should be considered. Photography, however, is not a science but a form of art and, even more, a form of personal expression. So rules of composition are to be broken if your intent is to do something different or to do something that is more likely to attract attention. You can attract attention with images that are different from the ordinary, different from the way we usually see things, and that rule applies to composition as well.

Composition in Different Film Formats

Depending on the medium format camera or film magazine, the scene may have to be composed in a square or in rectangles with different aspect ratios between width and length (about 1:1.4 for 4.5 × 6 cm; 1:1.25 for 6 × 7 cm; and 1:1.5 for 6 × 9 cm). The aspect ratio is even greater for panoramic formats.

The principles of composition are usually explained in relation to the rectangular image format, which many consider the normal or standard for photographic purposes. All of these principles, however, apply as well to the square format. One third from the left side, for instance, is the same in the square as it is in a vertical or horizontal.

Any subject can be composed in the square at least as effectively as in a vertical or horizontal, especially because it is a good compromise between the two. The statement I hear occasionally—that a full-length bride and groom photograph has to be vertical and a group photograph of the bridal party has to be horizontal—has no truth. Such shots can be vertical or horizontal, but they could also be square or even reversed (the bride and groom as a horizontal, the bridal party as a vertical) by changing the camera position and making foreground and background elements part of the composition.

Evaluating Composition

Composition can be studied in any type of viewfinder, even a simple frame finder, but the ground glass of SLR or TLR cameras must be considered the best. On the ground glass, what is sharp and what is not depends on the lens and lens setting. This is especially important for your treatment of distracting elements. A highlight may be hardly noticed as a sharp point but becomes distracting as a large, blurred circle. On a ground glass, the positioning of the elements in relation to the frame becomes clearer. This is true especially for the large medium format screen.

Square negatives sent to a laboratory for producing rectangular prints should be accompanied by the proper cropping instructions. Many laboratories supply masks for that purpose. However, if you compose the subject to fit into the proper guidelines on the ground-glass screen, the laboratory can simply print the center area. No special cropping instructions, except to specify a vertical or horizontal, are needed.

Exposure and Metering Modes

Exposure is determined by the amount of light, the sensitivity of the film, lens aperture, and shutter speed. The amount of light is usually predetermined. The sensitivity of the film is decided by the type of film, which leaves two major controls for exposure: the aperture and the shutter speed. These two settings must be adjusted so that the proper amount of light reaches the film in the camera.

APERTURE

The aperture ring opens and closes the diaphragm built into each lens. The size of the diaphragm opening is engraved on the lens in f stops or numbers. A large opening, letting more light onto the film, is indicated by a small number, such as $f2.8$; a small opening letting less light onto the film is a high number, such as $f16$. On some lenses, especially those made in Europe, the aperture is engraved as a ratio; 1:4 means $f4$. The f number is the ratio between the diameter of the entrance pupil and the focal length of the lens. A 150 mm lens is $f4$ because the entrance pupil is 37.5 mm in diameter (150 ÷ 37.5 − 4).

Aperture numbers are multiples of 1.41 (for example, $f4 = f2.8 \times 1.41$, $f22 = f16 \times 1.41$) because 1.41 is the square root of 2, and light intensity increases or decreases in the proportion of the square root of 2. The f numbers work in the same way.

A change in aperture from one figure to the next doubles or halves the amount of light reaching the film. The amount of light doubles when you move the setting to the next lower number (from $f5.6$ to $f4$); it is reduced by half when you go to the next higher setting number (to $f16$ from $f11$).

143

The maximum aperture of a lens is frequently referred to as the *speed of the lens*, and large aperture lenses are known as *fast lenses*. (Note: A large aperture means more speed.)

SHUTTER SPEED

Shutters, focal plane or leaf, control the length of time the light coming through the lens shines on the film. Aperture and shutter speed together, therefore, determine the total amount of light that reaches the film. The same amount of light can reach the film with many different combinations of aperture and shutter speed. As aperture numbers double or halve the amount of light, it is easy to compensate for these changes by adjusting shutter speed.

If the aperture is closed one number (from $f4$ to $f5.6$, for example), only half the amount of light passes through the opening. If this amount of light passes through the opening for twice as long—the shutter speed is made longer from 1/250 second to 1/125 second—the exposure is the same. If the aperture is opened one number (from $f16$ to $f11$) the shutter speed must be shortened (to 1/30 second from 1/15 second) to achieve the same exposure.

EXPOSURE VALUES

Some camera lenses and most exposure meters also have an exposure value scale (EVS) in addition to aperture and shutter speed. Exposure values (EV) were established some time ago by camera and meter manufacturers as a single figure to indicate how much light exists for the film in the camera. The EV reading at a given light level depends on the sensitivity of the film in the camera because you set the meter for the film speed prior to taking the meter reading. If the EV is 12 for 100 ASA film, it will be 14 for 400 ASA.

The exposure value system in some ways offers simplicity; it is easy to remember a single number and to transfer it from the meter to the lens or from one lens to another. It is also a simple way to remember the exposure values for a particular film when used in standard lighting conditions.

The greatest benefits of EV, however, are derived when aperture and shutter speed rings on the lens are coupled. Once such a lens is set to the EV, any of the aperture and shutter speed combinations of the coupled rings will give you a correct exposure.

In a way, coupled aperture and shutter speed rings offer the same automation found on built-in meters. If you change shutter speed from 1/30 to 1/125 second, the aperture changes automatically, say from $f8$ to $f4$. If the lens is set to 1/500 at $f2.8$ and you want $f8$, turn the aperture ring four notches, and the speed will automatically be set to 1/60 second.

Exposure values (EV) are an indication of the amount of available light. A low EV number indicates a small amount of light; a high number indicates a greater amount. EVs are also related to the speed of the film in the camera. For example, for 400 ASA film, the EV may be 10, while under the same lighting conditions using 200 ASA film, the value would be 9. Once the exposure value has been determined, several aperture and shutter speed combinations will give the correct exposure—for example, ƒ2.8 and 1/60 second or ƒ16 and 1/2 second.

FILM SENSITIVITY

The lens settings also depend on the sensitivity of the film. If you use a meter, separate or built into the camera, the film sensitivity must be set on the meter before you make a reading. The sensitivity, also called *speed of film*, is usually indicated in two ways: DIN (the German standard) and ASA, or now ISO, the international standard. ASA and ISO numbers are identical: 40 ASA = 40 ISO.

A film that has double the ISO or ASA as another film is twice as fast. Close the aperture one ƒ stop to compensate for the difference. If 100 ISO or ASA requires ƒ5.6, ƒ8 will give the same exposure on 200 ISO or ASA. In the DIN system, a film twice as sensitive is three numbers higher. DIN 24 requires ƒ8 if ƒ5.6 is correct for DIN 21.

ESTIMATING LENS SETTINGS

Many seasoned photographers, especially those frequently working under similar light conditions, decide on lens settings based on experience or the instruction sheet supplied with the film and end up with accurate results. In many situations, light is extremely constant, so it makes no sense to meter for every shot. Such situations exist inside where there are no windows. Most living and working areas are lit to a fairly even level. A constant light situation can also exist outdoors on clear, sunny days. The amount of sunlight that falls on the subject is the same everywhere and most of the day except early morning or late afternoon. The so-called sunny 16 rule works well, at least for slide film for front- or side-lit

scenes: in sunlight, set the aperture at f16 and the shutter speed at the inverse value of the ASA film speed. For 100 ASA, it is f16 at 1/100 second; for 400 ASA, f16 at 1/400 second or the setting closest to it. If you work with exposure values, EV 14 is correct for 64 ASA and EV 16 for 200 ASA.

EXPOSURE METERS

Most photographers base lens settings on the readings from an exposure meter—a meter built into the camera or a separate accessory. Both types and all light meters made by all companies produce good results if used properly. More important than the make of the meter is the metering method. You must learn in detail how the meter measures the light and how it must be used to provide the best results in all situations.

Meters as Part of the Camera System

Most modern medium format cameras offer some way of measuring the light in the camera. The metering system may be in the camera body or in an accessory viewfinder. Both types measure the light reflected off the subject, but they measure it through the camera lens. Measuring the light in the camera has a few advantages. The viewfinder shows what area is measured, and when the lens is changed, the measuring angle of the meter also changes. This is especially valuable when you are working at long focal lengths and photographing distant subjects that you may not be able to meter separately close up. Because you see the meter reading in the viewfinder, you can see changes in brightness while viewing the subject. The built-in meter also measures through any accessories placed in front of the lens (such as filters) or any accessories placed between lens and film (such as extension tubes and bellows). With built-in meters, therefore, you can get exposure readings without having to consider filter or exposure factors.

Built-in meters also eliminate the need to carry a separate meter. But on the other hand, a repair of the meter also requires giving up the camera or that particular finder.

Built-in Measuring Methods

Although all built-in meters measure the light through the lens, they can measure it in different ways. The meter may measure the entire area seen in the finder equally from center to corners—the averaging method. There are built-in meters that work like a spot meter, measuring only a small area of the viewfinder image. Or the built-in meter can be a combination of the two—a method known as center-weighted. The meter measures the

entire ground-glass area, but it favors the center (or quite often the lower center). Some built-in meters measure only a center area.

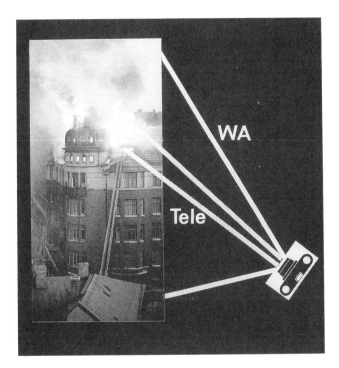

With a built-in meter, the reading is made through the lens that actually takes the picture. The reading is thus based on the reflectance of the area covered by that particular lens.

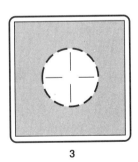

1 2 3

An averaging built-in meter measures the image evenly from center to corner (1). A spotmeter measures only a specific area indicated on the ground-glass screen (2). The popular center-weighted system measures the entire area but not evenly. The major reading is made in the central area (3) or the entire reading is made in the center.

A popular metering method today, especially in 35 mm, is matrix metering. In matrix metering, the scene is electronically split into various sections, and each section is metered individually. A computer in the camera then compares the various readings and computes an average.

Some cameras only offer one measuring method, some may give you a choice, so you can use one or the other, perhaps depending on the subject or the lighting situation. While having a choice between metering methods may offer some benefits, it is more important that you know exactly how your camera measures the light and then learn the basics of exposure metering discussed later in this chapter. Keep in mind that a built-in meter does not provide correct exposure automatically and does not necessarily provide more accurate exposure than a separate meter. Built-in meters, like separate meters, provide correct lens settings only if used properly.

Advantages of Different Metering Methods

Matrix metering undoubtedly produces the highest percentage of good exposures and is, therefore, a good system for average subjects and for general photography. It provides good results for snapshooting. The exposure, however, is determined by a computer, and a serious photographer does not know what the meter is measuring, what the lens settings are based on, and consequently what the results will be. The matrix system, therefore, would not be chosen by photographers who want to know and control how the image is recorded on the particular film that is in the camera.

A center-weighted system works well in many cases because it reduces the danger of measuring unimportant dark or light background areas. It also gives the photographer a fairly good idea of what the meter is measuring. Consequently this system indicates how the camera should be pointed at the scene or subject to obtain the correct meter reading.

Averaging metering cannot be recommended for serious photography because the meter can be excessively affected by unimportant background areas.

A well-designed spotmeter only measures the light reflected off a small outlined area and is completely unaffected by any light, regardless how bright, coming from outside areas. A built-in spotmeter must be considered the ultimate measuring instrument for the serious and critical photographer.

While the measuring area as indicated on the focusing screen is the same with all lenses, the spotmeter's measuring angle depends on the focal length of the lens. On the same camera it could vary from perhaps 10° for an extreme wide angle lens to less than 1° for a long telephoto.

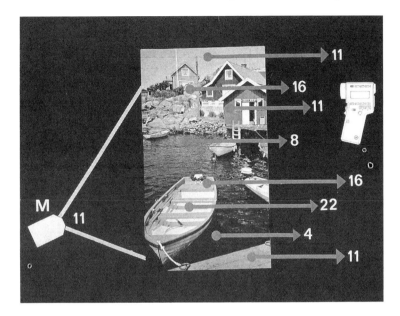

A normal reflected meter (M) gives an average value for the entire scene. A spotmeter (right) measures definite small areas and gives different values depending on the brightness of the area. The differences can amount to four *f* stops.

Advantages of Spotmetering

A spotmeter (whether separate or built into the camera) shows you exactly what area is being measured, which is the main reason it must be classified as the photographer's most complete and exact means of personal exposure control. Knowing exactly what you are measuring allows you to determine precisely whether the indicated lens settings are correct or whether adjustments need to be made, and if so, how much. For the knowledgeable photographer the spotmeter eliminates all guesswork and can produce perfect exposures, thus eliminating the need for shooting the image at two or more different lens settings (bracketing).

A spotmeter can do more than just give an exposure. It allows you to measure different areas within the subject or scene to see the differences between lighted and shaded areas and between the main subject and the background, to determine the contrast range, and to make changes in lighting if you need to increase or decrease contrast before shooting. The spotmeter readings between light and dark can be used to determine the developing time for black-and-white film that will either increase or decrease the contrast range of the negative.

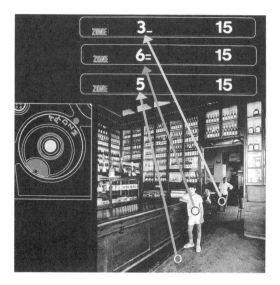

A spotmeter allows the zone system photographer to measure different areas and determine the contrast range. A built-in meter that shows zone values directly is helpful and exists in the medium format.

The advantages of a spotmeter are further enhanced when it is built into a camera. Then light is measured through the lens, thereby offering all the benefits of through the lens (TTL) metering.

Meter Operation and Automated Functions

Built-in meters vary not only in the way the subject is metered but also in the way you set the meter information on the camera and lens. On various medium format camera systems, the meter is not in the camera but in the viewfinder, and it measures light off the focusing screen. The information, the EV value perhaps, must then manually be transferred to the camera and/or lens. The system is then nothing more than a good metering system that measures the light through the lens and eliminates the need for carrying a separate meter.

If the camera measures the light off the ground-glass screen and the camera offers interchangeable screens, ascertain from the manufacturer or through your own tests whether all screens provide the same reading—or if some require that you make an adjustment, perhaps in the ISO setting.

Medium format camera systems also come with many different degrees of automation in the lens settings. For example, if you set the aperture, the camera may automatically set the shutter speed. This is known as *aperture priority*. You may have to set the shutter speed and the aperture sets itself, known as *shutter priority*. While there are arguments regarding

aperture or shutter speed priority, most serious photographers seem to prefer being able to preset the aperture for the desired depth of field.

In medium format camera systems with built-in meters, lenses and film magazines are usually electronically coupled to the camera body. The film sensitivity is set on the magazine and electronically transferred into the camera's metering system. Information between lens and camera body are also electronically transferred to the metering system.

When looking for a camera with a built-in metering system you may want to give serious consideration to investing in a system with the latest digital electronics, since this technology has a reputation for being the most reliable and requires fewer contacts between camera, lens, and film magazine. Contacts, even when gold plated, are a major cause of problems.

In a modern metering camera, the necessary data and warning signals are most likely visible in the viewfinder.

The degree of automation must be your decision. Since a medium format system is not likely used for "point and shoot" photography, automation should not be a major consideration in your choice of a camera. Keep in mind that built-in automation is a convenience that can eliminate mistakes, but that your photographs will have perfect exposure only if you understand the basics of exposure and then meter the scene accordingly.

Using the Built-in Meter

All built-in meters are reflected light meters. They measure the light reflected off the area or subject that is being photographed. They must be used basically as you would use any other reflected meter. Consider everything that is discussed later in this chapter about reflected meter readings and make the same adjustments as you would if you were using a separate reflected meter.

METHODS OF MEASURING LIGHT LEVELS

There are two basic methods of measuring light levels for photographic purposes: using incident light meters or reflected light meters.

Incident Light Meters

In incident reading, the meter measures the light *falling on* the subject. The cell of the incident light meter is usually covered with a domelike diffusion disc. You hold the meter in front of the subject with the cell facing toward the camera, or sometimes facing in a direction between the camera and the main light. You can use many handheld reflected light

meters to measure incident light by sliding or attaching a diffusion disc over the cell.

Incident light meters give the same reading whether held in front of a white, gray, or black subject. In most cases, the reading of the incident meter is correct, so you don't need to bracket, and don't have to learn much about exposure metering. From the point of view of consistency in exposure and simplicity of operation, the incident meter must be a photographer's choice.

Yet because the meter reading must be made by holding the meter in front of the subject, incident light metering is time consuming. It is also impractical, because you have to move away from the camera to make the

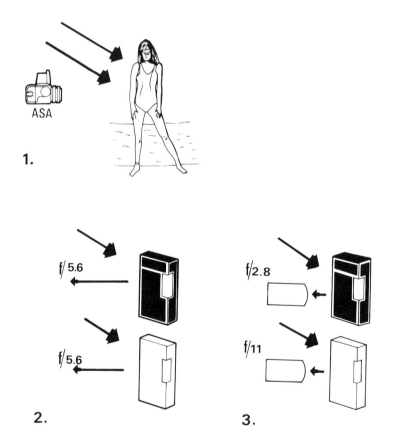

Correct lens settings for exposure are determined by the sensitivity of the film in the camera and the amount of light that falls on the subject (1). The reading on an incident meter is determined only by the amount of light falling on the subject. The reading is, therefore, the same whether the subject is white or black or any shade in between (2). Reflected-light meters measure the amount of light reflected off the subject and, therefore, give different readings for different colored subjects (3).

meter reading. This may be impossible, especially when you are working with a handheld camera.

Obviously, it is faster and more practical to take a meter reading from the camera position, or even with the camera itself. This, however, means you are no longer measuring the light falling on the subject; it means measuring the reflected light.

Reflected Light Meters

Measuring the light from the camera position or through the camera means measuring the light *reflected from* the subject; it means measuring the brightness of the subject as the lens sees it. The meter reading, with the meter pointed at the subject, therefore, depends on two factors: (1) the amount of light that falls on the subject, and (2) the amount of light reflected back from the subject. A light subject gives a higher reading than a dark subject even when both subjects are lit in the same way.

A reflected light meter reading is high for white or yellow subjects, low for black or dark brown, and somewhere in between for green, blue, and red. The variation between white or bright yellow and dark brown or black can amount to four EV values or f stops.

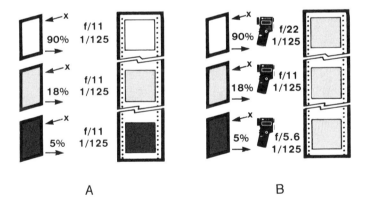

A B

The lens settings that provide correct exposure are based on the amount of light falling on the subject. The lens settings must be the same whether you photograph a subject that is white, gray, or black, and these lens settings will record white as white, gray as gray, black as black. An incident meter (a) provides these correct lens settings. A reflected meter reading is different if you point the meter at a white, gray, or black area even though the same amount of light falls on all (b). If you set the lens for the white reading (f22 at 1/125), white would be recorded as gray, not white. The image is underexposed. A lens set for the black reading (f5.6 at 1/125) would record black also as gray, not black. The image is overexposed. The meter readings are correct only when the meter is pointed at a subject or area that reflects approximately 18 percent of the light (grey, which measures f11 and 1/125).

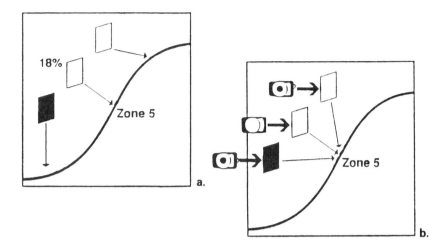

The principle of reflected meter readings is discussed in detail by Ansel Adams in his explanation of the zone system. In Ansel Adam's own words: "Lens settings based on a meter reading of 18% gray will record 18% gray as a middle gray or zone 5. A meter pointed at white will record white also as a zone 5 middle gray and will do the same for black" (b). Normally only middle gray should be recorded as zone 5. To place white and black at the ends of the curve, adjustments must be made in the reflected meter readings (a).

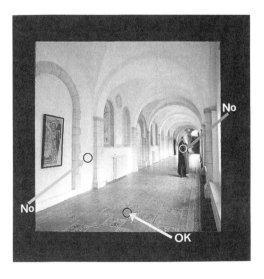

A reflected meter reading gives the correct lens settings only if the reading is taken off an area of average brightness reflecting approximately 18 percent of the light. It is incorrect if the measured area is brighter or darker.

LIGHT REFLECTANCE AND GRAY TONES

The measuring cell in any separate or built-in metering device is adjusted at the factory for a specific value, and the standard in all meters is a middle gray that reflects approximately 18 percent of the light. The meter reading is correct only if the meter is pointed at an area that has a reflectance of approximately 18 percent (a gray card or something similar). A manual adjustment must be made when it is pointed at an area that reflects more or less light.

If the reflected meter reading is taken from a brighter subject, one that reflects more than 18 percent, set the lens at an aperture or exposure value (EV) setting one or two stops larger (*f*8 instead of *f*11; EV 10 instead of 11). Some typical subjects requiring such adjustment are fog (+1 EV number), sand (+1 1/2), snow (+1 1/2–2), white flesh tones (+1), and the palm of the hand (+1). In all cases, *open up* the lens for these lighter subjects.

For subjects that reflect less than 18 percent, *close down* the lens— for example, a blackboard (–2 *f* stops or EV numbers), black flesh tones (−1–1 1/2).

It seems to confuse many photographers why the aperture must be opened on any reflected light meter when reading bright subjects and closed down for reading dark ones. To demonstrate this point, consider the following example: A reflected light meter reading of a subject with an 18 percent reflectance may require settings of 1/125 second and *f*11. The reflected meter reading off a white subject (snow) would be 1/125 second at *f*22. To bring the exposure to the correct 18 percent reflectance reading, you must open the aperture from *f*22 to *f*11.

A reading from any reflected light exposure meter is correct only when taken off a subject of average brightness. Exposure must be increased when reading brighter areas and decreased for readings of darker areas.

Many subjects are of average brightness and, therefore, any metering method will provide correct lens settings for any film, especially in diffused light without lighted and shaded areas.

What Is 18 Percent Gray?

Obviously, we see most of the subjects in the world not as a range of gray tones from white to black, but in all different shades of colors. Each color, like the different gray tones from white to black, reflects a certain amount of light.

Surprisingly, many ordinary scenes reflect about 18 percent of the light that falls on them, so you need correct exposure only rarely. Some typical 18 percent reflectance subjects are green fields and trees, brown earth, fall foliage, blue skies, suntanned faces.

Using a Gray Card

Instead of taking reflected meter readings of subjects of different brightnesses and adjusting for the differences, you can always take an 18 percent gray reading by using the gray card available in camera stores. Hold the gray card in front of the subject, facing the camera, and take a reflected light meter reading from its 18 percent reflectance, so that the same light

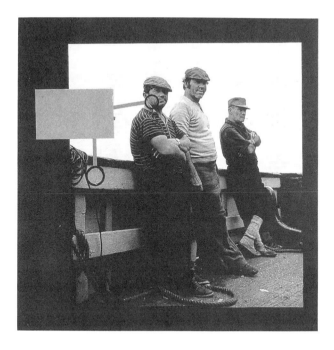

A gray card can be helpful to determine what subject areas have the same value and to compare reflectance values.

that falls on the subject falls on the gray card. Hold the meter not more than 20 cm (8 in.) from the card so that it measures only the gray area. The indicated reading can then be used for the exposure. Although using a gray card is not always practical, the gray card is an excellent tool for close-up photography and for copying.

For photographing documents, lay the gray card flat on the artwork.

Instead of measuring the light reflected off the subject, you can measure the light reflected off an 18 percent gray card. The reading is then the same whether the card is held in front of light or dark subjects.

WHAT TO EXPOSE FOR

Shadows versus Highlights

Usually areas in a picture not only are of different colors but also receive more light than others: some subjects are in bright light, some are in the shade. Which area should you expose for—the shaded areas, the lighted areas, or somewhere in between? I am not referring to dark- and light-colored subjects, but to the amount of light falling on these dark and light subjects. The logical thought might be to set the lens somewhere between the readings of the lighted and shaded areas. If the contrast is not too great, the result probably will be acceptable for negatives, but never the best. Negatives exposed in this way may lack printable shadow details, and slides unquestionably will have washed-out highlights.

Exposing Slides versus Negatives

Negatives must have adequate details in the primary shadow areas, or they will not produce a satisfactory print. With negative films (black and white or color), the meter must be pointed at a primary shaded area that reflects approximately 18 percent of the light.

Transparency (positive) films must generally be exposed for the lighted areas; otherwise, highlights look overexposed, become washed out, and lose color saturation. For good exposures on slide film, the metering area must point at an 18 percent reflectance area in the important lighted part of the scene or subject. Because an exposure meter—even one that is built into the camera—does not know whether the camera is loaded with transparency or negative film, you must determine what area must be measured.

BRACKETING

If you use the exposure meter as recommended, you should have satisfactory exposure in all negatives or slides. *Bracketing*, which means shooting the image at two or more different lens settings, should not be necessary. Bracketing uses a lot of film, especially if you bracket every shot.

Many times bracketing is impossible. When photographing action—sports, candids, anything that is not staged—you do not have the luxury of a second shot, so the first must be right.

Bracketing is recommended when you are shooting slide film of subjects with extreme contrast. The reason is not so much for obtaining a good exposure but for producing the most effective image. Perfect exposure in such cases is not necessarily determined by technical considerations but may be a matter of personal preference. A darker image may be effective because it is dramatic. Early morning shots of scenery or people may be more effective when colors are on the pastel side, creating a low-key effect.

Since today's black-and-white and color films have good exposure latitude, I suggest bracketing in full stops. A difference in one-half f stop is hardly noticeable. One-half f stop bracketing, however, is still recommended for critical work on slide film.

EXPOSURE WITH TELE-EXTENDERS

Tele-extenders (teleconverters) mounted between the camera and lens for the purpose of increasing the focal length of the lens reduce the amount of light reaching the film. The loss is equivalent to two f stops for a 2× extender; one f stop for a 1.4× type. This loss is based on optical functioning and happens in any format, on any camera, with any lens.

How does the loss of light affect the meter reading? With TTL metering, no adjustment is necessary. The built-in meter reading should be correct. If the built-in meter must be set for the lens aperture (usually necessary in prism finders) set it to the maximum aperture engraved on the lens. When the reading is made with a separate meter, increase the reading two stops (for a 2× extender) or one stop (for a 1.4× type).

EXPOSURE WITH PC LENSES OR PC CONVERTERS

With PC lenses or converters no special considerations are necessary when you use a separate meter except the standard adjustments for a converter.

When using PC lenses or converters on a camera with a built-in meter, it is recommended that you take the meter reading before shifting. The ground-glass image may darken as you shift and may give a wrong reading (depending on how the light is measured).

SPECIAL EFFECTS ACCESSORIES

When accessories are placed in front of the lens, exposure of a separate or built-in meter may have to be adjusted. When using accessories that are made from clear glass or plastic, such as close-up lenses and some diffusion filters covering the entire lens or image area, you are not required to make an adjustment regardless of whether the reading is taken from a separate or built-in meter.

Accessories made from colored glass or gelatin and covering the entire lens absorb light and require an increase in exposure when you are using a separate meter. Built-in meter readings are correct with most filters because the light is measured through the filter.

Black masks and vignettes block off some of the light that reaches a built-in meter, so the built-in meter reading made through the mask will be incorrect. The simplest way to obtain the correct reading is to take the meter reading without the mask or vignette and lock the setting, if necessary, with a built-in meter.

OTHER USES OF METERS AND GRAY CARDS

Exposure meters are ideal for determining ratios between main and fill lights, front lights and back lights, subject and background, and shaded and lighted areas. They are important or necessary to ensure even lighting distribution, especially when you are photographing interiors or documents. In all of these cases, use either an incident meter or a reflected light meter with a gray card. When photographing documents, take readings in the center and at all four corners.

Measuring the light falling on the background and comparing it with the light falling on the main subject is especially important in color photography. The background appears on the film in the color observed visually only if it receives the same amount of light as the main subject. Check the lighting ratio with an incident meter by holding the meter in front of the main subject and in front of the background behind the subject. With a reflected meter, make the reading from the gray card held in front of the main subject and then held in front of the background.

DOUBLE AND MULTIPLE EXPOSURES

Combining two, three, or more images on the same negative or transparency creates unusual images that are likely to attract attention because they create a sense of unreality. It requires some artistic sense to decide which images go together, how the lines, shapes, colors of the two images will combine together, and how two or more images can be arranged so that the combination is more effective and beautiful than each individual image. The two or more images need not be exposed on top of each other; they can be composed so that they fall next to each other, or the second image can be arranged so that it falls into an unexposed area of the first.

The double exposure can be a combination of two sharp, general images. More often the best effects are obtained if only one image has a well-defined subject while the other is a pattern of colors and/or shapes and acts as a background for the first. Beautiful images have been created with brick walls, clouds, reflections, flowers, burlap, or paintings as backgrounds. Extremely interesting and unusual possibilities are obtained in color when one of the images is out of focus; it adds touches of color rather than a pattern to the image.

Two images exposed on the same area of the film result in overexposure if normal lens settings are used. For each image, exposure must be decreased an aperture about one and a half stops smaller than indicated on the meter.

One of the two images can be made more or less visible compared to the other by changing exposure, underexposing one more than the other.

The image resulting from double or multiple exposures made in the camera can be seen only after they have been recorded on film—not by

If your camera offers film magazine interchangeability, you need not make the two images to be superimposed one right after the other. You can remove the magazine with the first exposure before the film is advanced, and then attach a second magazine. You can reattach the first magazine with the first exposure anytime later for making the second exposure. This advantage can be very valuable, especially for wedding photographers. You can create many different effects with double exposures. Here a side-lit close-up of a piece of burlap was recorded in the camera over a portrait.

looking through the viewfinder. Test exposures are, therefore, recommended if possible.

GHOST IMAGES

A figure appears as a ghost when the background is visible through the figure. To accomplish this, photograph the same area twice: once with the figure, once without, adjusting exposure as explained previously in the section about double and multiple exposures. This technique can be successful only if the camera remains absolutely stationary between the two exposures.

Electronic and Dedicated Flash

Electronic flash has become the most popular artificial light source in the studio and on location. Portable flash units are small yet produce a large amount of light. The duration of the flash is very short and, therefore, freezes fast action and helps to eliminate unsharp images owing to camera movement. The color temperature of electronic flash matches that of normal daylight, so the two can be combined in color photography.

This chapter mainly describes flash photography with portable units rather than studio lights. The use and application of studio lights is the same in medium format photography as in 35 mm or when working with large format cameras.

FLASH SYNCHRONIZATION

The electronic flash must fire when the shutter is fully open; otherwise a completely or partially blank or underexposed image results. With focal plane shutters, this happens only up to a certain shutter speed. The shortest flash synchronized focal plane shutter speed on medium format cameras is at present 1/90 second.

It is easier to synchronize the flash unit with a lens shutter since a lens shutter exposes the entire film area at the same time. That is why lens shutters can be used with flash at all speeds up to 1/500 second.

Checking Flash Synchronization

If your camera permits you to open the back or remove the film magazine so you can look straight through the lens and shutter, you have an easy way to

163

check whether the electronic flash is synchronized with the shutter. With lens shutters, set the diaphragm to its widest aperture and the camera at the shutter speed to be checked. Attach the synchronization cord to the PC flash socket. With the flash unit connected to the lens or camera, point the camera toward a light wall. Place your eye approximately 1 ft. behind the rear of the camera and trip the shutter while looking through the back of the camera. If you see a perfect full circle, the flash is synchronized. If the flash is not visible at all or not through the fully open lens, the flash synchronization is off. For a complete check, test synchronization at all shutter speeds, including the top speed of 1/500 second.

Check a focal plane shutter in the same way. The flash is synchronized with the focal plane shutter if you can see the flash over the entire film area. For a complete check, test at all the synchronized shutter speeds.

FLASH UNIT SIZE

The size of a flash unit is determined mainly by the power source, which in turn determines the brightness of the flash and the number of flashes per charge. A small camera-mounted flash is fine if you work mainly within about 5 m (17 ft.) of your subject, but it will not give sufficient light to photograph a banquet hall or factory interior, especially when the required depth of field means that you must use small apertures.

BATTERIES

Flash units can be powered by regular penlight batteries.

Rechargeable batteries are the choice of the working photographer who uses flash frequently. They can be recharged a great number of times, and if used frequently, are more economical than regular penlight batteries.

AC-powered flash units, limited to indoor use, usually consist of separate lamp heads and a power pack. The lamp heads are usually mounted on light stands together with reflectors or umbrellas.

LIGHT OUTPUT AND GUIDE NUMBERS

The brightness of most portable units is indicated in guide numbers. The guide number is the product of the lens aperture multiplied by the distance needed for correct exposure. For any flash unit the guide number varies with the speed of the film you use. Most companies quote the guide number for 100 ASA (21 DIN) film.

If the guide number for a certain film sensitivity is not available, you can determine it easily from the guide number of a lower or higher expo-

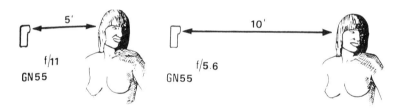

To determine the correct aperture for a flash photograph, divide the guide number into the distance between the flash and the subject. For example, if the guide number (GN) is 55 and the distance is 5 ft., the correct aperture is $f11$ (55 ÷ 5 = 11). With the same GN, but at twice the distance, the correct aperture would be $f5.6$ (55 ÷ 10 = 5.5).

sure index rating as follows: For an ASA rating twice as high (or the DIN rating three points higher), multiply the guide number by 1.4; for example, if the guide number for 200 ASA film is 110, then the guide number for 400 ASA is 110 × 1.4 = 154. Divide by 1.4 for an ASA rating of half (or a DIN value three points lower); for example, if the guide number for 21 DIN is 42, the guide number for 18 DIN is 42 ÷ 1.4 = 30.

COVERING POWER

Guide numbers do not tell the entire story about the performance of a flash unit. Its brightness at a certain distance depends on the size of the area over which the light is spread.

You can have a flash unit that is very bright but covers only a limited area. The covering power indicates the area over which the unit spreads the light fairly evenly. This is an important specification especially if you work with wide angle lenses.

All portable units will cover the area of the standard lens; most of them also cover the area of a "long" wide angle (about 60 mm on a 2 1/4 in. square or 6 × 4.5 cm camera). Few will light the area of shorter wide angles satisfactorily. Check the unit specifications. Many portable units have an accessory lens or diffuser for increasing the covering power. If proper coverage is not possible, consider incident or bounced flash, multiple flash, or bare bulbs.

FILTERS

All electronic flash units produce a daylight-type lighting and produce pleasing colors on daylight film without the need for filters. With flash units that are considered somewhat on the cool, bluish side, warmer results can be obtained with an R1.5, an 81A, or an 81B color balance filter.

READY LIGHT

The ready light indicates when the flash unit's capacitor is charged and thus when the camera can be released again. If a picture is made before the ready light is on, the flash will not fire or will fire with less than the full amount of light, a frequent cause of underexposure.

PORTABLE FLASH UNITS

Portable flash units can be mounted on the camera with a camera bracket or can be used on a separate stand using extension cables or slave units. The shutter synchronizing connection is usually made with a sync cable between flash and camera or lens.

Slave Units

Off-the-camera flash units, studio and portable types, can be fired by slave units, eliminating the need for cable connections between camera and flash. One small flash, mounted on the camera, can fire one or any number of flash units off the camera as long as each flash unit is equipped with its own slave.

Radio and infrared slaves have become popular. They work by transmitting a sync signal to a receiver. The triggering device and the slave do not need to be in a direct line to each other. The radio or infrared signal offers more flexibility in the positioning and allows for placing flashes at greater distances. The sync signal is not apt to be fired by another photographer unless the other photographer is working on the same radio frequency.

Synchronization Cable Polarity

Synchronization cables can usually be attached to portable flash units in only one way, so there is no problem about polarity. Flash cables used on studio units, however, may have plugs that can be connected either way. For safety's sake and to avoid possible damage to the synchronization contacts in the camera, connect the cable so that the grounded contact on the flash unit connects to the shutter contact that is grounded to the camera body. You can check the cable hookup as follows: Attach the cable to the power pack and camera. Touch any exposed metal part on the lamp head or light stand with an exposed metal part of the camera. If the light does not flash, polarity is correct. If the light flashes, reverse the cable.

ON-CAMERA FLASH

A flash unit mounted on the camera offers the greatest camera mobility, but it also produces flat front lighting, not the type one usually associates

with portrait photography. However, this setup has its advantages: the subject's eyes—the most important part of the facial features—are well lit, and wrinkles are suppressed.

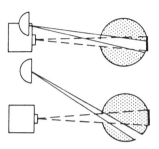

Using on-camera flash when photographing people often produces pink eye, which is caused by the reflection of the flash light off the back of the blood-filled retina (top). You can avoid this problem by placing the flash farther from the camera so that the retina is not caught straight on (bottom).

A good position for a flash unit is above the camera lens—high enough to avoid pink eye.

The best position for the flash is directly above the camera. Place the flash head at least several inches—preferably about a foot—above the camera lens to eliminate pink eye. *Pink eye* is caused when the flash is reflected straight back from the retina at the back of each eye. With the flash well above the camera lens, the light enters the pupil at a slanted angle and does not illuminate the retina directly behind the pupil. Pink eye may also be avoided by photographing people with their heads slightly turned, rather than looking straight into the camera.

A flash placed directly above the camera lens also casts the shadows from people's heads below their shoulders where they might not be seen. How high the flash must be to accomplish this depends on the subject-to-camera distance and the subject-to-background distance. The closer the

subject to the background or the further the camera from the subject, the higher the flash unit needs to be.

INDIRECT AND BOUNCED FLASH

Indirect flash, with the light reflected off umbrellas, reflectors, walls, or ceilings rather than shining directly on the subject, produces a soft over-all light. The light illuminates the subject from various angles and there-fore reduces or eliminates harsh, sharp shadows.

Umbrellas offer the simplest, most portable solution for indirect flash illumination; the umbrella can be folded when not in use. Flash unit and umbrella are mounted together, with the flash tube pointing at the center of the umbrella. The softness of the lighting produced by umbrellas and any other reflectors is directly related to their size and distance from the subject. The larger the umbrella or reflector, the larger is the spread of light. If positioned close to the subject, the umbrella or reflector provides light that reaches the subject from different angles, producing an almost shadowless light. The same umbrella or reflector placed far from the sub-ject becomes more a point source of light, producing stronger shadows, al-most like direct flash.

For the softest light, use the largest-sized umbrella, positioned close to the subject. A soft lighting can also be obtained with portrait studio lights or a soft box, which is nothing more than a flash head with a large diffusion screen in front of it; the diffusion screen, usually made from a white translucent fabric, can be of any size.

Walls and ceilings in a room can be used to bounce flash. Ceilings are satisfactory for long and group shots but not for portraits. Illuminating people from above does not produce a very flattering image; it produces shadows under the eyes and little light in the eyes, especially when the light comes from a steep angle.

Bounced lighting can be improved by adding some direct light. Some new flash units incorporate this principle by incorporating two flash heads.

Some flash units come with diffusion filters, which can be placed in front of the flash tube. A diffusion filter can spread the light over a larger area, but it can produce a softer illumination only if the filter is much larger in diameter than the flash head.

MODELING LIGHTS

AC-powered studio units are usually equipped with modeling lights that allow you to see the lighting effect on the subject. Because the modeling lights stay on when the flash exposure is made, they should not be too bright; otherwise they register on the film as a secondary (ghost) image or

as a slight change in exposure and color. The effect can be avoided by using faster speeds (1/125–1/500 second) or by turning off the modeling lights when shooting.

SPECIAL FLASH UNITS

You can achieve lighting without shadows when light of equal intensity reaches the subject from all directions. In commercial photography a tent is a popular method to accomplish this result. The object or objects are placed inside this tent made from white translucent material, and the light sources are placed outside.

The ring light is another solution for surrounding a small subject with light. A ring light, a round flash tube that can be mounted over the camera lens, lights the subject evenly from all sides but only when the flash-to-subject distance is close. The ring light is popular in medical photography. But its greatest value is that it allows photographing of the inside of radios, television sets, and other machinery; otherwise it is practically impossible to light every corner and eliminate disturbing shadows.

Makroflash units consist of two compact flash units mounted on the front of the lens with a bracket. By moving the flash units to different positions, you can produce an almost shadowless light or other lighting effects using only one flash head.

FLASH FIRING FAILURES

Probably the most annoying occurrence in photography is when flash pictures are made and the flash does not fire.

If you have a flash failure, make sure you know where and what to check. Most flash units have an on-off switch. Start by checking this switch. Check whether the ready light is on. If it is not, there may be no batteries in the unit, or the batteries may be dead or very weak. The battery contact may be poor, perhaps corroded, or an AC unit may not be plugged in. Make certain the flash synchronization lever is at X, if this is necessary, or the shutter speed is set within its synchronization capability. On some cameras, the flash will not fire if the shutter speed is set beyond the synchronization range. Determine whether the synchronization cables are properly connected; sometimes they can become disconnected from the contact on the camera or lens or from the connection on the flash.

PC coaxial plugs are not good electrical connections. If one feels too loose, gently squeeze it with pliers into an oval shape, thereby making a firm connection at least on two sides. It is a good practice to have spare sync cables readily available. If the synchronization terminal on the lens

appears to be loose, replace the terminal. If you use the flash a lot, the insulation in the terminal may wear out, permitting drain on a flash unit's capacitor. Try another cable if available. If nothing helps, the fault may be in the shutter synchronization, which then should be professionally repaired. You might try another lens, or, in the case of focal plane shutter models, switch from the lens to the camera shutter, or vice versa.

FLASH EXPOSURE

Flash Meters

Flash meters are usually incident light meters. You hold the meter in front of the subject and measure the light that falls on the subject when the flash is firing. The exposure readings are very reliable and unaffected by the color and brightness of the subject. Practically all professionals use these meters when working with electronic flash in the studio—not only for correct exposure but also for checking lighting ratios and for measuring and comparing the amount of light falling on the subject and the background.

Determining Aperture

In manual flash, setting the correct aperture depends on determining the flash-to-subject distance, which is where the flash unit guide number comes in. To obtain the correct aperture, divide the guide number into the

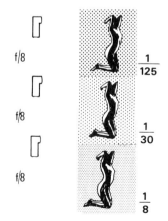

With electronic flash, the exposure is determined only by the aperture. The shutter speed has no effect as long as it falls within the synchronization range of the camera.

flash-to-subject distance. (Guide numbers are given either in feet or in meters, so choose the same units.) For example, if the guide number is 110 and the subject is 10 ft. away, the correct aperture is 110 ÷ 10 = ƒ11.

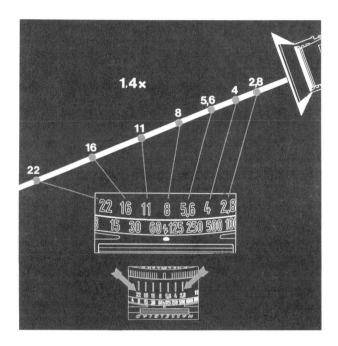

The brightness of any light source is reduced the equivalent of one ƒ stop if the light is moved 1.4× further away. The aperture values on a lens are also multiples of 1.4 and can, therefore, be used as distances in feet or meters. To reduce the light the equivalent of one ƒ stop, for example, move the light from 8 feet (ƒ8) to 11 feet (ƒ11).

You can also calculate the flash distance for any aperture. For example, to use ƒ11 with a guide number of 88, the correct flash distance is 88 ÷ 11 = 8 ft. With today's flash units, these calculations are no longer necessary because the information is on the flash unit.

Power Ratio

Today photographers are not limited to one aperture for each distance and film sensitivity. They can match the flash to a certain aperture that produces the desired depth of field, or vice versa. This is extremely helpful when you are combining flash and daylight.

Modern portable flash units include a capability that has been found in studio units for years: variable power output, the thyristor concept applied to manual operation. By changing a switch to 1/2, 1/4, 1/8, or perhaps

up to 1/64, the amount of light is reduced to 50 percent, to 25 percent, or frequently down to 1.6 percent, allowing one to photograph at different apertures.

The shortened recycling time of a reduced flash is another highly appreciated benefit of variable power output. When the unit is set at less than full power, only a fraction of the stored energy is used up. Thus, it takes a shorter time to refill the capacitor. Instead of having to wait 6 to 8 seconds for the ready light to go on, you are ready to shoot again in a second or less.

Refilling a partially emptied capacitor also requires less power from the batteries. Instead of getting perhaps sixty flashes, the same battery or batteries give several hundred—perhaps even more than a thousand flashes at 1/64.

Shutter Speed

Since flash duration is likely shorter than the speed of the focal plane or lens shutter, shutter speeds do not affect flash exposure. If flash pictures are made in a completely dark room of more or less stationary subjects, the image on the film is the same at any shutter speed.

But rarely are flash pictures taken in a completely dark place. In a house, an office, a school, a store, a restaurant, a gymnasium, or outdoors—there is other light: daylight, tungsten, or fluorescent. As soon as there is another light source, the shutter speed becomes important for determining the most effective exposure for the picture. The shutter speed determines the brightness of the surrounding areas—the living room, the church interior, the outdoors.

You can make the area surrounding the subject dark by using a fast shutter speed—a desirable approach when the background is unattractive, might be distracting, or simply if you want to concentrate attention on the flash-lit subject.

The surrounding area, the room, becomes part of the image with a slower shutter speed, with the flash becoming almost a secondary rather than the main light. You can determine the shutter speed by doing a meter reading of the ambient, the existing room light. The effect of a slow shutter speed is especially beautiful and natural with incandescent lights, which produce a warmer color than the flash.

Selecting Aperture and Shutter Speed

In most locations the effectiveness of flash pictures depends on the lighting ratio between the existing light and the flash. In producing a good

Right: Flash fill (b) adds light and life to an outdoor portrait. The flash exposure can easily be balanced to the daylight.

A B

When flash is used in any location with ambient light (usually the case), shutter selection is very important. The shutter speed will determine how much of the ambient light is recorded on the film. For example, at an aperture of $f8$ (a), a shutter speed of 1/125 second will record very little background detail, whereas one of 1/8 second will give a much lighter background at the same aperture.

A B

combination of light, selecting aperture and shutter speed becomes crucial. Proceed as follows:

1. Use your regular handheld or built-in exposure meter to determine the amount of ambient light—the daylight outside the window, the light in the room, or the light in the background of an outdoor portrait—and decide which aperture and shutter speed combination provides the desired depth of field and the desired exposure for that part of the scene. Keep the focal plane shutter speed within its flash sync range.
2. Set the selected aperture and shutter speed on the lens or camera, which then will provide the desired exposure for the existing light.
3. With dedicated or automatic flash, make the exposure. With manual flash, set the flash unit to the distance required for the set aperture.

In dedicated or automatic flash, you set aperture and shutter speed to give the desired depth of field and exposure for the existing light, the background. Flash exposure is automatic based upon the set aperture.

Changing the Lighting Ratio

The foregoing procedure should produce a 1:1 *lighting ratio*, which means correct exposure for the flash and the existing light; this is fine in

many cases. At this lighting ratio, pictures of people, however, may look somewhat overflashed, which is desirable when it is important to see their features, as in publicity shots. Outdoor or wedding portraits, on the other hand, would look overflashed, so for more pictorial results set the flash exposure at one stop less. How is this done without changing the exposure for the existing light? In dedicated operation, simply change the ASA setting. For a one-stop reduction, set the ASA to double the rating of the film—to 200 for 100 ASA film.

With automatic flash, make the same ASA adjustment on the flash unit. In manual operation, close the lens aperture one stop then compensate the ambient light exposure by lengthening the shutter speed.

Some of the newest medium format cameras made for dedicated flash have a flash fill function. The desired reduction in the flash exposure is programmed into the camera. For example, if you program −2/3, the flash exposure is reduced 2/3 without changing the ISO setting. You can always change the exposure for the ambiant light by changing the shutter speed, as discussed earlier.

AUTOMATIC FLASH

An automatic flash unit is equipped with a sensor in the unit pointing in the same direction as the flash head. The sensor picks up the light reflected from the subject, just as a reflected light meter does. As soon as the sensor receives the correct amount of light from the flash for the aperture setting, it turns off the flash.

Automatic units provide surprisingly accurate exposures within the distance range indicated on the flash unit. But as with exposure meters, you will not obtain perfect exposures automatically at all times. You must pay attention to a few points.

The sensor must aim at the main subject, not at something closer or farther away (a background wall, for instance). The main subject must also be sufficiently large in size to be read by the sensor. Furthermore, keep in mind that the sensor reads reflected light, and the reading is affected by the reflectance of the subject. Exposure is most accurate when the subject reflects about 18 percent of the light. A bright subject reflecting more light shuts the flash off too soon, resulting in underexposure. A dark subject keeps the flash on too long, causing overexposure.

DEDICATED FLASH

Dedicated flash is a modern, convenient, reliable, and useful form of location flash photography. Unlike in an automatic flash unit, the automation works hand-in-hand with the camera, through special contacts between the camera and the flash unit.

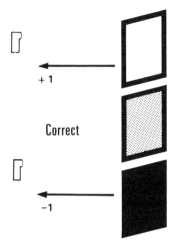

In dedicated and automatic flash, the amount of light reflected back to the sensor depends on the brightness of the subject. A light subject reflects more than the average amount of light and may cause underexposure; a dark subject reflects less light, keeps the flash on too long, and causes overexposure. To compensate adjust the ISO setting.

The electronic components necessary to dedicate camera and flash may be built into the camera or flash unit, or the dedication can be obtained with an adapter mounted between flash and camera. The film sensitivity is set on the camera, (not the flash unit). The photographer sets the flash unit to the TTL engraving on the flash unit.

The electronic interfacing between camera and flash relies on a sensor in the camera, usually measuring the light reflected off the film plane (OTF). This OTF measuring has many obvious advantages that eliminate mistakes and result in better exposures. The sensor measures the light that actually reaches the film and does so with the lens diaphragm already set to the aperture for shooting. You need not worry about matching the aperture setting on the lens with the flash. You can change the lens aperture while shooting without having to make a change on the flash. Because it always reads the actual amount of light falling on the film, the sensor works with direct or bounced flash, whether the flash is on or off the camera. Backlight does not falsify the reading, and you need not compensate when using bellows or extension tubes.

Dedicated flash photography offers one other important benefit and convenience that must be emphasized: there is a flash-ready light visible in the camera viewfinder. You can keep your eye constantly on the viewfinder, a valuable benefit when you need to shoot fast or when you want to take several pictures of the same subject. The same or another signal in the viewfinder usually indicates whether the flash produced sufficient light for correct exposure.

Although dedicated flash works beautifully and provides consistent exposures in the simplest possible way, there are a few facts you must know and understand to obtain the best possible results.

Color of the Subject

A sensor measures the light reflected off the subject. Strictly speaking, exposure can be correct only when the subject has average brightness (that is, reflects about 18 percent of the light). A much brighter subject turns the flash off too soon and results in underexposure; a darker subject does the opposite. These variations will exist and may cause concern, especially for the wedding photographer, who works with brides dressed in white and grooms dressed in black. Wedding photographers who have been using a dedicated system for years will admit that variations exist, but they also claim that their exposures are well within limits, seldom exceeding half an f stop. This is probably because it is rare that the subject covering the measuring area is all white or all dark; it is usually a combination of many shades, giving an acceptable average exposure.

If you want or need to make an adjustment, you can easily do so by changing the ISO. Set it higher for bright subjects, lower for dark ones.

Different Films

Exposure is determined by the amount of light reflected off the film surface. As film bases vary somewhat in color and reflectance, there can be slight differences in exposure from one film to another.

The variations among transparency films seem to be small. Slides should have the correct flash exposure regardless of what film you use, because the sensor in cameras is usually adjusted for slide films. Most black-and-white and color negative films reflect somewhat more light, turning the dedicated flash off too early. This results in underexposure that can amount to one third to two thirds of an f stop. While this still results in good printable negatives, you may want to compensate by setting the ASA slightly lower, to about 80 for 100 ASA film; to 320 for 400 ASA. It is naturally best to make your own film tests and then have the results evaluated by your lab.

Test Exposures

When using dedicated flash, the exposure is determined by the light reflected off the film. Therefore, you must have film in the camera even if you only want to check whether the light is sufficient for the selected aperture. You may have to waste a frame. Of course, you could use out-

dated film for this purpose in a special magazine, or the sheet film holder. You can also make many test exposures on the same frame of film.

NOTES ABOUT COMBINING FLASH
WITH DAYLIGHT

Portraits, fashion shots, publicity pictures, and family snapshots are very beautiful when the sunlight is used as a backlight or strong side light. When photographing during sunsets or sunrises, use a warming filter over the flash to match the warm light of the setting sun and sky. Otherwise, the use of flash is too obvious.

A 1:1 lighting ratio between the sunlit background and the flash fill is fine for a publicity photograph (left). Reducing the flash by one stop without changing the exposure for daylight results in a pictorially better image, with the sunlight becoming the dominant light source (right).

For using flash outdoors as a fill-in light when photographing people, you may want to consider a small shoe-mount unit. You will need very little light because very seldom will you be shooting from more than 3 m (10 ft.) from the subject, and outdoor portraits are usually made at large lens apertures to blur out backgrounds.

Flash can also be used outdoors as a main light. When you are photographing in flat overcast lighting, the flash can take the place of the missing sun. Flash can also be used as an accent light, to add either highlights to products or a hair light to portraits, which may be missing on an overcast day, or when you are photographing in the shade.

Flash is a superb solution when you are photographing close-up nature pictures on an overcast day. Flash adds life, gives the impression of sunlight, allows you to work at smaller apertures, and can reduce the likelihood of blurry pictures owing to camera or subject movement. You have tremendous flexibility in your use of lighting: you can make the flash a front light or even better, a side light or a back light.

GHOST IMAGES

Shutter speeds are an important consideration when you are photographing fast-moving subjects, such as indoor sports. To freeze action, you want to get an exposure from the flash only, not from the ambient light. The latter produces a *ghost image*—an image that overlaps the sharp flash image. The total effect is unsharpness.

When photographing with flash in a well-lit location, such as at an inside sporting event, a high shutter speed is needed to eliminate the ghost image created by the existing light. The secondary ghost image is the reason for the unsharpness and the shadows along the skater's body, photographed at 1/60 second (left). At 1/500 second, the existing light will not register on the film, resulting in a sharper image with no ghost effect (right).

In sports arenas, on a theatre stage, the existing lights can be very bright, causing a ghost image even at relatively fast shutter speeds of 1/30 or 1/60 second.

For this type of photography, full flash synchronization up to 1/500 second is a prime requirement. It is the only way to eliminate ghost images. Most basketball pictures, for example, are made at 1/500 second.

In other fields of photography, you may actually want to use this ghost effect to create a special image—a combination of the sharp image created by the flash and the blur produced by the combination of ambient light and a long shutter speed. Shutter speeds can be of any length, 1 second or even longer, since all shutters synchronize with flash at longer speeds. The ghost (streak) effect can be produced either with a moving subject or a moving camera.

In either case the flash gives the sharpness, the moving subject or camera, the blur. At longer shutter speeds, shutters usually fire the flash the moment they are fully open. The sharp flash image is, therefore, produced first; the "ghost" comes afterwards. Accessories are available to do the opposite with lens and focal plane shutters—fire the flash at the end of the exposure. The "ghost" is then produced first, the sharp image afterwards.

Close-up Photography

BUILT-IN BELLOWS

If close-up photography is a prime objective, the medium format camera with built-in bellows deserves serious consideration, provided that the other features meet your requirements.

Bellows, long popular accessories for close-up photography, are built into some medium format cameras. Instead of the lens being mounted into the camera body, it is attached to a board that is coupled to the camera with a bellows. This construction eliminates the need for individual focusing mechanisms in the lenses. The built-in bellows is not just for close-up photography; it is the focusing mechanism for photographing at all distances from infinity down to a certain close focusing limit.

With a bellows, the minimum focusing distance is considerably closer for all lenses than with the equivalent lenses mounted on a camera body. This can be a great advantage not only when you are doing close-up photography but also when you are working with longer lenses.

Bellow-fitted lenses are interchangeable just as are regular lenses that mount on the camera body. The minimum area coverage and the magnification depend on the focusing range of the lens. A built-in bellows may not extend as far as a bellows accessory, but it can still allow you to photograph all possible close-ups using shorter focal length lenses. Since it is part of the camera, the bellows is always there, ready to be used, and it does not need to be removed for shooting at long distances. Working with a bellows camera is somewhat like working with a view camera. All focusing is done by extending the bellows more or less. The camera-lens connection is not as rigid as with a lens mounted directly on a camera body, so you need to be somewhat more careful handling and operating the bellows camera so as not to disturb the optical relationship.

On other medium format SLR cameras with interchangeable lenses, to photograph at close distances you need to use accessories.

Close-up accessories are easy to use and do not complicate operations or require calculations. The choice of accessory depends on the size of the area to be covered and the focal length of the lens.

LENSES

Macrolenses (lenses that focus from infinity down to inches) have become popular in 35 mm, but they do not exist for medium format cameras.

The longer focal lengths require longer focusing travel, which together with the larger lens diameter necessary for the medium format makes macrolens mounts difficult to design and manufacture.

Close-up photographs can add the most interesting images to your library, showing greatly magnified details that we normally overlook.

In close-up photography lenses behave exactly as they do at longer distances. The camera-to-subject distance determines the perspective. Different focal length lenses cover different background areas. Different focal length lenses can also cover the same area from different distances. Longer focal length lenses blur backgrounds more than do shorter ones.

Standard and short telephotos will produce good image quality in close-up photography with a medium format camera system.

The retrofocus wide angle lenses on SLR cameras are good at long distances but suffer a loss of quality at close distances even without acces-

sories. Used even closer with accessories, the loss of quality is even greater. The retrofocus types with floating lens elements are better than the ordinary type. If the wide angle, on the other hand, is the only lens that produces the desired results, use it. Close down the aperture to compensate partially or completely for the loss of quality.

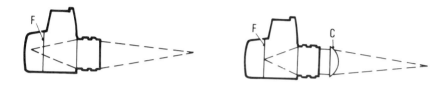

A subject that is closer to the lens than the minimum focusing distance of the lens forms its image behind the film plane (F). The addition of a Proxar lens (C) can bring the image onto the film plane.

Close-up Accessories: Close-up Lenses

Proxar or close-up lenses are positive lenses that are mounted in front of the camera lens like a filter. They should be positioned as near the front element as possible. Proxars can be used with any focal length lens and also with zoom lenses. A Proxar allows closer focusing, but you must remove it for shooting long shots. Most manufacturers indicate the strength of their close-up lenses in diopter power like eyeglass lenses; others engrave the focal length on the lens. Diopter is just another way of expressing the focal length of a lens. The diopter power of various close-up lenses is found on the chart on page 184.

The diopter power or focal length determines the subject distance at which the lens produces sharp images. With the lens on the camera set at infinity, a close-up lens always produces a sharp image when the subject distance, measured from the close-up lens, is equal to the focal length of the close-up lens.

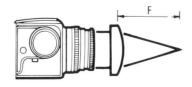

With the lens on the camera set to infinity, the correct subject distance measured from the Proxar lens is always equal to the focal length (F) of the Proxar lens.

The following distances thus apply:

Focal Length of Close-up Lens	Diopter Power	Subject Distance*	
2m	+0.5	79 in.	2 m
1m	+1	39½ in.	1 m
0.5 m	+2	19¾ in.	0.5 m
0.33 m	+3	13 in.	0.33 m
0.25 m	+4	10 in.	0.25 m

*Subject distances in this case are measured from the close-up lens, not from the film plane.

Although these distances apply for the infinity setting on all lenses, the focusing ring on the lenses need not be at infinity when you take the picture. You can use the focusing ring as you normally would for fine focusing.

Since adding a close-up lens means adding a lens element to a well-corrected camera lens, image quality on the edges suffers somewhat, depending on the power of the Proxar. Stopping down two to three f stops can restore quality. With lenses up to 0.5 m (+2 diopters), the loss of quality is rarely noticeable at the small apertures normally used in close-up work.

You can combine two Proxar lenses. The power of the combination is obtained by adding the two diopter strengths. For example, a +1 and a +2 close-up lens yields a +3 diopter lens.

Close-up lenses do not alter the exposure, so you can use the lens settings obtained from your normal exposure meter.

Proxars are the easiest of the close-up accessories to use, but they are meant only for low magnification work—when it is necessary to go just a little closer than the focusing range of the lens. Strong close-up lenses (+4 to +10 diopters) could be used for higher magnifications but with an obvious loss of quality.

EXTENSION TUBES AND BELLOWS

Extension tubes and bellows are physically different but serve the same purpose in close-up photography. Both are mounted between camera and lens so that the lens is farther away from the film plane. They are, therefore, an extension of the focusing ring. The longer the tube or bellows you use with any particular focal length lens, the closer you can photograph and consequently the higher the magnification is.

The same extension tube or extension on the bellows gives different magnification with different focal length lenses—a higher magnification with shorter lenses, a lower magnification with longer ones. The necessary

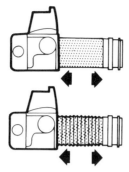

Extension tubes and bellows serve the same purpose; they move the lens farther away from the film plane. An extension tube and a bellows extended to the same length produce the same magnification and image.

extension length for various lenses can be determined from the following formula:

length of extension = focal length of lens × magnification.

For example, the extension necessary to obtain 0.5 times magnification with an 80 mm lens is 80 × 0.5 = 40 mm; and with a 120 mm lens, 120 × 0.5 = 60 mm. Knowing this relationship eliminates time-consuming experimenting, moving cameras, and adding and changing lenses and accessories to find out what area you can cover.

From the same formula, you can determine the magnification:

$$\text{magnification} = \frac{\text{length of extension}}{\text{focal length of lens}}$$

The formulas above are not scientifically accurate because they depend on the design of the lens, but they are sufficiently accurate for photographic purposes.

$$E = M \times F$$
$$E = .5 \times 80 = 40$$
$$E = .5 \times 150 = 75$$

The necessary length of an extension tube or bellows for a particular magnification can be determined easily from the formula E = M × F, where E is the length of the tube or bellows, M the magnification, and F the focal length of the lens.

If close-up photography is not a daily affair, extension tubes will serve your needs. Since they are fixed in length, you may need two or three tubes. But they are small and lightweight, so even two or three are easy to carry.

Bellows are suggested for higher magnifications and when close-up work is a major part of your medium format photography.

This life-size magnification image was made with a bellows and electronic flash.

Right: A good bellows offers the advantage of two controls. One moves the entire camera-lens combination and thus changes the subject distance (S). The other moves the film plane farther from the lens and thus changes the image distance (I).

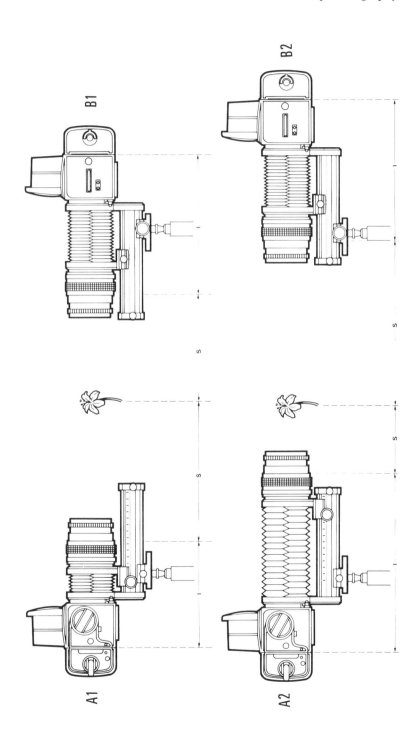

MAGNIFICATION

Everything in close-up photography revolves around magnification. Magnification indicates how much larger (or smaller) a subject is recorded on the film; it is the ratio in size between the actual subject and the size of the image recorded on the film. You can measure the image on the focusing screen after sliding off the viewfinder. A more practical way is to base the size on the area coverage. We know the dimension of the film format—55 mm for both sides of the 2 1/4 in. square or the longer side of 4.5 cm × 6 cm, about 70 mm for the long side of 6 × 7 cm. You can calculate magnification by dividing the negative side into the width or length of the area covered. If you can cover an area 220 mm wide, the magnification is 55 ÷ 220 = 0.25 or 1:4 for the 2 1/4 in. square.

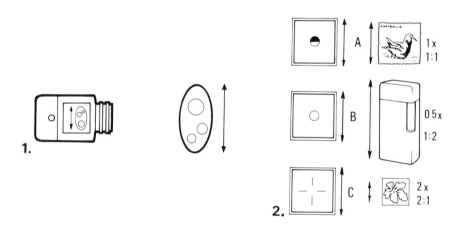

Magnification is the relationship between the size of the actual subject and the size of its image as recorded on the film or seen on the ground-glass screen of the camera (1). Because the size of the subject is usually known in close-up photography, magnification can be determined quickly by relating the subject size to negative size (2). For example, if the subject is about the same size as the negative, there is 1:1 magnification (A); when the subject is twice as large (B), there is 0.5× or 1:2 magnification; and when the negative is filled with a small subject half as large as the negative (C), there is 2× times or 2:1 magnification.

PHOTOGRAPHING SUBJECTS LIFE SIZED

A subject is recorded life sized, in 1:1 magnification, when the area coverage of the subject is equal to the film format; the length of the extension needed is equal to the focal length of the lens (80 mm with an 80 mm lens, for example).

You can obtain life-size magnification with any camera and lens when the distance between camera and lens is increased by an amount

equal to the focal length of the lens. In reference to close-up accessories, adding a bellows extension or extension tubes equal in length to the focal length of the lens produces life-size magnification.

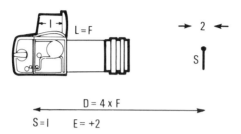

Life-size magnification is always obtained when the length of the extension tube or bellows, L, is equal to the focal length, F, of the lens (L = F). The distance from the subject to the film plane, D, is equal to four times the focal length (D = 4 × F). The exposure increase, E, is always two *f* stops. The depth of field at *f*11 is about 2 mm.

DEPTH OF FIELD

Depth of field in close-up photography is determined only by the area coverage (magnification) and the aperture (*f* stop) of the lens.

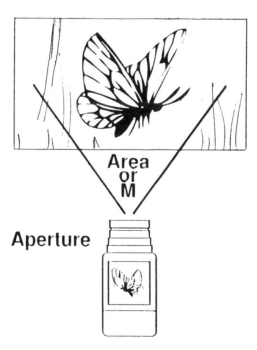

In a way, depth of field is determined only by area coverage (magnification) and lens aperture.

If tubes and bellows seem to produce less depth of field, it is not because of the equipment but because of the higher magnification. Since the area coverage or magnification is usually predetermined, depth of field can be increased or decreased only by opening or closing the aperture. Although depth of field is identical with different lenses, the sharpness beyond the limits of the depth of field falls off rapidly with a longer lens and more gradually with a shorter lens.

DEPTH OF FIELD AT VARIOUS MAGNIFICATIONS

Magnification	Total Depth of Field in mm at $f11$*	
	A	B
0.1×	100	50
0.2×	30	15
0.3×	15	7
0.5×	6	3
0.8×	3	1½
1×	2	1
1.2×	1.5	0.7
1.5×	1	0.5
2×	0.8	0.4
3×	0.4	0.2

*About half of the depth of field is in front and half behind the set distance.
A: Circle of confusion 0.06 mm (1/400 in.).
B: Circle of confusion 0.03 mm (1/800 in.) for very critical work.

To determine the depth of field at other apertures, keep in mind that when you close the aperture two stops, the depth of field becomes about twice as large; by opening the aperture two stops, depth of field is cut down to about half.

The above figures clearly indicate the limited depth of field in close-up photography and show the importance of extreme accuracy in focusing.

EXPOSURE

Correct exposure in close-up photography is no different from that of photography at long distances. Take the meter reading within the small area recorded on the film based on the principles discussed in the chapter on exposure.

A built-in meter, especially if it is a spotmeter, simplifies reading the small area. With a separate meter consider taking a gray card reading; it gives a large area for a reflected meter reading and reflects the proper amount of light for correct exposure. The gray card is a good aid for all reflected meters, even in combination with a built-in meter.

The built-in meter reads through the accessory, so there is no need to consider extension factors. Whatever the meter says should be correct regardless of what lens and close-up accessories you are using.

If you are taking a meter reading with a separate meter, you need to consider the so-called exposure factor. This is necessary because the tubes and bellows move the lens farther from the film plane and the light is spread over a larger area; consequently less light reaches the film.

A formula to determine the correct aperture with a tube or bellows (new A) is shown here. F is the focal length of the lens, L the length of the tube or bellows, and A the aperture indicated on a separate light meter.

The increase in exposure is based mainly on the ratio between the focal length of the lens and the length of the extension. The increase can be determined from a simple chart, as shown below, which applies to any camera. This chart is helpful when close-up tables are not available.

EXPOSURE INCREASES

Extension ÷ focal length	*Increase in Exposure in f Stops or EVs*
$^1/_{10}$ to $^1/_5$	$^1/_2$
$^1/_4$ to $^1/_3$	1
$^1/_2$	$1^1/_2$
1	2
$1^1/_2$	$2^1/_2$
2	3

For example, a 120 mm lens with a bellows extension of 180 mm will need an increase in exposure of 2 1/2 f stops or 2 1/2 EV (180 ÷ 120 = 1 1/2) based on the previous chart.

THE CAMERA

The SLR camera with its accurate framing and focusing makes close-up photography easy.

A motor-driven camera offers advantages. The motor-driven film advance eliminates the danger of moving the camera, which can happen when you have to advance film manually. A tripod is recommended for most close-up work. The mirror lockup must be used.

FOCUSING

In handheld close-up photography, focusing is made easier by moving the camera back and forth rather than turning the focusing ring until the subject is sharp on the ground glass. You can hold the camera with both hands in the most convenient fashion rather than holding the camera with one hand and using the other for operating the lens.

Close-up accessories can be combined. A Proxar in front of the lens can be added to a tube and bellows.

Filters for Better Image Quality

There are five basic reasons for using filters: to obtain 'correct' color rendition on color film or correct gray tones on black-and-white film; to enhance color images or change gray tones in black and white; to create special effects and moods; to reduce the amount of light reaching the film; and to protect the lens.

FILTERS AS LENS PROTECTION

Lenses are the most expensive components in a camera system. They are also the components that are most easily damaged and probably the most expensive to repair. A simple way to protect the front element is with an optically plain piece of glass, which is easy to clean and relatively cheap to replace. A skylight, ultraviolet, or haze filter can serve this purpose. These filters do not change the colors or gray tones noticeably and do not require a change in exposure.

Each of your lenses should be equipped with a filter. It is too time-consuming to switch filters from one lens to another every time you change lenses. Since the filter becomes a permanent part of the lens and all pictures are taken through this additional piece of glass, the filter must be made to the same degree of perfection as the lens. For color photography, use the same filter on every lens made by the same company to avoid possible differences in color rendition. A sunshade over the lens is essential when you use a filter. It is a further protection against possible mechanical damage and prevents snow or rain from falling on the lens element.

NEUTRAL DENSITY FILTERS

Neutral density filters, also called gray filters, are used in both black-and-white and color photography. Made from neutral gray-colored glass, the neutral density filter is designed to reduce the amount of light reaching the film without changing the tonal rendition of various colors. Neutral density filters come in different densities requiring the following compensating increases in exposure:

Density	Percentage Light Transmission	Increase in Exposure in Exposure Values or f stops
0.3	50	1
0.6	25	2
0.9	12	3
1.2	6	4
1.5	3	5
1.8	1.5	6

Neutral density filters can be combined, but this also means you need to increase the exposure. To obtain the total density, add up the densities of each filter; for example, the 0.3 and 0.6 filters combined have a density of 0.9.

Neutral density filters can be used outdoors—for example, when the sunlight is too bright to permit photography at large apertures with shallow depths of field or to allow slow shutter speeds for blurred motion or zoom effects. Neutral density filters can also be used to compensate for different film sensitivities. The most valuable application for neutral density filters in practical photography is for experimenting with Polaroid test shots; you can use the same aperture and shutter speed for both the test shot and the final image.

FILTERS FOR BLACK-AND-WHITE
PHOTOGRAPHY

In black-and-white photography, colors are recorded in a range of gray tones from white to black.

The main application of filters in black-and-white photography is for darkening or lightening certain colors to emphasize, suppress, separate, increase, or reduce contrasts. You can lighten or darken any color. The color of the filter determines what happens to what color; the degree of color change is determined by the density of the filter. The color wheel, as shown on the next page, makes it easy to determine the effect of filters

in black-and-white photography. To lighten a color, use a filter of the same color or at least from the same side of the color wheel. To darken a color, select the color directly across the wheel or at least from the opposite side. A yellow filter darkens colors from blue-green to violet. Green filters lighten green and darken purple and red.

The color wheel makes it easy to determine how a color filter affects the recording of gray tones. Subjects that have the same color as the filter will be lighter. Those having a color on the opposite side of the wheel will be recorded darker. A yellow filter darkens blue skies.

In black-and-white photography, a yellow filter produces some improvement in distant shots, but orange and red filters are more effective. Complete or almost complete haze penetration can be obtained with a red filter combined with infrared film, but other colors also change; for instance, green appears as white.

EXPOSURE INCREASE

A filter absorbs light. With light-colored filters (UV, haze, and some light-balance and color-compensating types), the light loss is so small that it need not be considered in exposure determination. Darker filters, on the other hand, take away a sufficient amount of light to affect exposure. As a

result, you need to adjust lens settings. With a built-in metering system, the light is measured through the filter, and the light loss is automatically compensated for. The meter readings are, therefore, correct for most filters. When a separate meter measures the light, you need to make an adjustment in the exposure settings based on the information from the filter manufacturer.

Some companies provide the necessary increases in filter factors, others in apertures. It is important to know which figure is on the chart so that you will know how to apply the numbers.

FILTER FACTORS AND f STOPS/EV

Filter factor	1.5	2	2.5	4	6	8	16	32	64
Increase in exposure in f stops or EV	½	1	1½	2	2½	3	4	5	6

The exposure correction shown in the chart can be made either by multiplying the shutter speed by the filter factor or altering the f stop or EV setting by the aperture increase. For example, with a 4× (or +2 stop) filter, change from EV 13 to EV 11 or from f11 to f5.6.

HAZE PENETRATION: HAZE, UV, AND SKYLIGHT FILTERS

Most modern lenses absorb UV light to a greater extent than do haze or UV filters. Modern glasses used in lenses have reduced or eliminated the need for UV, skylight, and haze filters, but these filters are still recommended for lens protection.

COLOR QUALITY OF LIGHT

Color transparency films are manufactured for a specific so-called color temperature of the light source, and correct color can be obtained only if the color of the light matches that for which the film is balanced. The color quality of light, its color temperature, is expressed either in Kelvin or in decamired values. Kelvin and decamired values are directly related by the formula

$$\text{DM value} = \frac{100,000}{\text{Kelvin value}}$$

The color films used in medium-format photography are matched to the following color temperature values:

Daylight type 18 DM, 5600 K

Tungsten type 31 DM, 3200 K

To determine the temperature of an unknown light source in critical color photography, use a color temperature meter.

COLOR TEMPERATURE OF TYPICAL LIGHT SOURCES

DM	Kelvin	Type of Light
8	12,500	Shade with clear blue sky
16	6,250	Overcast day
17	5,900	Electronic flash
18	5,600	Sunlight at noon
29	3,450	Photofloods
31	3,200	Tungsten lamps
34	2,900	100–200 W household lamps
36	2,800	40–75 W household lamps
54	1,850	Candlelight

LIGHT BALANCE AND CONVERSION FILTERS

Light balance and conversion filters are used in color photography for matching the color quality of the illumination to that of the film or to obtain a warmer or cooler color rendition in the image. Light balance filters are used for minor adjustments, conversion filters for a more drastic change.

The filters that have a warming effect are the decamired red types, the 81 series light balance and 85 conversion types; those with cooling effects are the decamired blue types, or the 82 series light balance and 80 conversion filters. The warming filters are used when the light is too blue for the film in the camera; the cooling filters when the light is too red.

The proper or suggested filter is obtained from charts or from the indications on a color temperature meter.

FILTER VALUES REQUIRED IN VARIOUS CONDITIONS

Purpose	Decamired Filters	Wratten Filters
For a warmer rendition with some electronic flash units (some units produce a bluish light)	R 1.5	81A
To reduce warm tones in early morning and late afternoon photography	B 3	82B
To use Tungsten type color film in daylight	R 13.5	85B
To use daylight film with 3200 K light	B 13.5	80A
To use daylight film with 3400 K light	B 12	80B
To use Tungsten type film with 3400 K light	R 1.5	81A
With flash cubes on daylight film	B 1.5	82A
When using Tungsten type film with household lamps	B 3	82C

Slight warming filters such as 81A or 81B (R 1.5 or R 3) used to be recommended for all color photography outdoors on overcast days or to reduce the blue in shaded areas. The color films that we have today have been improved and produce warmer colors, eliminating the need for these filters. This is true especially for the X designated films that have come on the market recently. Make your own tests.

COLOR-COMPENSATING FILTERS

Color-compensating filters (CC filters) are available in six colors (yellow, magenta, cyan, red, green, and blue) and in different densities in each color, from about 0.05 to 0.50. These filters are most readily available in gelatin. One of their main applications is compensating for variations in the color balance of professional films. Some other applications are photographing through tinted windows; photographing underwater, to compensate for the loss of red; photographing under fluorescent lights; and general adjustments or corrections in the color rendition.

SPECIAL FILTERS FOR FLUORESCENT LIGHTS

The light from a fluorescent tube is not evenly distributed through the spectrum, so the quality of photographs taken under fluorescent light with color film can be unpredictable. Film and fluorescent tube manufacturers publish charts showing which color-compensating filters produce the most satisfactory results.

Special filters for fluorescent lights are also available—usually one filter for daylight film, another for Tungsten type. These can produce acceptable results with some fluorescent tubes.

POLARIZING FILTERS

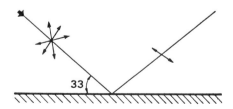

Reflected light is polarized only if it hits the surface at a certain angle—between 30° and 40°.

Opposite page: A polarizing filter can eliminate or reduce reflections, but only when you photograph the subject with the reflecting surface (the store window, in this case) from an angle.

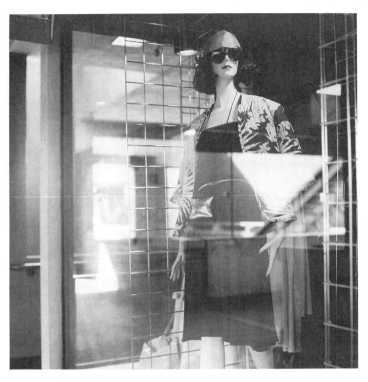

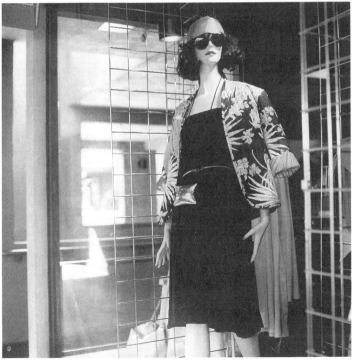

Natural, unpolarized light vibrates in all directions (A). As it passes through a polarizing filter (B), the light becomes polarized; it vibrates in one direction only. If this polarized light meets another polarizing filter (C) with its axis of polarization in the same direction as the first, the light can pass through. A polarizing filter with its axis of polarization at right angles (D) to the first will absorb all the light. This arrangement is called *cross-polarization.*

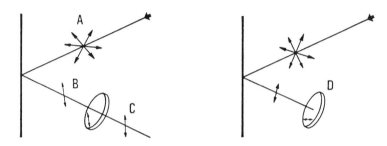

When natural, unpolarized light is reflected by a surface, it becomes polarized and vibrates in one direction only. In this state, it can pass through a polarizing filter with an axis of polarization in line with the light (A), but not through one at right angles to this position (B). In the latter case, reflections are eliminated.

Light that reaches our eyes or the camera lens directly is usually unpolarized; the light waves vibrate in all directions perpendicular to the light path. If such light reaches glass, water, or many other reflecting surfaces at an angle, between 30° and 40°, it becomes polarized; the resulting light waves vibrate in one direction only.

Polarizing filters are made from a material that changes natural into polarized light. If the light reaching the polarizing filter is already polarized, the filter can either let the polarized light pass through or absorb it.

Uses for Polarizing Filters

A polarizer is an outdoor photographer's most important filter with a wide range of applications:

Maximum polarization (darkening of the sky) is obtained when the sun is to the side. With front or back light, the polarizing filter has no effect.

1. For darkening skies. This is only possible with side light. The filter has no effect when you photograph toward or directly away from the sun. Polarizing filters offer the only practical method for darkening blue skies on color film.
2. To improve the details in distant shots. The polarizer is the only filter that will improve such images in color photography. This, again, works only when you photograph in side light.
3. To reduce or eliminate reflections from virtually any shiny surface (except bare metal).

The reflections can be from store windows, walls of buildings, reflections of water, rain-covered streets, wet leaves, grass or from glossy photographs, paintings, pictures under glass or in any type of copying. When you reduce reflections, you increase color saturation, so many surfaces appear deeper in color.

Such reflections are reduced or eliminated only when the subject, the window, for instance, is photographed at an angle of 30° to 40°, not straight on.

In copying or photographing art, of course, you want to photograph straight on to avoid keystoning. In such cases, the polarizing filter is of benefit only if you also place polarizers over the light source or light sources so that the light reaching the subject is already polarized. This process is described in more detail in chapter 17 in the section on copying.

Light must also be polarized to eliminate reflections from bare metal.

While reducing or eliminating reflections is very desirable, or even necessary, it can also be undesirable, as reflections are very natural, for example, on porcelain and silver. Reflections add life and beauty to water surfaces. Eliminating them can make subjects appear dull and uninteresting, so watch the effect in the viewfinder when you use polarizing filters.

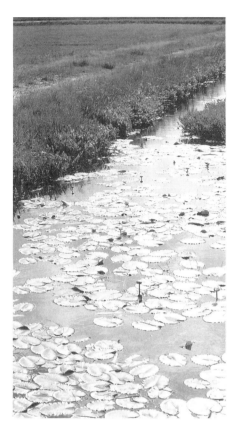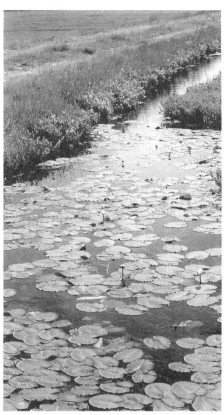

Images of water surfaces can be changed drastically with a polarizing filter, which eliminates or reduces the reflections. Many times reflections are desirable since they add life and color to the water surface.

Technical Points about Polarizers

When using polarizers you can see the effect in the SLR finder or by simply holding and turning the polarizer in front of your eyes. Thus you can know beforehand whether and to what degree the filter improves the shot.

Because polarization depends on the angle of reflection, the polarizing effect may not be the same over the entire image area, especially when you are using wide angle lenses. Reflections on a water surface may be eliminated at the bottom of the image but not at the top; a blue sky may be bluer at the bottom than at the top, or bluer on the left side than on the right. Such differences can be picked up in the viewfinder, so evaluate the image carefully before shooting.

Polarizing filters require an increase in exposure because the polarizing material is not clear but has a grayish tint, somewhat like a neutral density filter. The increase is usually one or one and a half f stops. The required increase is the same regardless of how the filter is rotated—whether to the position of minimum or maximum polarization. If the polarizing filter eliminates reflections over a large area of the frame, however, the resulting image may appear darker. In such cases, another half-stop increase in exposure may give you better results.

Exposure meters built into cameras may or may not give the correct lens settings when the light is measured through a polarizing filter. It depends on the design of the meter. Check with the manufacturer or make your own tests.

Although polarizing filters look like neutral density filters, unlike the latter, they may cause a slight change in color rendition. The change is visible only when you compare two pictures, taken in the same location with the same light, both with and without a polarizing filter.

PARTIAL FILTERS

Filters that are clear over half of their area and neutral gray or colored over the other half are readily available. The filters must be square and mounted in a square filter holder so that you can move them vertically or horizontally. You can use these partial filters to improve an image or to create a special effect. Neutral density filters can be used to darken some areas while leaving other areas undisturbed. You can change colors in some areas with color filters while leaving other areas unfiltered.

When positioning the filter, you need to view the ground-glass image at the aperture that you plan to use or, even better, determine the aperture that produces the desired results while manually opening and closing the diaphragm. The dividing line between the filtered and nonfiltered area and its position in the image depends on the aperture setting.

If the filter darkens or changes the color over the main subject area, you need to consider the filter factor in determining exposure. More often, the filter is used to darken or change the color over a secondary area such as the sky, in which case you don't need to consider the filter factor in determining exposure. In that case the main area—the landscape, the water, and the beach below the sky—is not affected by the filter, so your lens settings are based on the regular meter reading of the unchanged area.

QUALITY OF FILTERS

Filters used with high-quality lenses for critical photography must be made to the same quality standards. This is especially important when you use filters all the time, when you combine filters with long focal length lenses, or when you combine filters.

Although optically polished glass filters should be your first choice from a quality point of view, some of the latest acrylic types seem to come close or even match the quality of glass filters.

FILTER MAINTENANCE

Glass filters are cleaned like lens surfaces, by blowing or brushing off dust; clean them with lens tissue and lens cleaner only if necessary. Never use lens cleaner or any other chemical solvent for cleaning plastic types. A soft brush or blower will remove dust. Grease or finger marks can be removed with a soft polishing cloth, if necessary, after you breathe on the filter surface. Avoid unnecessary brushing and cleaning.

Place a lens cap over a filter on the lens, and store loose filters in a plastic case.

The flowers in the foreground are completely blurred by using a 250 mm lens wide open. They add a touch of color to the composition. The square format makes the outdoor setting an effective part of the composition. Photograph by Ernst Wildi.

Closing the aperture on the telephoto lens to f32 provides the desired maximum depth of field. Photograph by Ernst Wildi.

Completely different moods and feelings are created on a bright, sunny day (top) and on a foggy morning (bottom). Photographs by Ernst Wildi.

Overcast, rainy days add a beautiful mood and feeling to an outdoor setting and eliminate the need for worrying about the contrast between lighted and shaded areas. This is especially helpful when you are photographing in wooded areas. Photograph by Ernst Wildi.

The evening sun provides dramatic lighting, effective shadow patterns, and beautiful warm colors in an ordinary outdoor location—here a swimming pool in Cyprus. Photograph by Ernst Wildi.

A compact, lightweight medium format camera with a large aperture lens can be used handheld for documentary work just like a 35 mm. Taken at a ƒ2 aperture on 100 ASA film. Photograph by Ernst Wildi.

Large aperture lenses allow you to shoot medium format photographs in low light levels without high speed films. Taken at ƒ2 on 100 ASA film at the Grand Old Opry, Nashville. Photograph by Ernst Wildi.

Polarizing filters can improve the color saturation drastically in distant shots, but only when the light comes from the side. Photographs by Ernst Wildi.

Soft focus filters provide the simplest solution for adding a soft touch to a bridal portrait taken during the wedding ceremony and allow you to use the same lens, a short telephoto in this case, for sharp candids. Photograph by Andy Marcus.

A compact, lightweight medium format camera makes a superb tool for all wedding work, whether it is a portrait or candid handheld photography during the wedding. Photograph by Andy Marcus.

A full-frame fish-eye lens is not just for special effects, but can be a most effective tool for creating that special picture of a special occasion without the typical "fish-eye distortion." Photograph by Monte and Clay.

This image was created with a standard electronic flash and a medium format camera equipped with a digital imaging back equipped with an area array. Image data was downloaded directly into a computer. Photograph by Rudy Guttosch.

Taken with a standard lens and 2× tele-extender. A small lens aperture also provided depth of field from foreground to background. Photograph by Ernst Wildi.

A medium format camera with a PC lens or PC teleconverter can produce professional architecturals with perfectly straight verticals. Taken with a 50 mm lens and PC teleconverter. Photograph by Ernst Wildi.

The possibilities for close-up photographs are unlimited with most medium format SLR cameras. Taken with an accessory bellows. Photograph by Harry Przekop.

Professional Soft Focus Photography

There are many wonderful opportunities for creating beautiful images with a "soft touch" in a number of fields of medium format photography. Soft focus adds a glamorous touch to portraits, bridal shots, and fashion shots while at the same time reducing the need for negative or print retouching. Softness in advertising images of beauty products or anything else associated with beauty and romance, food and drinks, can enhance the sales appeal. In landscapes, a soft touch can emphasize the shimmering highlights of a backlit scene.

Although soft focus photography is not too frequently used in 35 mm, it is an important and extensively used approach in many fields of medium format photography.

CREATING THE SOFT FOCUS EFFECT

From an optical point of view, you can soften an image in a number of different ways:

1. With a special lens that is optically corrected to produce a soft image. The degree of softness is determined by the lens aperture.
2. With a specially designed lens that produces a sharp image through its center but diffracts the light going through holes of different sizes on its outside portion. The degree of diffusion is determined by the aperture and the size of the holes.
3. By placing in front of a regular sharp lens a glass or plastic plate which refracts part of the light before it enters the lens, introducing superimposed illumination over the image.

4. By attaching a filter containing nontransparent particles. The filter diffracts part of the light before it enters a regular sharp lens.

SOFT FOCUS LENS OR ACCESSORY

Many portrait photographers believe that it is necessary to invest in a special soft focus lens and that only such a lens can produce professionally salable results. Other photographers who have combined sharp lenses with soft focus accessories feel that their approach makes more sense and that they can produce equally effective results.

In my mind either approach works, but here are some of the points that you need to keep in mind when making a decision about how to achieve soft focus:

1. Soft focus accessories can produce a beautiful and completely professional soft touch at a much lower cost than special soft focus lenses.
2. Since you can produce the soft touch with your existing lenses, you need not carry an additional lens on location just for this purpose.
3. With a soft focus lens, all soft pictures must be made at one and the same focal length—the focal length of that special lens. With accessories you can select the focal length that is perfect for that particular shot—a wide angle, a standard, or a telephoto—and can switch from one to the other instantly.

Because you can remove the soft focus accessory, you are free to experiment with shooting identical images with and without softness or with different degrees of softness without even moving the camera.
4. When evaluating the soft focus images, look not only for the soft effect but also for sharpness. An effective soft focus image cannot have an overall appearance of unsharpness because our eyes are used to seeing sharp contours. Decide on a soft touch method that maintains sharp contours and just adds a soft glow to the edges for a poetic touch.
5. With a soft focus approach that maintains sharp contours, focusing the image on the ground glass should be easy since you can focus on sharp details within the subject. With an accessory device you can probably also focus the lens without the accessory, if you prefer.
6. You must definitely find out whether the lens or accessory produces the same degree of softness at all apertures or whether the soft effect depends on the lens aperture. Some lenses or accessories produce a very soft image at large apertures but less or no softness when stopped down. In order to achieve the desired softness with these devices, you must shoot at prescribed apertures. This is unacceptable for many applications.

Opposite page: A professional soft focus effect (top) can be created with filters used in front of a regular, sharp lens (bottom). A good soft focus filter bleeds the highlights into the shaded areas without creating an overall blur. Note the sharpness of the buttons, the dots in the model's shirt, the fingernails, and the bracelet.

Outdoor scenes, product shots, especially close-ups, may require the smallest aperture for depth of field. A portrait, on the other hand, may call for a large aperture to blur the background. Choose a soft focus lens or accessory that gives you the freedom to select the lens opening for the desired or necessary depth of field and allows you to change the aperture without changing the softness.

7. Soft filters can also be used in enlarging for areas where shade bleeds into highlights. Used on an enlarger, soft filters also reduce the visibility of the grain and subdue highlights, an effect that is often desirable.

EXPOSURE

With soft focus lenses the aperture is set based on the meter reading as with any other lens. Soft focus accessories that are completely clear should not require an increase in exposure. Other accessories that create the soft effect through a pattern of clear and nontransparent areas may absorb some of the light and, therefore, require an increase in exposure, but the increase is likely less than one f stop.

DEGREE OF SOFTNESS

The desired degree of softness in an image is mainly a personal choice of the photographer or the client. If your main or only purpose is "optical retouching"—reducing the visibility of skin imperfections to limit expensive and time-consuming negative or print retouching—a touch of softness is sufficient or best. Heavy diffusion is best limited to those instances when you want to emphasize the soft effect. The desired degree of softness in a picture depends on other aspects, mainly lighting.

LIGHTING

A more directional light, which produces a higher lighting ratio and sharp-edged shadows, requires more diffusion than the light from an umbrella or soft box placed close to a subject, which produces a soft light with soft-edged shadows. Here I refer to the directional aspect of the light, not the lighting ratio between main and fill light.

To say it another way, if you increase the directional aspect of the light, you may want to change to a stronger diffuser. If you make the light softer, you may want to reduce the degree of diffusion.

In portrait photography, it is best to decide on the direction and type of lighting first based on your desired results; you can decide on the degree of softness afterwards. If you use a soft focus accessory it is easy to

check and evaluate the lighting before placing the accessory in front of the lens.

IMAGE SIZE

You may prefer a higher degree of diffusion in a large image, a close-up portrait, than in a full-length shot outdoors where the background is an important part of the image. It is then not so much the size of the figure that determines the degree of softness but the mood and feeling that you want to create. For scenics, backlight offers usually the most effective opportunities for soft effects.

BACKGROUNDS

In most cases the background in a studio portrait does not determine the degree of diffusion, although some experts will say that a portrait made in front of a brightly lit white background requires less diffusion than a portrait made on a darker background. Nevertheless, careful choice of a background is important indoors and out because you need to avoid creating a halo effect.

HALO EFFECT

Since all soft focus accessories and soft focus lenses bleed highlights into shaded areas, a halo may become visible next to brightly lit areas. When such halos are obvious they are disturbing; usually halos occur when the subject is photographed against a dark background. Evaluate the image carefully on the focusing screen. If the halo looks objectionable, switch to a lighter background, perhaps a different lighting or a weaker diffuser.

CLEANING SOFT FOCUS ACCESSORIES

Most soft focus accessories are made from a synthetic resin material. They should never be cleaned with any chemicals or lens cleaning fluid. Brush; if necessary, use water. Although many manufacturers claim that these new accessories are scratch resistant, treat them with care.

Digital Imaging and Medium Format

by Rudy Guttosch

During the past several years the increased use of computers in imaging has resulted in a profound change in the image production methods used in publishing. As computers have become faster, software more diverse, peripheral devices capable of higher quality, and the cost to acquire all this technology has decreased, the use of digital imaging has expanded to many photographic disciplines and specialties. And, of course, medium format has not been left behind in this digital revolution.

You may have no need or interest in getting involved in electronic imaging right now, but you cannot ignore it. I highly recommend that every serious photographer, especially every professional photographer, embrace electronic imaging and learn as much as possible about it.

IMAGE INPUT

Digital Backs for Medium Format Cameras

Available today, specifically for the medium format photographer, are products that one might call *digital film magazines*. They have been designed for attaching to a medium format camera body in the same way that you would attach film magazines.

A digital back uses a "charge coupled device" (CCD) to digitize an image. CCDs are light-sensitive microelectronic devices that are manufactured using the same type of technology that is used to make memory chips and CPUs for computers, as well as other solid state devices.

Here a digital imaging back is attached to a medium format camera instead of the regular roll film magazine.

CCDs are most often manufactured in two basic geometries: linear and area (see figure, opposite page). A linear array, as its name implies, is a series of light-sensitive cells arranged in a line on a silicon wafer. An area array is a two-dimensional array of light sensitive cells. Both types of sensors are employed in digital imaging products that attach to medium format cameras.

Both linear and area arrays are used in digital backs for medium format cameras; linear arrays are also used in many desktop scanners. With a linear CCD, it is necessary to physically move the array through the image plane in order to record an image; with an area array no physical movement is required. Some general characteristics for cameras built around linear and area arrays are given in the table.

Area Array	*Linear Array*
Medium resolution (files typically 12MB)	Usually higher resolution (files can be 40 MB or more)
No lighting restrictions	Requires special lighting (lights must be DC powered)
Can photograph moving subjects in color or black and white	Cannot photograph moving subjects in black and white or color

LINEAR ARRAYS IN DIGITAL BACKS

Linear arrays are especially useful for digitizing flat artwork—that is, large prints or chromes that require extra-fine detail or that will be blown up to a

Linear ## Area

Digital imaging backs with both linear and area array CCD geometries are available for medium format cameras.

very large size. They are also useful in studio situations for still subjects that will be reproduced at a very large size. By contrast, area arrays provide somewhat lower resolution, but some still have enough resolution to reproduce images at up to 12× enlargement (the enlargement factor is based on the physical sensor size) using a 150 lines per inch halftone screen.

A typical linear array setup will involve a medium format camera body and lens along with the digital imaging back and a computer. The computer controls the movement of the linear array through the image plane and the acquisition of image data. As the array moves, it transfers image data directly back to the computer. Image capture takes time, in some cases up to several minutes. As a result, you cannot record moving subjects and cannot use electronic flash.

Lighting

You need a stable light source to illuminate the scene. The light must not vary either in color or strength while the linear array is moving through the image plane.

Even the typical tungsten light that you might have in your studio is unsuitable. Such light sources have a high-frequency ripple that, while not observable by the human eye, is nonetheless present. This ripple manifests itself as dark and light banding in a digitized image.

Fluorescent lighting is also not suitable for similar reasons. Natural daylight can work as long as the light remains constant and the exposure isn't so long that it permits moving shadows.

For best results, special lighting is recommended. The most popular flicker-free light source is called HMI. It produces a constant light output and can be used in video and movie production as well.

The digital imaging backs usually have some method for automatically balancing themselves to the color temperature of the light source. This function is similar to that found on video cameras.

Color Images

You can obtain color images by using red, green, and blue filter strips, which are mechanically placed in front of the linear array during the image acquisition interval. For color images the array will make three passes over the image plane, changing filters for each pass or the back may employ three linear sensors mounted side-by-side and moving in unison. In this case each of the three sensors is covered by a red, green, or blue filter.

AREA ARRAYS IN DIGITAL BACKS

Area arrays are used in several digital camera designs, and there are digital imaging backs on the market that fit specific medium format cameras; there are no moving parts in the back itself. With the area array the entire image plane is captured at one time. An area array is most like film, and when exposure times of less than a second are used, it can be treated in much the same way.

Lighting

Since an area array captures an entire scene with one exposure, there are fewer restrictions on light sources. Fluorescent, tungsten, HMI, electronic flash, and natural daylight can be used.

Since the CCD's sensitivity is deficient in the blue portion of the spectrum, it is advisable that you use light sources with a strong blue component, such as electronic flash or daylight-balanced HMI.

Resolution

With the current CCD technology, area arrays have lower resolution than linear arrays. However, the resolution of area-array-equipped digital backs for medium format cameras is excellent for images up to 15 × 15 inches, and perhaps even larger if images are resampled on the computer.

Color Images

Color images with an area array can be obtained with one of two techniques: a filter wheel can be placed over the lens or a mosaic of minute filters can be deposited over the array during its manufacture.

With a filter wheel, three exposures are necessary, with the wheel being rotated before each exposure. This approach rules out using the camera for moving subjects.

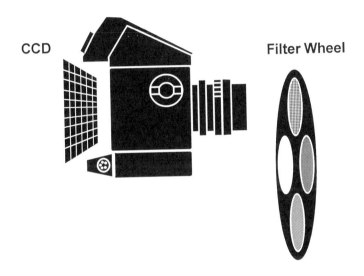

CCD　　　　　　　　　　　　　　　**Filter Wheel**

A filter wheel is one method of obtaining color with a CCD area array.

A filter mosaic will allow motion photography but will reduce the effective resolution of the image as compared with a filter wheel. To see why this is so, let's consider a 2048×2048 element CCD area array. With a filter wheel, each of the three exposures results in a full 2048×2048 record of the filter. With the mosaic method, there is only one exposure on a 2048×2048 array, and three colors wind up sharing the image data. At first glance it appears that the mosaic method results in an image with one third the image data of the filter wheel method. But with some image processing and the appropriate choice of filter colors, this loss in image data can be reduced somewhat.

Before investing in a digital camera back for a medium format camera, consider the final size of the images you need as well as the type of photography you plan to do. These considerations will determine your choice of color capture technology.

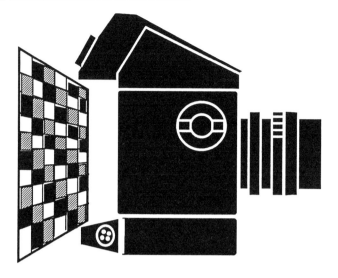

A mosaic of red, green, and blue filters can be placed over the CCD to create color images.

SCANNERS

Scanners can be used to digitize your medium format film and prints. There are a number of options for scanning your film or prints. Also you may choose to buy your own scanner or send your images out to be scanned.

The two types of desktop scanners commonly used for digitizing images are flatbed and film. Both types usually come with their own software that allows you to control the scanner directly with popular image editing programs.

Flatbed scanners are usually used for scanning reflective artwork such as photographic prints or drawings. Optional equipment may also allow you to scan transparencies. Before buying any piece of equipment, check it out to make sure it will perform at the desired quality level.

Film scanners are designed to scan film. Some can scan only positive film; others can handle negatives as well. Many film scanners are made to accept 35 mm film only. Some are multiformat and will scan 35 mm, medium format, and 4 × 5 originals.

Instead of buying your own scanner, you can engage a service bureau to produce scans for you and record them on a removable disk. A variety of disks are commonly used, including removable magnetic, magneto-optical, and photo CD disks. This way, you can get scans for use on your computer without investing in hardware yourself.

COMPUTER IMAGE ENHANCEMENT EQUIPMENT

Hardware

To be able to handle image files on your computer, you will need hardware customized for image handling. A computer that performs well when calculating spreadsheets can become overburdened when processing images. Therefore, when planning a computer system for image editing, understand your needs and budget. Here are a number of devices you need to consider:

Microprocessor

Image editing will require a fast computer processor. Images can take up several tens of megabytes (some are even larger!), and to push around that much data in a reasonable amount of time requires a powerful microprocessor. If you skimp here and buy yesterday's technology to save money, you may not be happy when you end up spending a lot of time waiting for your computer to complete successive processing steps.

RAM (Random Access Memory)

Image processing programs run faster when there is a large amount of RAM available. Plan on at least 16 MB of RAM. If you want to do commercial work, plan on more.

Video Controller

To be able to see accurate colors on your video monitor, you will need to use a video controller card that enables your monitor to display more than 256 colors (an 8-bit video board). You will need a card capable of 16- or 24-bit color display (16,000 or 16 million colors). If you will be doing commercial work, you'll need a 24-bit color card.

Monitor Size

A large monitor will let you view more of your image while you are editing. It is important to keep in mind that many video controller cards are specified to deliver a certain number of colors at a certain display size. Make sure your monitor and video controller card are compatible.

Hard Disk

Just as you will need plenty of RAM when processing your images, you will need a large-capacity hard disk for storing your images. A couple of hundred megabytes is not enough. At least 300 MB is a good starting place. Again, if you plan on doing commercial work, a larger capacity disk is a good idea.

Removable Media

Some type of removable storage medium is a good idea. Removable media will allow you not only to get scanned files back from a service bureau but also to back up your disk files for safety. If you are wondering what type to get, you might talk to knowledgeable service bureau personnel in your area to see what types of disks and tapes they can accept.

Software

The sophisticated software that used to be available only on million-dollar space program computers can now be purchased for well under a thousand dollars. Of interest to photographers are three types of programs that are used to enhance and retouch images, create drawings and illustrations, and place these images and illustrations together with type on a finished page.

Image editing programs typically give you the ability to control scanner input, adjust contrast and color balance, use retouching tools, and control output to printers. Sharpening, special effects filters, and cloning are usually also included.

By using an illustrating program along with image editing software, it is possible to combine electronic images with drawn objects. The resulting hybrid images can be unusual and quite striking.

If you plan to do commercial work, software for page makeup will likely be necessary. This software combines type and graphics and allows you to place them in position on a finished page. In addition to controls for typeface, type style, and type size, most of these programs also provide controls for other factors such as line spacing, letter spacing, kerning, and tracking. You can crop images, resize them if necessary, and then place them in position on the page. Finally, you can send the entire page out to a service bureau to make separations and produce a proof.

IMAGE OUTPUT

The final result of most photographic efforts is some kind of printed hard copy, often in the form of a retouched chrome, a photographic print, or a

four-color printed piece. Choices for hard copy output from a computer-based image are varied. It is possible to produce prints, four-color proofs, and film directly from a computer or from a disk made in the studio.

Paper Prints

Paper prints can be made in two types of printers—color print paper recorders and thermal dye sublimation printers.

Color Print Paper Recorders

A color print paper recorder can take output from a computer and write the image onto a piece of photographic paper. Often the image is written with lasers or a filtered beam of light. After exposing, the paper is processed normally. Advantages of this type of printer include the low cost of consumables (paper and chemistry) and a product that looks and feels like a traditional print.

Thermal Dye Sublimation Prints

Another option for hard copy output is to transfer the computer image data to a thermal dye sublimation printer. This printer uses heat to force

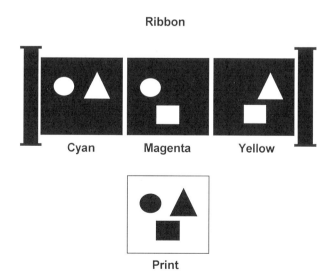

Thermal dye sublimation printers use a ribbon divided into three sections—cyan, magenta, and yellow.

dye out of a color ribbon and onto a sheet of receiver paper. The ribbon is divided into repeating sections of cyan, magenta, and yellow dye. To produce a print, the printer makes three passes each with a color ribbon section in contact with the paper. There is no wet chemistry involved in making the prints. The cost of prints is higher than with color print paper recorders because of the high cost of consumables.

Film Recorders

For producing a retouched and composed chrome from the computer, a film recorder is required. Most film recorders produce an image by taking image data from a computer to modulate a beam on a monochrome CRT. The CRT is sequentially filtered with red, green, and blue filters to expose color images on film. The film is then developed manually. Most film recorders have a variety of film backs available including 35 mm, medium format, and 4 × 5. A few recorders even support cinematic film magazines and are used extensively by the motion picture industry for special effects work.

A film recorder can be a useful tool when you are working with customers who are used to looking at transparencies.

A CRT and a filter wheel are used to create images in a film recorder.

EQUIPMENT INVESTMENT

Purchasing all the necessary hardware and software for direct digital image capture, film scanning, image manipulation, and output will naturally involve a large capital expenditure. To make such an approach economically feasible, you should have a stable client base willing to pay for such services.

You can also become actively involved in digital imaging without this expenditure. You must simply decide to what extent you want to do the work yourself. There are service bureaus and professional color labs that have equipment for scanning, manipulating, and writing out hard copies of your digital dream. When you work with these vendors you become essentially an art director, defining your vision of the finished product.

Another option is to have a pro lab or service bureau scan the film and return the scanned image files to you on a disk. Then you take the scanned image files and work on them using your own computer. Many labs and service bureaus work with photo CD equipment, so to work with them you would need a computer with a CD-ROM drive capable of reading photo CD format. In addition, you need to have image manipulation software. For output, you send a digital file to the lab or service bureau where prints, transparencies, negatives, or color separations can be made.

Applications and Specialized Fields of Photography

Medium format cameras are excellent for just about every photographic application. The large negative size combined with camera portability is one reason. The extensive interchangeability of components combined with the wide range of accessories available for many camera models is another.

Each field of photography, each application has its own requirements. Some camera types are undoubtedly better suited for some applications than others. Some types of photography are simplified by certain camera features, or accessories; other types may require special accessories. It is, therefore, worthwhile to making the choice of a medium format camera a personal one, while carefully considering the type of photography you will be doing.

WILDLIFE AND BIRD PHOTOGRAPHY

Long focal length lenses combined with an SLR camera are a must in wildlife and bird photography. A built-in meter is helpful for determining the light level at distant areas. A motor drive is a great help, especially when you are following birds or animals. If you want the bird or animal to trigger the camera, a motor-driven camera that can be released from a distance is a necessity. Black cameras and black lenses are less noticeable than the more reflective chrome-trimmed models. Camera noise should also be considered.

Most medium format cameras are excellent for special applications as well as for news and documentary coverage. Even with longer lenses, fast, handheld photography is possible. The larger negative offers great possibilities for cropping into the important part of the negative.

NATURE PHOTOGRAPHY

Nature photography can include anything from scenics to extreme close-ups, the latter usually constituting the large portion of nature subjects.

Nature close-up photography frequently involves recording moving subjects. Your setup time may be limited, and you must be prepared to move fast. Handheld close-up photography may be desirable or necessary. All close-up accessories, even bellows, can be used handheld.

The necessary camera and accessory equipment are determined by the size of the area to be photographed. SLR cameras are a must. Built-in light meters simplify exposure. A mirror lockup is another must because exposure times are often fairly long.

OUTDOOR SCENERY

Most outdoor photography is shot at medium and long distances; thus just about any camera can serve the purpose. The choice of lenses is not so much determined by the photographic technique as by personal choice. Some photographers like to concentrate on patterns, lines, shapes, and small areas that require long lenses. Others like to enhance the space,

Nature photography calls for the SLR camera type that allows accurate framing and focusing at all distances and with all lenses and close-up accessories.

the relationship between close and far, with wide angles. For a spectacular presentation of the outdoor space, a panoramic camera can be used.

HIGH MAGNIFICATION PHOTOGRAPHY

High magnification means photography using magnification at 2× or higher. For magnification up to approximately twenty-five times, special lenses are easy to use in combination with a bellows between camera body and lens. The special lenses, which look like objectives for a microscope but are optically designed for use without an ocular, are available from various microscope manufacturers. Each lens has a standard male microscope thread and requires a plate with a female microscope thread for mounting on the camera or bellows. A ready-made plate is available from some medium format camera manufacturers.

High magnification photography requires a lot of light. Electronic flash is by far the most satisfactory light source—bright, short, and cool. With electronic flash, a camera or lens shutter is not really necessary. Use the open flash method. Set the lens or camera shutter on B, depress the release, and fire the flash.

Correct exposure is best determined with a Polaroid film magazine.

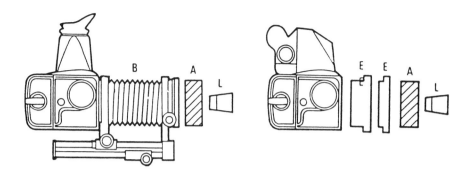

Special objectives for high-magnification photography from about three times to twenty-five times (L), can be used on SLR cameras with interchangeable lenses. The objective is mounted into a board (A) that fits into the bellows (B) or extension tube (E). The bellows is recommended, as it offers a range of magnifications, as well as a convenient method of focusing.

Here is an example of the possibilities with high-magnification lenses. The photo above shows a 2× magnification of a postage stamp and the photo on p. 227 shows a detail out of the stamp with a 10× magnification.

PHOTOGRAPHY THROUGH THE MICROSCOPE

For higher magnifications the medium format SLR camera can be com-
bined with a compound microscope, which consists of an objective and an
ocular (eyepiece), which magnifies the image created by the objective.
Usually you mount the camera without the lens over the microscope,
using a separate stand. A light-tight connection between camera and eye-
piece (microscope adapter) is necessary. Making Polaroid film test shots is
helpful for checking the camera setup and determining proper exposure. A
mirror lockup is even more important than for general close-ups. A motor
drive also reduces the possibility that the camera will move and the deli-
cate microscope setup will be disturbed while the film is advancing.

In photomicrography, the eyepiece (E) forms the image, so no camera lens is used. The microscope adapter (A) holds the eyepiece and shields the camera from extraneous light. The eyepiece is dropped into the microscope adapter, and the adapter is then attached to the camera like a lens. The microscope objective is shown at D.

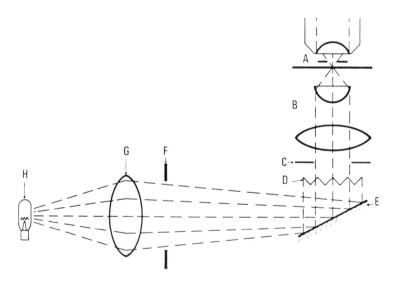

Proper illumination is the most important step to successful photomicrography. The recommended specimen illumination is obtained by first centering the lamp and then changing the distance between the lamp (H) and the condenser lens on the lamp until a sharp image of the filament is recorded on the back surface of the stopped-down substage diaphragm (C). Stop down the field diaphragm (A), and adjust the position of the substage condenser (B) until a sharp image of the field diaphragm appears on the ground glass of the camera. The image of the field diaphragm is then recorded in the specimen plane. The field diaphragm is opened just enough so its image fills the entire diameter of the objective lens.

A built-in meter can provide exposure information for photomicrography if the image is bright enough. Some separate meters have special attachments for this purpose. The best and most accurate approach is to use the Polaroid film magazine to make test shots.

AERIAL PHOTOGRAPHY

Medium format cameras are an excellent choice for aerial photography, either with the camera built into the aircraft or with a handheld camera. Motor drives are desirable but not essential.

There are arguments about appropriate shutter speeds. Some photographers feel that 1/500 or 1/1000 second is sufficient; others will insist and prove that a 1/2000 second speed provides sharper results. You certainly could not go wrong using the 1/2000 or 1/1000 second shutter speed for any aerial applications.

An SLR-type camera is not necessary, but if you use one, it must have a prism or frame finder. Interchangeable film magazines are a must, and a larger capacity 70 mm film magazine is very desirable because it reduces the number of magazine changes and allows you to use infrared film. For multispectral photography, two to four motor-driven cameras are used. They must be connected to a camera release so all cameras release at the same time.

Good image contrast is necessary for a quality aerial image. Contrast can be achieved in color and black and white mainly by using the daylight properly. Avoid flat lighting. Try to obtain images with shaded and lighted areas by photographing when the sun is low. Side light is best in most cases. Yellow, orange, and red filters can help in black and white work. A polarizing filter would help in color but is not practical because it would need to be rotated constantly as the plane or helicopter changes direction.

ARCHITECTURAL PHOTOGRAPHY

Quality is vital in architectural photography, so the choice of lens is most important. Retrofocus-type wide angle lenses on an SLR model are fine, but for even better corner-to-corner sharpness and less distortion, consider one of the special medium format wide angle cameras equipped with an optically true wide angle lens. A spirit level, built in or as an accessory, is necessary. PC (perspective control) lenses or PC teleconverters will provide even more extensive applications, and you won't need to use a view camera. A Polaroid back is highly desirable so you can make test shots for checking the evenness of illumination and lighting ratios and detecting troublesome reflections.

WEDDING PHOTOGRAPHY

Since you carry your camera constantly for three or more hours when photographing a wedding, size, weight, and convenience of carrying must be the first considerations. But otherwise almost any type of medium format camera can be used in this field. Film format is the last consideration. Wedding photographs for an album or for displaying any other way are equally beautiful as squares or rectangles.

Your equipment should be simple: two lenses and perhaps a close-up accessory for photographing hand and ring shots are sufficient. A popular lens is a slight wide angle with a horizontal angle of view of about 50°. This lens allows full-length bridal shots even in small rooms.

Flash synchronization at all shutter speeds is important for flash-fill outdoor work.

FASHION AND BEAUTY PHOTOGRAPHY

Beauty photography is studio work and frequently means tight head shots and shots of hands and legs, all of which can be done with a regular portrait lens 150 to 200 mm. Longer telephotos are also popular. Their longer shooting distance compresses perspective and brings out the elements that are important in beauty: the eyes, lips, and cheeks.

Fashion photography is almost equally divided between studio and location work. In the studio, photographs are often taken from a tripod, and on location from a tripod or with a handheld camera. Motor drives are very helpful; they allow you to shoot additional pictures the moment the expression or pose changes. Professional models are expensive, so speedy shooting without time-consuming film loading is essential. A Polaroid magazine allows the client or art director, who is usually present during the shooting, to see and approve the results.

A good sunshade is essential in the studio because much of fashion and beauty photography is done against white backgrounds. Image sharpness is a main requirement for magazine cover shots. Beauty photography is a competitive business, so you cannot compromise on quality.

PORTRAIT PHOTOGRAPHY

Portrait photography can be studio or location work and full-length, three-quarter, or head and shoulder shots. Portrait work, is best done from a tripod, because it helps to have your hands free for directing people. A prerelease mirror lockup must be used because exposure times are relatively long, especially in shaded locations outdoors. Portrait work usually means shooting negative film and making extensive use of diffusion devices or soft focus lenses.

The same compact medium format camera makes a superb tool for portrait photography in the studio as well as on location. Photographing from a tripod makes it easier to direct the model.

CHILD PHOTOGRAPHY

Although any "portrait camera" is suitable, many of the top child photographers prefer to work with motor-driven types with remote release capability, so that they need not stand behind the camera. A remote release allows you to stand next to the child, perhaps using a toy to get that precious expression so important in child photography.

In the studio, light-colored backgrounds are more likely to convey the happy mood related to childhood. High key—light subjects with light clothing and no shadows photographed against white backgrounds—is very popular. Location portraiture showing the child in a natural surrounding offers much greater possibilities, puts children more at ease, and produces more "natural looking" images.

PRESS PHOTOGRAPHY

Convenience and speed of shooting are most important in news photography. An SLR camera with a built-in motor is a good choice, but a good rangefinder type can be even better. Motor drives are not as necessary as with 35 mm because medium format motor drives will not provide the shooting speed of several frames per second. Flash synchronization at all shutter speeds is very helpful or necessary in many news applications. Your camera should be rugged and solidly built.

SPORTS PHOTOGRAPHY

For the spectator who needs to photograph from the viewing stand, close-ups can be obtained only with long and very long telephotos. A professional with a press pass can do much sports photography with practically any medium format camera and a standard lens and telephoto short enough for handheld work.

Zoom lenses are popular in 35 mm, but their limited zoom range limits their value somewhat in the medium format. Yet zoom lenses are still helpful for composing a shot without changing lenses.

A monopod is a great help. Train yourself to follow moving actions with the camera handheld and mounted with a long telephoto. A prism finder ensures that you move the SLR or TLR camera in the right direction when you are following action.

The slight delay between depressing the release and making the exposure in SLR cameras may have to be avoided when you are photographing actions. Use the SLR camera in a prereleased mode (with the mirror locked up) while viewing through a frame or sportsfinder. With rangefinder and TLR cameras you don't have this delay, and there is no viewing blackout caused by the mirror moving up and down.

For professional results indoors, flash is necessary. To eliminate the ghost image caused by bright lights in an arena, the shutter speed must be 1/500 second. Therefore flash synchronization at shutter speeds up to 1/500 second is necessary.

MEDICAL PHOTOGRAPHY

Medical photography can involve anything from photographing patients to copying and photomicroscopy. Much medical work involves producing slides for presentation, so you need to investigate the client's slide projection capabilities.

COMMERCIAL PHOTOGRAPHY

Commercial clients are critical, so high quality and consistency are foremost requirements. Lens quality, color rendition, good field coverage of lenses, film flatness, and shutter accuracy must be primary camera requirements. Using a Polaroid film magazine is the best way to ensure that you can accomplish the desired results. An SLR camera is the definite choice.

A PC lens or PC converter allows you to make more extensive use of the medium format camera where a view camera might otherwise be necessary. A tilting lens that allows you to increase depth of field may also be

helpful but need not be a main requirement, as commercial photographers usually have access to a view camera that offers all the controls they need.

INDUSTRIAL PHOTOGRAPHY

The medium format camera is an ideal tool in the industrial field because industrial work can involve any type of photography from executive portraiture to commercial subjects and photomicroscopy. A versatile SLR-type camera, with its extensive range of lenses and accessories, can meet any requirement.

A medium format camera is an excellent tool for the industrial photographer, whose work involves everything from portraiture to action to nuts-and-bolts close-ups. Photography by Mike Fletcher.

CREATIVE EXPERIMENTING

There are hundreds of ways to experiment with cameras and create images in black and white or color that are different from the way we see things with our eyes. For most experimenting, an SLR camera is a must. The rest of the equipment depends on your individual purpose. The more interchangeable components the camera allows for and the wider the choice of accessories, the greater are your possibilities. Almost regardless of what you try to do, a Polaroid magazine will be your most valuable accessory because it provides the only way to see effects and results.

Extended Depth of Field Control

A camera-lens connection by means of a bellows gives the camera designer the possibility of building a tilt control into the medium format system, so that the lens board and the lens can be tilted (not shifted) up or down as on a view camera. The tilt with a bellows is limited to about 10°; nevertheless this feature offers extended depth of field control.

The tilt control is based on what is known as the Scheimpflug principle. It only works with an inclined subject plane. That is when the subjects at the bottom of the picture are closer than those on top, or vice versa; or the subjects on the left side are closer than those on the right, or vice versa. An inclined subject plane might occur when you tilt the camera upward to photograph a building from top to bottom, when you tilt it downward to photograph objects laid out on a table (a dinner arrangement), when you photograph a row of houses along one side of a street. Tilting the lens helps to bring both sides of the image within the film plane and thus keep them sharp.

When a lens is tilted, the film plane is no longer in the center of its optical axis. The lens, therefore, must have additional covering power to record off-center images with satisfactory quality and without objectionable loss of light.

The proper lens tilt can be determined accurately on paper. In actual photography it is done visually by checking the image on the ground glass and by making fine adjustments until the best sharpness exists from top to bottom or from side to side.

Medium Format View Cameras

Medium format photography can be combined with view cameras. The most versatile solution is the camera adapter board offered by some view camera manufacturers. You attach the medium format camera body to a board that fits in place of the ground glass at the rear of the view camera.

A medium format camera body with film magazine can also be attached to the rear of a view camera. It combines swing and tilt capability with the use of roll film. You can use the shutter in the view camera lens or the focal plane shutter if the camera has one.

This combination gives you the ability to use all the view camera controls, swings and tilts, with roll film, which is less expensive and allows for faster shooting. Advancing roll film in a magazine is faster and more convenient than changing sheet film holders. Attaching a medium format camera with an electric film advance actually results in a motor-driven view camera.

You view and focus using the ground glass of the medium format camera, and you operate the camera in the normal fashion. With a focal plane shutter camera, you can use the shutter in the camera after opening the view camera lens shutter or use the shutter in the view camera lens after the focal plane shutter is opened. With a lens shutter medium format camera, open the rear curtain and then make the exposure with the shutter in the view camera lens.

To appreciate the value of producing a medium format image on a view camera, you must understand how the various view camera controls are used to improve an image. Study a book on this subject.

SLIDE DUPLICATING

There can be many reasons for producing a duplicate of a slide: to protect the original against loss or damage; to have a duplicate in another size; to improve the original technically.

You might make improvements in the color rendition of a slide, for example, by placing color balance filters over the lens while the duplicate is being made. You can improve slides artistically by *cropping* (that is, by composing the duplicate differently from the original). Slide duplication offers almost unlimited creative possibilities, such as making radical changes in colors, changing colors over part of the slide through partial filtering, producing title slides, and making multiple exposures by duping two or more slides together.

Instead of producing a slide from a slide, you can also make a black-and-white or color negative from the slide. The only difference is the type of film loaded in the camera.

All this work can be done in laboratories, and for quantity production or the very best in quality, this is the best way to go.

Slide Copying Setup

The most reliable and easiest-to-use slide setup for duplicating is obtained when camera, lens, and slide holder are combined into one unit. Various medium format camera systems offer this possibility by combining a single lens reflex camera with bellows, bellows shade, and the transparency copy holder. The transparency copy holder has a diffusion glass to spread the light evenly over the slide, so no additional diffusion device is necessary between the light source and the slide.

Electronic flash is the recommended light source. Place the flash unit straight in front of the transparency holder, shining directly on the diffusion glass. The power of the light source and its distance from the slide determine the exposure. Tungsten lights can also be used if you place them far enough from the slide so that the heat does not create problems.

Exposure

Photographing a slide is like photographing the actual subject. A dedicated flash system is highly recommended and should produce excellent exposures of properly exposed originals, and without the need to take a meter reading. With other flash systems or tungsten light, making exposure tests on Polaroid film is the best way to go.

Films

Daylight color film is used with sunlight and with electronic flash. Slide-duplicating films are best for duplicating slides, but they are not readily available, so you have to use the regular color slide films. Tungsten film is necessary with tungsten lights.

Excellent black-and-white transparencies can be made from black-and-white negatives using Kodak Technical Pan film. Rate the film at 100 ASA and develop for 11 minutes at 68° F in HC110 diluted 1:7.

Another Duping Setup

This slide duplicating setup consists of a glass plate (A) about 26 in. above the ground; the electronic flash unit (B) is on the floor. An opal glass (C) on the table diffuses the light. The transparency (D) is on the opal glass. The camera is mounted on the tripod's reversed center post.

Slides can also be photographed very successfully using a glass table. Place the transparency above the table on an opal glass, which diffuses the light. And use a black mask with a cutout in the size of the transparency to prevent unwanted light from shining directly into the lens. A bellows on the camera is convenient for this setup.

COPYING

Photographing documents requires the utmost in corner-to-corner quality. A lens with high acutance and corrected to provide the best image quality at close distances is the best choice. Camera alignment is vital: the film plane must be parallel to the copy.

Camera Alignment and Focusing

A copy stand with a perpendicular center post is helpful. If you don't have access to one, do the alignment visually as accurately as possible.

If the object to be photographed has definite parallel lines, align the camera as carefully as possible so that the lines are perfectly parallel to the edges of the viewing screen. A ground-glass screen with engraved vertical and horizontal lines (checked screen) simplifies alignment.

When camera and copy are aligned parallel to each other, focus the lens as accurately as possible. If the subject does not have fine details for precise focusing, place a substitute focusing target, such as fine newsprint, over the copy.

Since corner-to-corner sharpness is a foremost requirement, closing the aperture about two stops is suggested, unless you have a special flat field lens designed for this purpose.

Films

Regular black-and-white and color films are used for copying. If maximum contrast is desired in black and white, developing times should be increased by about 20 percent. Technical Pan film rated at 100 ASA and developed in D-19 for about 5 minutes at 70° F is excellent for high-contrast copy work.

You can make beautiful transparencies by combining the high contrast copy image with colored gels in a glass slide mount.

When photographing colored originals on black-and-white film, use color filters to increase or reduce the contrast or to suppress or emphasize certain sections of the original. A yellow filter can be of value when you are photographing old, yellowed originals, as it will lighten the yellow background and, thereby, increase the contrast.

Lighting, Filters, and Exposure

For small copy, one light may be sufficient; two or more are needed at equal distances and angles for larger copy. Set the lights at about 35° to 45° to the copy. Lighting must be even from corner to corner, and there should be no disturbing reflections. Use an exposure meter to check the lighting of different areas.

With any type of copy, determine accurate exposure either by placing an incident meter in the center of the copy and measuring the light falling on the copy or, if flash is used, by holding the flash meter over the copy. With a reflected light handheld or built-in meter, place a gray card over the copy and measure the light reflected off the card.

With tungsten lights you can see and check the evenness of the lighting. You can do the same with electronic flash equipped with modeling lights. Such lights are recommended for this type of work.

Copying results can be improved, often dramatically, with polarized light, which eliminates or reduces reflection and produces images with higher contrast. When photographing the copy straight on, a polarizing filter over the camera lens alone is not enough. The light that reaches the copy must also be polarized, and the polarizing filter on the camera lens should be rotated for cross-polarization.

A simple setup for copying in polarized light consists of a copying stand or a sturdy tripod with the center post reversed so that the camera is held between the legs. Two lights (L), one on the left and the other on the right, illuminate the copy from the same angle. The light from both lamps goes through the polarizing material (P1), which can be mounted in picture frames, so that the light falling on the copy is polarized. A polarizing filter (P2) on the camera lens is turned to produce maximum contrast. Exposure is based on a meter reading (A) off a gray card placed on top of the copy.

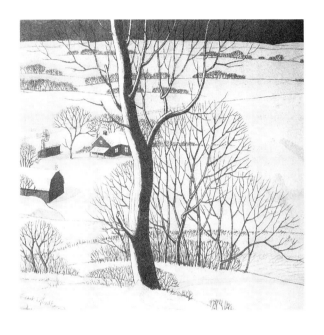

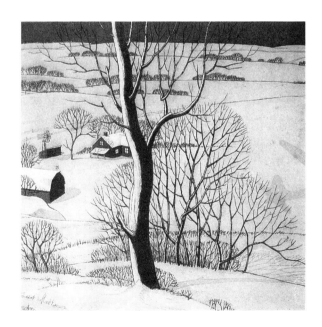

Copying in polarized light can greatly improve contrast and color saturation.

Polarizing filters must be placed over the light source or sources. They need not be of high quality. Sheets of polarizing material are satisfactory, but keep them away from the hot tungsten lights. If more than one filter is used, each must be rotated in the same direction as far as polarization is concerned. If the filters are not marked, hold the two on top of each other, and look through them while turning one of the sheets. You will notice that the view through the filters darkens and brightens as one of the sheets is turned. The filters are polarized in the same direction when the most light comes through.

When you use polarized light, take the light reading with the polarizing filter over the lights. In addition, it is necessary to compensate for the polarizing filter on the lens if you are taking the light reading with a separate meter.

UNDERWATER PHOTOGRAPHY

Special medium format cameras for underwater work are not made, but underwater cases, both amateur and professional types, are available for various cameras. In underwater photography wide angle lenses are used mostly because the higher refractive index of water cuts down the angle of view. Correction lenses are available for professional underwater housings. A motor drive simplifies operation underwater, and a large-capacity magazine reduces the frequency of surfacing for reloading.

INFRARED PHOTOGRAPHY

Infrared radiation, which is the invisible radiation with wavelengths beyond 700 nm, has important applications in scientific photography and exciting possibilities for those photographers who want to experiment with producing images with unusual colors or tonal renditions on black-and-white film.

Special infrared films must be used for infrared photography. Such films for color and black and white photography are not readily available everywhere or may be available only in a special version such as 70 mm. Practically all light sources can be used for infrared work.

All photographic lenses transmit infrared radiation and, therefore, can be used for infrared work. Lenses, however, are corrected only for the visible range of light and, therefore, only those wavelengths are focused on the film plane. Infrared, with its longer wavelengths, forms the image further from the lens and therefore behind the film plane.

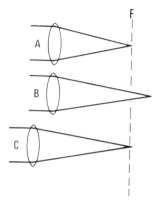

Infrared radiation (B) forms an image farther from the lens than does visible light (A). The image on the film plane (F) is, therefore, out of focus unless you compensate for this by moving the lens forward (C).

With color film, this shift of focus presents no problem because the image is not formed by infrared only. Images on infrared-sensitive black-and-white film, on the other hand, will be out of focus at the film plane. So you need to make a focus adjustment that amounts to about 1/200 of the lens's focal length. Many lenses have an infrared focusing index, which allows you to adjust for the aforementioned difference.

There are also lenses that are chromatically corrected into the infrared range. Such lenses produce the best image quality in all infrared work and do so without a focus adjustment.

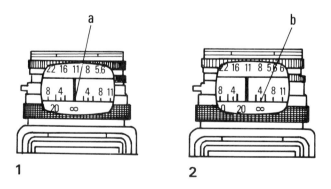

In infrared photography with lenses engraved with an IR index (1), focus the subject visually on the ground glass and read the distance (in this illustration, infinity) opposite the index line (a). (2) Turn the focusing ring so that the distance (infinity in this case) is opposite the red infrared index (b).

Black-and-white infrared films are used together with a red filter. They produce beautiful outdoor images with an unusual range of grey tones. Green, for example, appears as white.

Color infrared photography has wide applications in aerial surveying, medical, and biological photography, but it is also an exciting medium for the experimenting photographer. Exposures are usually made through orange filters (#12 or #15). For experimenting, other filters—red, green, blue, violet, yellow—can be used. Each produces different color arrangements.

ULTRAVIOLET PHOTOGRAPHY

Most ultraviolet photography is used in the medical and forensic fields, where the ultraviolet image can show things we cannot see with the naked eye, such as alterations on documents and restorations on paintings. Most of this work can be done at wavelengths of 320 or longer and, therefore, with regular black-and-white films and camera lenses. (Quartz lenses are necessary for shorter wavelengths.)

Color films can also be used for UV photography, but they offer no advantage over black and white, as only the blue-sensitive layer of film reacts to the UV radiation.

Consult a book on this subject for details about light sources and special camera techniques.

FLUORESCENCE PHOTOGRAPHY

Subjects that fluoresce when exposed to UV radiation can be photographed with any camera and lens because the fluorescent light that is reflected from the subject is ordinary visible light. The most frequently used light sources are the so-called black-light tubes. If you use these lights, make sure they are engraved BLB.

Most electronic flash units can also be used since they produce a large amount of UV radiation. Most or all of the visible light must be absorbed by placing a filter over the flash tube. Use the Kodak #12 filter or a special filter made by the manufacturer of the flash equipment.

Only light from the visible part of the spectrum should be recorded on the film, so place a UV-absorbing filter (such as Wratten No. 2A or 2B) over the lens; the filter will absorb all radiation below 400 nm but does not fluoresce.

The striking color effects of this technique call for color film. Whether to use daylight or tungsten films is mainly a matter of personal preference. On daylight film, yellows and reds will be more brilliant; tungsten-light film will accentuate the blues and greens.

Exposure can be determined with a regular meter, but film tests are suggested. A built-in meter that will measure the light through the UV absorbing filter on the lens is best.

Slides and Slide Projection

PROJECTION FORMATS

2 1/4 in. square (6 × 6 cm) and 6 × 4.5 cm slides will fit into 7 × 7 cm slide mounts for use in 2 1/4 in. slide projectors.

Slide mounts are available for slides produced on 120 and 220 roll film as well as those produced on 70 mm perforated film. Mounts are also available for 40 × 40 mm superslides for projecting in standard 35 mm machines. Slides in the 6 × 7 cm format can be placed into 8.5 × 8.5 cm mounts for use in a special projector made for this format. Special mounts with a panoramic cutout are also available in all sizes. Larger slides can only be projected in a lantern slide projector.

SLIDE MOUNTING

Since the film surface of all medium format slides is large, glass mounting is highly recommended to avoid popping caused by the heat in the projector. Glass mounts also ensure a more reliable slide transport than cardboard mounts.

Glass Mounts

Glass mounts protect slides physically but will not prolong their life or prevent the colors from fading. For longest life, slides should be kept in a cool, dry place. For the least amount of fading, they should not be exposed to the bright projection light any longer than necessary. Slides should be kept in the dark as much as possible, especially away from direct sunlight

and fluorescent lights (a light box, for instance), both of which have large amounts of ultraviolet rays.

For a faultless slide transport, the mount should have no rough edges or sharp corners. Plastic frames with rounded corners that slide or snap together are preferable to frames that must be taped together or metal frames that must be bent. The thickness of the mount is also important, because thick mounts cause problems in some projectors.

Always squeeze the two slide frames together firmly. Do not attach tape or labels to the frame. Write information (numbers) directly on the frame with a permanent marking pen.

Pin Registration

Slide mounts for pin registration are available in all sizes. The registration is achieved with registration holes that are punched into the slides. The necessary tools for doing this are available. Pin registration means that two or more slides are mounted so the images are registered to each other.

Mounts are also made with pegs for slides made on 70 mm perforated film. They will hold a 70 mm slide in place but serve pin registration purposes only with duplicates made on a 70 mm pin registered copy cameras. Slides produced in a 70 mm camera film magazine are not registered in relation to the perforation holes, and there is no readily available solution for producing pin registered 70 mm slides in a medium format camera.

Newton Rings

Glass for glass-mounted slides may come plain or with a coating to avoid *Newton rings*, rainbow-colored patterns caused by the contact of two extremely smooth surfaces—the film and the glass. Newton rings in slides are objectionable because they may be visible when the slide is projected on the screen. The rings are visible in light areas of the slide but rarely in darker areas.

Newton rings can be avoided by using anti-Newton glass, which has a coating or etched pattern designed to prevent the rings. If only one side of the glass has this coating, the coated side must face the shiny base side of the film. If necessary, check that the glass is properly positioned before mounting the slides. Hold the glass in such a way that a bright object is reflected on the glass. The reflection will appear with a sharp outline on the uncoated side and very diffused on the coated side. The diffused side should face the base side of the film.

Condensation

When slides are stored in a place with high humidity, the film base soaks up the moisture from the air. The heat from the projection lamp causes

the moisture to evaporate and settle between glass and film, eventually clouding the cover glass. The cloud may not be obvious when the image is projected on the screen, but it will reduce brilliance and contrast. Avoid condensation by storing slides, mounted or unmounted, in areas of low humidity (not basements). In addition, or especially when storage areas with high humidity cannot be avoided, store the slides with a desiccant such as silica gel.

Moisture that has settled between slide and glass should be removed as soon as possible to avoid the deforming of the slide and perhaps the growth of fungus. Take the slide apart and let it dry out before remounting.

Cleaning the Glass

Most new slide glasses are factory cleaned and need nothing more than brushing off the dust. For cleaning used glass with condensation, use either a glass cleaner or a solution of 1/4 cup ammonia (without soap) and a pint of water.

Identification

Medium format slides go into square mounts. They fit in the slide trays in every way so it is not necessary to pay special attention to the positioning of the film frame in the mount. It is wise to mark the slide frame with a dot in one corner or a band along one side to ensure that your slides are placed right side up. Proper positioning is assured when the bands on all slides are visible on top or when all dots are visible in the same corner.

SLIDE PROJECTORS

Superslides can be projected in a standard 35 mm projector using standard 35 mm slide trays. But most modern 35 mm slide projectors are made for the smaller 24 × 36 mm slides and do not project the large 40 × 40 mm superslides without objectionable loss of light and image quality at the corners. Do not produce superslides unless you have satisfactory projection equipment or you use the superslides for purposes other than projection.

Slides in the 2 1/4 in. square and 4 1/2 x 6 cm format can be used in the same slide projectors and same slide trays and thus can be intermixed within a slide presentation.

There are different types of projectors to choose from: a projector that is completely manual, including in the changing of slides; a projector that projects slides in a tray but is still basically single slide projection; or a professional machine that allows you to do everything that can be done

in 35 mm including the most sophisticated multi-image and multi-projector presentation.

With such a professional projector you can produce and arrange multi-image, multiscreen presentations as is done in 35 mm, but with the additional benefits of the larger slide, the much better image quality and image brightness, and the capability to project the image much larger.

Some medium format projectors can also be operated with the identical programming equipment used in 35 mm. This compatibility offers the possibility of combining 35 mm and medium format slides in the same presentation. Check with the manufacturer regarding the programming requirements.

SLIDE PRESENTATIONS

Projection from a single projector is fine for home use or perhaps for some lectures. Consider, however, using at least two projectors with dissolve for anything more professional, even for lecture purposes. The addition of one projector and dissolve makes the difference between an amateur and a professional show.

There are, of course, limits to what can be done even with two projectors. Double exposures are limited or impossible. You cannot change slides rapidly because you must wait until the slide in the projector is changed, which takes at least 1 1/2 seconds—rather long for a modern visual presentation. These limitations are eliminated when you use three projectors. Slides can be changed more rapidly, and double exposures can be made at any time.

Do not feel that a relatively simple presentation using two or three projectors is ineffective, outdated, or unsophisticated. Such a 2 1/4 in. slide show, properly put together, can be more effective than an elaborate 35 mm multi-image presentation that throws hundreds or thousands of images in front of an audience. This is true especially for the 2 1/4 in. slide. The quality and effectiveness of large slides can be visually more exciting than all the fancy techniques in an elaborate 35 mm show. It has been found, as a matter of fact, that most viewers of 2 1/4 in. slide shows are so overwhelmed by the quality of the image that they actually wish to have the images on the screen for longer periods.

Medium format slide shows made from square images are especially effective. All square images fill the same area of the screen, in most cases the entire square screen area. With square images filling the entire screen area, viewers are only aware of the effectiveness of each image. It is like looking at the real scene.

For a multi-image presentation you must plan the production of the images. You need to visualize the combination of the projected images and photograph them so they combine visually and effectively in the projected

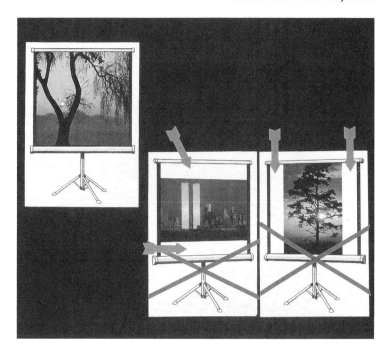

When you mix verticals and horizontals in a slide presentation, the horizontal leaves blank spaces on the top and bottom of the square screen, and the verticals leave blanks on both sides. Switching from vertical to horizontal rectangular shots is distracting for your viewers, who then become aware that they are looking at a projected image. When working in a rectangular format, it is preferable to produce all slides as horizontals and then project them on a movie screen with each filling the entire horizontal format screen. Square images are a more effective way to fill the entire square projection screen.

presentation. You may need to repeat the same image or similar images, so shoot multiple exposures to avoid the need for making duplicates.

For multi-image presentations, you may also need more than one image of a subject. You may need sequences of images taken from different angles and distances. You will probably discover that you need to shoot many more slides than you would for a print presentation or for a one- or two-projector show.

Maintaining Equipment and Materials

Keeping equipment clean is better than cleaning it. Keep all equipment away from dust and dirt whenever possible. Store each item in its case or box, and keep the cases clean by vacuuming them frequently. When you store or carry a camera without a lens or magazine, the inside of the camera is completely exposed. Fit protective covers on the lens mount and the back, or store and carry your camera with lens and magazine attached.

CARRYING CASES

Cases are the best means of protecting camera equipment. For shipping equipment and placing it on planes in the baggage compartment, only shipping cases with partitions for the various items should be considered. Place additional padding in each compartment so that the items cannot move.

Ever-ready cases are seldom used with medium format cameras. Most photographers prefer to hang the camera without a case over a shoulder or carry it with a neckstrap or camera grip.

Larger shoulder cases that hold the camera and additional lenses and accessories are popular and practical. Other photographers prefer the suitcase type of carrier that must be laid down to open. Once it is laid down and opened, you can see everything that's in the case.

Either way try to find a case that holds the camera complete with the items you normally use (lenses, lens shade, film magazines, view-finder,

and so forth). It is too time-consuming and inconvenient to assemble camera components every time you need to use your camera.

The case should be arranged so that each item can be stored in an orderly fashion and found instantly when needed. It is not likely that a case as it comes from the factory meets all these requirements. Cases need to be a compromise since almost every photographer has a different assortment of cameras, lenses, and accessories.

CLEANING THE CAMERA

Blow dust from small crevices with compressed air using a small syringe or a similar item. Take great care when dusting the mirror, viewing screen, or finders. Do not touch the focal plane curtains. Never use canned air; it is usually very cold and results in condensation, and the propellant agent may leave an oily residue. Cleaning the film magazines or film channel is most important. Focusing screens and some filters and soft focus devices may be plastic or glass and need special treatment.

Polaroid Film Magazine

The developing mechanism under the Polaroid magazine should be cleaned with a damp cloth after each film pack has been used, because chemical residue tends to accumulate on the rollers and may cause problems. If the magazine has a glass plate, clean it as you would a lens, especially when you are using negative-positive film. Dust marks on the negative may be very objectionable when the negative is enlarged.

Cleaning Lenses

All antireflection coatings are relatively hard but can be scratched by grit and other dirt on the lens surface. Before rubbing the surface of any lens with a tissue, blow away all loose particles of dust. Then use a soft brush, such as a special lens brush.

To remove a fingerprint, breathe on the surface and quickly wipe it with a soft tissue. Then check to see if the surface is thoroughly clean by breathing on it once again. If the fingerprint is gone, the condensation will form an even deposit without spots and will evaporate gradually and evenly. If the element is still dirty, repeat the process with a drop or two of lens cleaning fluid on a lens tissue. Never put the fluid directly on the lens as it may find its way into the lens mount. Use lens cleaning fluid sparingly. Do not clean lenses more than necessary. Image quality is not affected by dust particles.

ENVIRONMENTAL FACTORS

Fungus

When camera equipment is used in tropical climates or where humidity is high, clouding of glass surfaces, lenses, prisms, and filters often occurs. This is caused by a microscopically fine network of fungi that attack the polished surface by etching their pattern into the glass.

Fungi develops at humidities of 80 percent or more. Humidity can be decreased by heating the air surrounding the camera equipment. Keep the camera in the sun or in circulating air; do not enclose it in an equipment bag or box without using a desiccant. Exposing the camera to direct sunlight is helpful. Do not store equipment in cupboards or drawers that are dark and lack air circulation. Do not cover cameras and lenses with plastic bags or hoods, which limit air circulation. If possible, have a fan blowing air on the equipment.

Nutritive substances, grease, and dust can also help fungi to develop. It is of paramount importance that all equipment be cleaned thoroughly after each use; especially fingerprints, grease, and dust must be removed from all glass surfaces. Pay special attention to lens mounts, eyepieces, mirrors, and the interior of the camera.

Humidity in small areas can be reduced with desiccants. Silica gel, usually in the form of small crystals in a dust-proof bag, is best for this purpose. Place the bag inside camera cases or containers, which should be airtight. Choose indicator gel that changes color from blue to pink when it reaches saturation point and needs regeneration. To regenerate, heat it at 120–150° C (250–300°) for about 12 hours.

Cold Weather

Photography in cold weather is not only unpleasant for the photographer but also brings up problems in camera and battery operation that do not exist at normal temperatures.

In cold climates simplify camera operation as much as possible. Remove any unnecessary accessories that cannot be operated with gloves or add accessories that allow easier operation. Preload film magazine before you go out in the cold if possible.

Mounting cameras on tripods with tripod screws can be a frustrating experience in the cold. You will appreciate a tripod coupling in this setting. Once you are out in the cold, avoid touching unpainted metal surfaces with ungloved hands or your face or lips because your skin will stick to the metal. Do not breathe on lenses; the condensation will freeze, perhaps instantly, and it is very difficult to remove.

Condensation also occurs when cold equipment is brought into a warm room. This means that the chilled camera cannot be used indoors

until its temperature equals that of its surroundings. A camera with condensation also cannot be taken out into the cold until the condensation has evaporated; otherwise the condensation will freeze. Condensation can cause very serious problems because it may also cover the camera and lens mechanism inside and may freeze up the entire camera and lens operation; also interior camera parts may start to rust. It is possible to avoid this problem by placing the camera in an airtight plastic bag and squeezing out the air before entering a heated room from the cold.

Extreme cold causes leather and rubber to become brittle. A wax leather dressing of good quality should be rubbed into carrying cases and leather-covered cameras to prevent the absorption of moisture. Rubber should be avoided whenever possible.

The viscosity of lubricants increases (lubricants thicken) as the temperature declines. Consequently in cold weather, the camera mechanism operates more sluggishly, and mechanical reaction time increases with shutter speeds lengthening; for example, 1/4 second becomes effectively 1/2 second, especially if the lubricant in the lens and shutter is old and dirty. You will get better shutter operation if the lenses and shutters have been cleaned and lubricated recently. Another suggestion is that you operate all the shutter speeds a few times with the magazine removed or without film in the camera, which may help get the lubricant working. Electronically controlled shutters are less affected, but keep in mind that the opening and closing of the shutter is still a mechanical operation.

Camera and lens manufacturers do not publicize specific temperatures at which equipment is guaranteed to work because temperature is only one aspect that can affect operation. Other equally important factors are the wind-chill factor, humidity, the length of time equipment is exposed to the elements, and the amount of time that has elapsed since the equipment was last cleaned. The camera manufacturer or a qualified service station may be able to lubricate the camera and lenses with special cold weather lubricants. Although this measure is no guarantee against malfunctions, the use of special cold-weather lubricants does reduce some risk factors. On return to normal conditions, it is imperative to relubricate the equipment with a standard lubricant; otherwise camera wear will be greatly accelerated.

All batteries lose efficiency at low temperatures, and fresh batteries may become too weak to operate the equipment after only a little use. Keep batteries in a warm place, and do not put them into the camera until they are needed if that is possible and practical. Always carry a spare set and keep them warm (perhaps in a pocket) until they have to be used.

Lithium batteries perform best in cold temperatures.

X Rays

In addition to heat and humidity, fresh and exposed film can be damaged by X rays and industrial gases, motor exhaust fumes, and vapors from paints, solvents, cleaners, and mothballs. Keep films away from X rays, radium, or other radioactive materials.

The X-ray equipment used at airports is not likely to produce any visible effect on normal speed (up to 400 ASA) films during a one-time inspection. Based on new tests with the modern equipment used at most airports, even multiple exposure (twenty times or more) of the same film did not cause any visible effects. Films of 1000 ASA and higher need a little more attention.

Request hand inspection, which most security officials will honor if the inspection is easy.

Medium Format Cameras

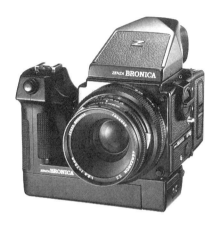

Bronica ETRSi. Courtesy GMI Photo.

Manufacturer: Bronica Co. Ltd.
Camera Model: Bronica ETRSi
Camera Type: SLR
Film Formats: 6 ¥ 4.5
Film Load: 120, 220; 70 mm, 35 mm, Polaroid with other magazine
Interchangeable Film Magazines: Yes
Interchangeable Lenses: Yes
Range of Lenses: From 40 mm to 500 mm
Special Lenses: Macro
Shutter Type: Lens Shutter
Shutter Speed Range: From 8 seconds to 1/500 second
Flash Sync Range: From 8 seconds to 1/500 second
Dedicated Flash System: Yes
Motor Drive: Yes, detachable accessory
Exposure Control: Yes, in viewfinder accessory
Weight: Camera Body + Standard Lens + Viewfinder + Film Magazine
 2 lbs. 14 oz.
Above with Motor: 3 lbs. 10 oz.
Special Features: Interchangeable film inserts

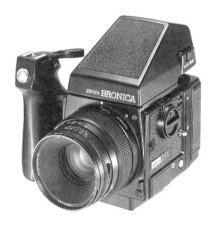

Bronica GS-1. Courtesy GMI Photo.

Manufacturer: Bronica Co. Ltd
Camera Model: Bronica GS-1
Camera Type: SLR
Film Formats: 6 × 7; 6 × 6, 6 × 4.5 with other magazines
Film Load: 120, 220 Polaroid with other magazine
Interchangeable Film Magazines: Yes
Interchangeable Lenses: Yes
Range of Lenses: From 50 mm to 500 mm
Special Lenses: Macro
Shutter Type: Lens Shutter
Shutter Speed Range: From 16 seconds to 1/500 second
Flash Sync Range: From 16 seconds to 1/500 second
Dedicated Flash System: Yes
Motor Drive: No
Exposure Control: Yes, in viewfinder accessory
Weight: Camera Body + Standard Lens + Viewfinder + Film Magazine
 4 lbs. 2 oz.
Special Features: Interchangeable film inserts

Figure 20-3. Bronica SQA-i. Courtesy GMI Photo.

Manufacturer: Bronica Co. Ltd
Camera Model: Bronica SQA-i
Camera Type: SLR
Film Formats: 6 × 6; 6 × 4.5, 35 mm with other magazine
Film Load: 120, 220, 35 mm Polaroid with other magazine
Interchangeable Film Magazines: Yes
Interchangeable Lenses: Yes
Range of Lenses: From 40 mm to 500 mm
Special Lenses: Macro
Shutter Type: Lens Shutter
Shutter Speed Range: From 16 seconds to 1/500 second
Flash Sync Range: From 16 seconds to 1/500 second
Dedicated Flash System: Yes
Motor Drive: Yes, detachable accessory
Exposure Control: Yes, in viewfinder accessory
Weight: Camera Body + Standard Lens + Viewfinder + Film Magazine
 3 lbs. 6 oz.
Above with Motor: 4 lbs. 5 oz.
Special Features: Interchangeable film inserts

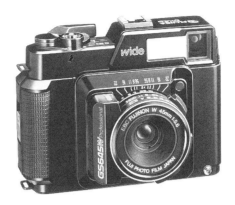

Fuji GS 645 S. Courtesy Fuji Photo Film USA.

Manufacturer: Fuji Photo Film
Camera Model: Fuji GS 645 S
Camera Type: Rangefinder
Film Formats: 6 × 4.5
Film Load: 120; 220
Interchangeable Film Magazines: No
Interchangeable Lenses: No
Lens: 60 mm
Shutter Type: Lens Shutter
Shutter Speed Range: From 1 second to 1/500 second
Flash Sync Range: From 1 second to 1/500 second
Dedicated Flash System: No
Motor Drive: No
Exposure Control: Yes, in camera
Weight: Camera Body + Standard Lens + Viewfinder + Film Magazine
 1 lb. 10 oz.

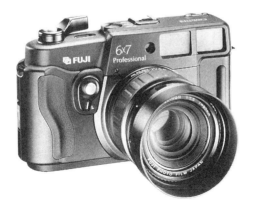

Fuji GW6 70 III. Courtesy Fuji Photo Film USA.

Manufacturer: Fuji Photo Film
Camera Model: Fuji GW 670 III
Camera Type: Rangefinder
Film Formats: 6 × 7
Film Load: 120, 220
Interchangeable Film Magazines: No
Interchangeable Lenses: No
Lens: 90 mm
Shutter Type: Lens Shutter
Shutter Speed Range: From 1 second to 1/500 second
Flash Sync Range: From 1 second to 1/500 second
Dedicated Flash System: No
Motor Drive: No
Exposure Control: No
Weight: Camera Body + Standard Lens + Viewfinder + Film Magazine
 3 lbs. 4 oz.
Special Features: Level device

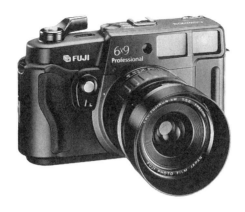

Fuji GSW 690 III. Courtesy Fuji Photo Film USA.

Manufacturer: Fuji Photo Film
Camera Model: Fuji GSW 690 III
Camera Type: Rangefinder
Film Formats: 6 × 9
Film Load: 120; 220
Interchangeable Film Magazines: No
Interchangeable Lenses: No
Lens: 65 mm
Shutter Type: Lens Shutter
Shutter Speed Range: From 1 second to 1/500 second
Flash Sync Range: From 1 second to 1/500 second
Dedicated Flash System: No
Motor Drive: No
Exposure Control: No
Weight: Camera Body + Standard Lens + Viewfinder + Film Magazine
 3 lbs. 5 oz.

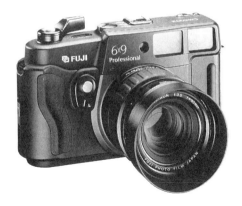

Fuji GW 690 III. Courtesy Fuji Photo Film USA.

Manufacturer: Fuji Photo Film
Camera Model: Fuji GW 690 III
Camera Type: Rangefinder
Film Formats: 6 × 9
Film Load: 120; 220
Interchangeable Film Magazines: No
Interchangeable Lenses: No
Lens: 90 mm
Shutter Type: Lens Shutter
Shutter Speed Range: From 1 second to 1/500 second
Flash Sync Range: From 1 second to 1/500 second
Dedicated Flash System: No
Motor Drive: No
Exposure Control: No
Weight: Camera Body + Standard Lens + Viewfinder + Film Magazine
 3 lbs. 3 oz.

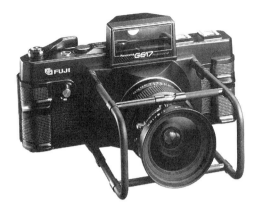

Fuji G 617. Courtesy Fuji Photo Film USA.

Manufacturer: Fuji Photo Film
Camera Model: Fuji G 617
Camera Type: Panoramic
Film Formats: 6 × 17
Film Load: 120; 220
Interchangeable Film Magazines: No
Interchangeable Lenses: No
Lens: 105 mm
Shutter Type: Lens Shutter
Shutter Speed Range: From 1 second to 1/500 second
Dedicated Flash System: No
Motor Drive: No
Exposure Control: No
Weight: Camera Body + Standard Lens + Viewfinder + Film Magazine
 5 lbs. 2 oz.

Fuji GX 617 with multi-lens system. Courtesy Fuji Photo Film USA.

Manufacturer: Fuji Photo Film
Camera Model: Fuji GX 617
Camera Type: Panoramic
Film Formats: 6 × 17
Film Load: 120; 220
Interchangeable Film Magazines: No
Interchangeable Lenses: Yes
Range of Lenses: From 90 mm to 180 mm
Shutter Type: Lens Shutter
Shutter Speed Range: From 1 second to 1/500 second
Flash Sync Range: From 1 second to 1/500 second
Dedicated Flash System: No
Motor Drive: No
Exposure Control: No
Weight: Camera Body + Standard Lens + Viewfinder + Film Magazine
 5 lbs. 5 oz.
Special Features: Level device

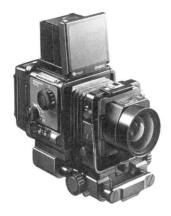

Fuji GX 680. Courtesy Fuji Photo Film USA.

Manufacturer: Fuji Photo Film
Camera Model: Fuji GX 680
Camera Type: SLR
Film Formats: 6 × 8
Film Load: 120; 220
Interchangeable Film Magazines: Yes
Interchangeable Lenses: Yes
Range of Lenses: From 65 mm to 3000 mm
Special Lenses: Soft Focus
Shutter Type: Lens Shutter
Shutter Speed Range: From 8 second to 1/400 second
Flash Sync Range: From 8 second to 1/400 second
Dedicated Flash System: No
Motor Drive: Yes, built-in
Exposure Control: Yes, in viewfinder
Weight: Camera Body + Standard Lens + Viewfinder + Film Magazine
 with Motor: 9 lbs. 3 oz.
Special Features: Revolving film magazine, bellows focusing; swing, tilt,
 shift, rise and fall control

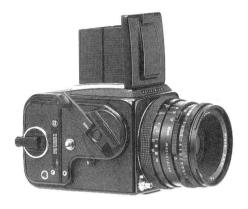

Hasselblad 501C. Courtesy Victor Hasselblad.

Manufacturer: Victor Hasselblad
Camera Model: 501C
Camera Type: SLR
Film Formats: 6 × 6; 6 × 4.5 with other film magazine
Film Load: 120; 220, 70 mm, Polaroid with other magazines
Interchangeable Film Magazines: Yes
Interchangeable Lenses: Yes
Range of Lenses: From 30 mm to 500 mm + 2× converter
Special Lenses: Fish-eye, Zoom, PC (Shift), (Soft Focus accessory), Macro
Shutter Type: Lens Shutter
Shutter Speed Range: From 1 second to 1/500 second
Flash Sync Range: From 1 second to 1/500 second
Dedicated Flash System: No
Motor Drive: No
Exposure Control: Yes, in viewfinder accessory
Weight: Camera Body + Standard Lens + Viewfinder + Film Magazine
 3 lbs. 5 oz.
Special Features: Sold complete with 80 mm lens and 120 film magazine

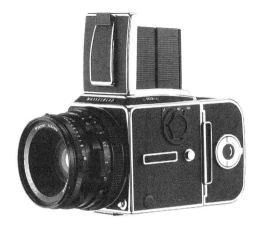

Hasselblad 503 CXi. Courtesy Victor Hasselblad.

Manufacturer: Victor Hasselblad
Camera Model: 503 CXi
Camera Type: SLR
Film Formats: 6 × 6; 6 × 4.5 with other magazine
Film Load: 120; 220, Polaroid, 70 mm with other magazines, Electronic
 Imaging back
Interchangeable Film Magazines: Yes
Interchangeable Lenses: Yes
Range of Lenses: From 30 mm to 500 mm + 2x converter
Special Lenses: Fish-eye, Zoom, PC (Shift), (Soft Focus accessory), Macro
Shutter Type: Lens Shutter
Shutter Speed Range: From 1 second to 1/500 second
Flash Sync Range: From 1 second to 1/500 second
Dedicated Flash System: Yes
Motor Drive: No
Exposure Control: Yes, in viewfinder accessory
Weight: Camera Body + Standard Lens + Viewfinder + Film Magazine
 3 lbs. 5 oz.

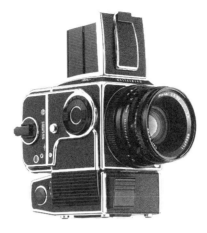

Hasselblad 553 ELX. Courtesy Victor Hasselblad.

Manufacturer: Victor Hasselblad
Camera Model: 553 ELX
Camera Type: Motor-driven SLR
Film Formats: 6 × 6; 6 × 4.5 with other magazine
Film Load: 120; 220; 70 mm Polaroid with other magazines, Electronic
 Imaging back
Interchangeable Film Magazines: Yes
Interchangeable Lenses: Yes
Range of Lenses: From 30 mm to 50 mm + 2× converter
Special Lenses: Fish-eye, Zoom, PC (Shift), (Soft Focus accessory), Macro
Shutter Type: Lens Shutter
Shutter Speed Range: From 1 second to 1/500 second
Flash Sync Range: From 1 second to 1/500 second
Dedicated Flash System: Yes
Motor Drive: Yes, built-in
Exposure Control: Yes, in viewfinder accessory
Weight: Camera Body + Standard Lens + Viewfinder + Film Magazine
 Above with Motor: 4 lbs. 11 oz.
Special Features: Remote releasing

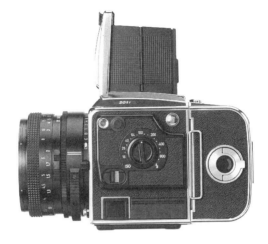

Hasselblad 201 F. Courtesy Victor Hasselblad.

Manufacturer: Victor Hasselblad
Camera Model: 201 F
Camera Type: SLR
Film Formats: 6 × 6; 6 × 4.5 with other magazines
Film Load: 120; 220, 70 mm Polaroid with other magazine
Interchangeable Film Magazines: Yes
Interchangeable Lenses: Yes
Range of Lenses: From 30 mm to 500 mm + 2× converter
Special Lenses: Fish-eye, Zoom, PC (Shift), (Soft Focus accessory), Macro
Shutter Type: Focal Plane
Shutter Speed Range: From 1 second to 1/1000 second
Flash Sync Range: From 1 second to 1/90 second; shorter with CF lenses
Dedicated Flash System: Yes
Motor Drive: Yes, detachable accessory
Exposure Control: Yes, in Viewfinder accessory
Weight: Camera Body + Standard Lens + Viewfinder + Film Magazine
 3 lbs. 8 oz.
Above with Motor: 4 lbs. 8 oz.
Special Features: Use of large aperture lenses (up to ƒ2); self-timer with 2
 and 10 second delay.

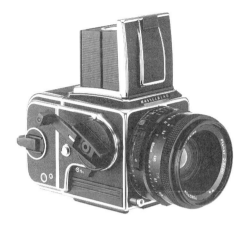

Hasselblad 203 FE. Courtesy Victor Hasselblad.

Manufacturer: Victor Hasselblad
Camera Model: 203 FE
Camera Type: SLR
Film Formats: 6 × 6; 6 × 4.5 with other magazine
Film Load: 120; 220, 70 mm, Polaroid with other magazines
Interchangeable Film Magazines: Yes
Interchangeable Lenses: Yes
Range of Lenses: From 30 mm to 500 mm + 2× converter
Special Lenses: Fish-eye, Zoom, PC (Shift), (Soft Focus accessory), Macro
Shutter Type: Focal Plane
Shutter Speed Range: From 34 minutes to 1/2000 second
Flash Sync Range: From 34 minutes to 1/90 second; shorter with CF lenses
Dedicated Flash System: Yes
Motor Drive: Yes, detachable accessory
Exposure Control: Yes, in camera, large area spotmeter
Weight: Camera Body + Standard Lens + Viewfinder + Film Magazine
 3 lbs. 9 oz.
Above with Motor: 4 lbs. 9 oz.
Special Features: Automatic bracketing; fill flash adjustment; reference
 programming; use of large aperture lenses up to $f/2$.

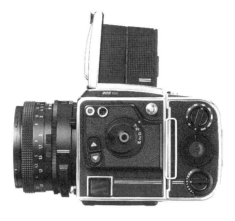

Hasselblad 205 TCC. Courtesy Victor Hasselblad.

Manufacturer: Victor Hasselblad
Camera Model: 205 TCC
Camera Type: SLR
Film Formats: 6 × 6; 6 × 4.5 with other magazine
Film Load: 120; 220, 70 mm, Polaroid with other magazine
Interchangeable Film Magazines: Yes
Interchangeable Lenses: Yes
Range of Lenses: From 30 mm to 500 mm + 2× converter
Special Lenses: Fish-eye, Zoom, PC (Shift), (Soft Focus accessory), Macro
Shutter Type: Focal Plane
Shutter Speed Range: From 16 second to 1/2000 second
Flash Sync Range: From 16 seconds to 1/90 second; shorter with CF lenses
Dedicated Flash System: Yes
Motor Drive: Yes, detachable accessory
Exposure Control: Yes, in camera, spotmeter
Weight: Camera Body + Standard Lens + Viewfinder + Film Magazine
 3 lbs. 8 oz.
Above with Motor: 4 lbs. 8 oz.
Special Features: Use of large aperture lenses, up to f2; self-timer 2 seconds
 to 60 seconds; zone metering mode.

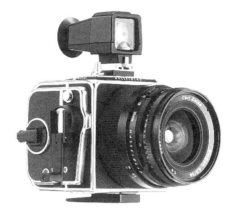

Hasselblad 903 SWC. Courtesy Victor Hasselblad.

Manufacturer: Victor Hasselblad
Camera Model: 903 SWC
Camera Type: Wide angle, optical finder
Film Formats: 6 × 6; 6 × 4.5 with other magazine
Film Load: 120; 220; 70 mm Polaroid with other magazines
Interchangeable Film Magazines: Yes
Interchangeable Lenses: No
Lens: 38 mm wide angle
Shutter Type: Lens Shutter
Shutter Speed Range: From 1 second to 1/500 second
Flash Sync Range: From 1 second to 1/500 second
Dedicated Flash System: No
Motor Drive: No
Exposure Control: Yes, in viewfinder accessory with focusing screen accessory
Weight: Camera Body + Standard Lens + Viewfinder + Film Magazine
 2 lbs. 15 oz.
Special Features: Optically true wide angle lens; spirit level in viewfinder

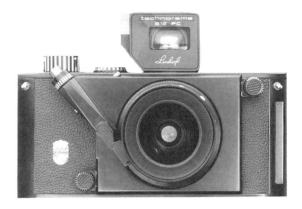

Linhof Technorama 612 PC. Courtesy HP Marketing Corp.

Manufacturer: Linhof
Camera Model: Linhof Technorama 612 PC
Camera Type: Panoramic, Optical finder
Film Formats: 6 × 12
Film Load: 120, 220
Interchangeable Film Magazines: No
Interchangeable Lenses: Yes
Range of Lenses: From 18 mm to 135 mm
Shutter Type: Lens Shutter
Shutter Speed Range: From 1 second to 1/500 second
Flash Sync Range: From 1 second to 1/500 second
Dedicated Flash System: No
Motor Drive: No
Exposure Control: No
Weight: Camera Body + Standard Lens + Viewfinder + Film Magazine
 2 lbs. 3 oz.

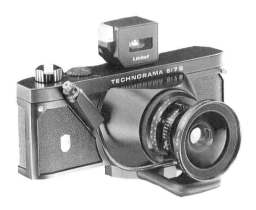

Linhof Technorama 617S. Courtesy HP Marketing Corp.

Manufacturer: Linhof
Camera Model: Linhof Technorama 617S
Camera Type: Panoramic, Optical finder
Film Formats: 6 × 17
Film Load: 120; 220
Interchangeable Film Magazines: No
Interchangeable Lenses: No
Lens: 90 mm
Shutter Type: Lens Shutter
Shutter Speed Range: From 1 second to 1/500 second
Flash Sync Range: From 1 second to 1/500 second
Dedicated Flash System: No
Motor Drive: No
Exposure Control: No
Weight: Camera Body + Standard Lens + Viewfinder + Film Magazine
 5 lbs. 5 oz.
Special Features: 87° horizontal coverage

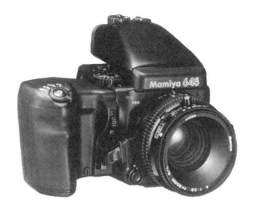

Mamiya 645 PRO. Courtesy Mamiya America Corp.

Manufacturer: Mamiya Camera Co.
Camera Model: Mamiya 645 PRO
Camera Type: SLR
Film Formats: 6 × 4.5, also 35 mm; 35 mm panoramic
Film Load: 120; 220 Polaroid, 35 mm with other magazine
Interchangeable Film Magazines: Yes
Interchangeable Lenses: Yes
Range of Lenses: From 24 mm to 500 mm
Special Lenses: Fish-eye, Zoom, Soft Focus, Macro
Shutter Type: Focal Plane
Shutter Speed Range: From 8 seconds to 1/1000 second
Flash Sync Range: From 8 seconds to 1/60 second; 1/500 second with
 special lenses
Dedicated Flash System: No
Motor Drive: Yes, detachable accessory
Exposure Control: Yes, in viewfinder accessory
Weight: Camera Body + Standard Lens + Viewfinder + Film Magazine
 3 lbs. 2 oz.
Above with Motor: 3 lbs. 13 oz.
Special Features: Remote control; self-timer; interchangeable film inserts

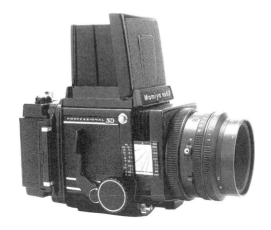

Mamiya RB 67 SD. Courtesy Mamiya America Corp.

Manufacturer: Mamiya Camera Co
Camera Model: Mamiya RB 67 SD
Camera Type: SLR
Film Formats: 6 × 7; 6 × 4.5; 6 × 6; 72 × 72 mm with other magazine
Film Load: 120; 220; Polaroid, cut film, 4 × 5 Quadra electronic imaging with
 other magazines
Interchangeable Film Magazines: Yes
Interchangeable Lenses: Yes
Range of Lenses: From 37 mm to 500 mm
Special Lenses: Fish-eye, Zoom, PC (Shift), Soft Focus, Macro
Shutter Type: Lens Shutter
Shutter Speed Range: From 8 seconds to 1/400 second
Flash Sync Range: From 8 second to 1/400 second
Dedicated Flash System: No
Motor Drive: No
Exposure Control: Yes, in viewfinder accessory
Weight: Camera Body + Standard Lens + Viewfinder + Film Magazine
 5 lbs. 8 oz.
Special Features: Interchangeable film inserts; revolving film magazine;
 bellows focusing in camera

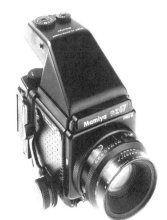

Mamiya RZ 67 PRO II. Courtesy Mamiya America Corp.

Manufacturer: Mamiya Camera Co.
Camera Model: Mamiya RZ 67 Pro II
Camera Type: SLR
Film Formats: 6 × 7; 6 × 4.5; 6 × 6; 72 × 72 with other magazines
Film Load: 120, 220; Polaroid, cut film; 4 × 5 Quadra electronic imaging with other magazines
Interchangeable Film Magazines: Yes
Interchangeable Lenses: Yes
Range of Lenses: From 37 mm to 500 mm
Special Lenses: Fish-eye, Zoom, PC (Shift), Soft Focus, Macro
Shutter Type: Lens Shutter
Shutter Speed Range: From 8 seconds to 1/400 second
Flash Sync Range: From 8 seconds to 1/400 second
Dedicated Flash System: No
Motor Drive: Yes, detachable accessory
Exposure Control: Yes, in viewfinder
Weight: Camera Body + Standard Lens + Viewfinder + Film Magazine 5 lbs. 8 oz.
Above with Motor: 6 lbs. 12 oz.
Special Features: Remote control; revolving film magazine; bellows focusing in camera; interchangeable film inserts

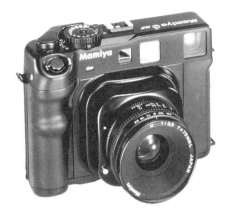

Mamiya 6 MF. Courtesy Mamiya America Corp.

Manufacturer: Mamiya Camera Co.
Camera Model: Mamiya 6 MF
Camera Type: Rangefinder
Film Formats: 6 × 6; 6 × 4.5; 24 × 54 mm with other magazine or adapter
Film Load: 120, 220, 35 mm with adapter magazine
Interchangeable Film Magazines: No but 35 mm adapter
Interchangeable Lenses: Yes
Range of Lenses: From 50 mm to 150 mm
Shutter Type: Lens Shutter
Shutter Speed Range: From 4 seconds to 1/500 second
Flash Sync Range: From 4 seconds to 1/500 second
Dedicated Flash System: No
Motor Drive: No
Exposure Control: Yes, in camera
Weight: Camera Body + Standard Lens + Viewfinder + Film Magazine
 2 lbs. 8 oz.
Special Features: Close-up adapter available

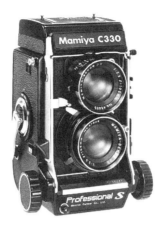

Mamiya C 330 S. Courtesy Mamiya America Corp.

Manufacturer: Mamiya Camera Co.
Camera Model: Mamiya C 330 S
Camera Type: TLR
Film Formats: 6 × 6
Film Load: 120, 220
Interchangeable Film Magazines: No
Interchangeable Lenses: Yes
Range of Lenses: From 55 mm to 180 mm
Shutter Type: Lens Shutter
Shutter Speed Range: From 1 second to 1/500 second
Flash Sync Range: From 1 second to 1/500 second
Dedicated Flash System: No
Motor Drive: No
Exposure Control: No
Weight: Camera Body + Standard Lens + Viewfinder + Film Magazine
 3 lbs. 10 oz.
Special Features: Bellows focusing for close-ups; Parallax correction
 indicator

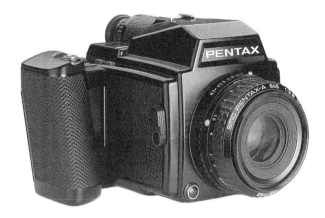

Pentax 645. Courtesy Pentax Corp.

Manufacturer: Pentax Corporation
Camera Model: Pentax 645
Camera Type: SLR
Film Formats: 6 × 4.5
Film Load: 120, 220, 70 mm with other magazine
Interchangeable Film Magazines: Yes, with limited film change
Interchangeable Lenses: Yes
Range of Lenses: From 35 mm to 600 mm
Special Lenses: Zoom, Macro
Shutter Type: Focal Plane
Shutter Speed Range: From 15 seconds to 1/1000 second
Flash Sync Range: From 15 seconds to 1/60 second; 1/500 with special
 lenses
Dedicated Flash System: Yes
Motor Drive: Yes, built-in
Exposure Control: Yes, in camera
Weight: Camera Body + Standard Lens + Viewfinder + Film Magazine
 Above with Motor: 3 lbs. 8 oz.
Special Features: Programmed auto exposure

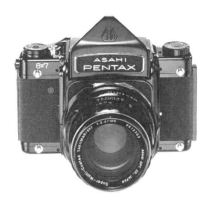

Pentax 67. Courtesy Pentax Corp.

Manufacturer: Pentax Corporation
Camera Model: Pentax 67
Camera Type: SLR
Film Formats: 6 × 7 cm
Film Load: 120, 220
Interchangeable Film Magazines: No
Interchangeable Lenses: Yes
Range of Lenses: From 35 mm to 1000 mm
Special Lenses: Fish-eye, PC (Shift), Soft Focus, Macro
Shutter Type: Focal Plane
Shutter Speed Range: From 1 second to 1/1000 second
Flash Sync Range: From 1 second to 1/30 second; 1/500 second with 165 mm lens
Dedicated Flash System: No
Motor Drive: No
Exposure Control: Yes, in viewfinder accessory
Weight: Camera Body + Standard Lens + Viewfinder + Film Magazine
 5 lbs. 5 oz.
Special Features: 35 mm body design

Rolleiflex 6003. Courtesy HP Marketing Corp.

Manufacturer: Rollei
Camera Model: Rolleiflex 6003 SRC 1000 Pro
Camera Type: SLR
Film Formats: 6 × 6; 6 × 4.5 with other magazine
Film Load: 120, 220, 70 mm, Polaroid, electronic imaging with other magazine
Interchangeable Film Magazines: Yes
Interchangeable Lenses: Yes
Range of Lenses: From 30 mm to 1000 mm
Special Lenses: Fish-eye, Zoom, PC (Shift), Macro
Shutter Type: Lens Shutter
Shutter Speed Range: From 30 seconds to 1/1000 second
Flash Sync Range: From 30 seconds to 1/1000 second
Dedicated Flash System: Yes
Motor Drive: Yes, built-in
Exposure Control: Yes, in camera
Weight: Camera Body + Standard Lens + Viewfinder + Film Magazine
 with Motor: 4 lbs. 2 oz.
Special Features: Different area metering; Aperture or shutter speed priority;
 Auto flash fill; 2 *f*ps (frames per second) motor

Rolleiflex 6008. Courtesy HP Marketing Corp.

Manufacturer: Rollei
Camera Model: Rolleiflex 6008 SRC 1000 Pro
Camera Type: SLR
Film Formats: 6 × 6; 6 × 4.5 with different magazine
Film Load: 120, 220, 70 mm, Polaroid, Electronic Imaging with other magazines
Interchangeable Film Magazines: Yes
Interchangeable Lenses: Yes
Range of Lenses: From 30 mm to 1000 mm
Special Lenses: Fish-eye, Zoom, PC (Shift), Macro
Shutter Type: Lens Shutter
Shutter Speed Range: From 30 seconds to 1/1000 second
Flash Sync Range: From 30 seconds to 1/1000 second
Dedicated Flash System: Yes
Motor Drive: Yes, built-in
Exposure Control: Yes, in camera
Weight: Camera Body + Standard Lens + Viewfinder + Film Magazine
 with Motor: 4 lbs. 8 oz.
Special Features: Autoflash fill; Different area metering; Aperture or shutter
 speed priority; 2 fps (frames per second) motor

Rolleiflex SL 66. Courtesy HP Marketing Corp.

Manufacturer: Rollei
Camera Model: Rolleiflex SL 66 SE
Camera Type: SLR
Film Formats: 6 × 6; 6 × 4.5 with other magazine
Film Load: 120, 220; Polaroid with other magazine
Interchangeable Film Magazines: Yes
Interchangeable Lenses: Yes
Range of Lenses: From 30 mm to 1000 mm
Special Lenses: Fish-eye, Macro
Shutter Type: Focal Plane
Shutter Speed Range: From 1 second to 1/1000 second
Flash Sync Range: From 1 second to 1/30 second
Dedicated Flash System: Yes
Motor Drive: No
Exposure Control: Yes, in camera
Weight: Camera Body + Standard Lens + Viewfinder + Film Magazine
 4 lbs. 1 oz.
Special Features: ±8° lens tilt; built-in bellows

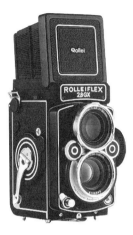

Rolleiflex 2.8GX. Courtesy HP Marketing Corp.

Manufacturer: Rollei
Camera Model: Rolleiflex 2.8GX
Camera Type: TLR
Film Formats: 6 × 6
Film Load: 120
Interchangeable Film Magazines: No
Interchangeable Lenses: No
Lens: 80 mm
Shutter Type: Lens Shutter
Shutter Speed Range: From 1 second to 1/500 second
Flash Sync Range: From 1 second to 1/500 second
Dedicated Flash System: Yes
Motor Drive: No
Exposure Control: Yes, in Camera
Weight: Camera Body + Standard Lens + Viewfinder + Film Magazine,
 2 lbs. 12 oz.
Special Features: Automatic Parallax Correction

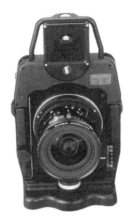

Silvestri Hermes. Courtesy HP Marketing Corp.

Manufacturer: Silvestri
Camera Model: Silvestri Hermes
Camera Type: Optical finder
Film Formats: 6 × 4.5, 6 × 6, 6 × 7, 6 × 8, 6 × 9, 6 × 12 with different magazines
Film Load: 120, 220, 70 mm, Polaroid with different magazines
Interchangeable Film Magazines: Yes
Interchangeable Lenses: Yes
Range of Lenses: From 47 mm to 180 mm
Shutter Type: Lens Shutter
Shutter Speed Range: From 1 second to 1/125 second
Flash Sync Range: From 1 second to 1/125 second
Dedicated Flash System: No
Motor Drive: No
Exposure Control: No
Weight: depends on configuration
Special Features: 360° revolving back; lens rise and drop; spirit level in
 finder; ground-glass focusing

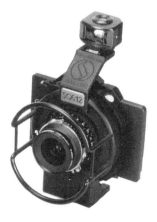

Silvestri SG 612. Courtesy HP Marketing Corp.

Manufacturer: Silvestri
Camera Model: Silvestri SG 612
Camera Type: Panoramic, Optical finder
Film Formats: 6 × 12
Film Load: 120
Interchangeable Film Magazines: Yes
Interchangeable Lenses: Yes
Range of Lenses: From 47 mm to 58 mm
Shutter Type: Lens Shutter
Shutter Speed Range: From 1 second to 1/125 second
Flash Sync Range: From 1 second to 1/125 second
Dedicated Flash System: No
Motor Drive: No
Exposure Control: No
Weight: Depends on configuration
Special Features: Spirit level in finder; 105° coverage with 47 mm lens

Index